The Finest
Houses
of Paris

The Finest Houses of Paris

Photography by
Jean-Bernard Naudin

Text by
Christiane de Nicolay-Mazery

THE VENDOME PRESS

INTRODUCTION

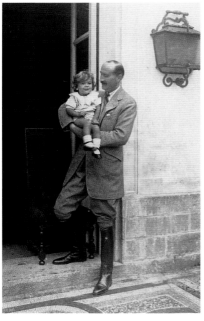

When I was a child, we lived in the country, but as Christmas approached and it was time to leave for Paris, I was seized with a feeling of great impatience. We would soon rediscover the house of my grandparents on the rue Saint-Guillaume, with its monumental porch, an eighteenth-century courtyard, its hedged garden filled with statuary, and the great stone staircase on whose steps my mother had been photographed on the day of her marriage. I dreamt about the floors with their ancient Versailles parquets, on which guests danced at balls given for my older sisters: I seemed to hear an Argentine orchestra in the garden. All this captivated and fascinated me.

My grandmother used to receive us in her ground-floor apartment, which looked out onto the French-style garden. She was surrounded by Chinese art: lacquered Coromandel screens, ceramic camels of the Tang Dynasty, and lovely, precious small boxes were placed on every table.

When we entered the dining room, with its white and gold paneling with inset mirrors, and its clock suspended in a bird cage, we were plunged suddenly into the eighteenth century. My grandmother reminisced about the period in her life during which, together with my grandfather, she would invite for lunch or dinner both French and foreign political personalities, and such writers as André Maurois, Saint-John Perse, or Edith Wharton. This was life in the center of France's aristocratic and intellectual society between the wars, the Faubourg Saint-Germain, which she recreated so vividly for me.

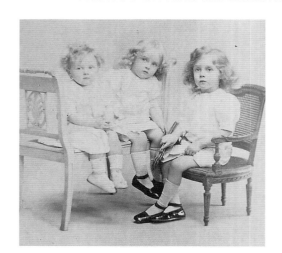

When my father spoke about his own childhood, it seemed even more astonishing. Before World War I, his family life was divided into two, with six months in the country and six in Paris. Then his studies became serious when tutors no longer sufficed, high school attendance was necessary, and the periods in town grew longer. His family occupied three floors of a town house on the avenue Bosquet, looking out over the Seine. My father used to tell us how the children scampered up and down the staircase at the sound of a bell rung by the concierge to announce mealtimes, a bell timed so precisely that it was used as a clock by the neighbors. We also heard about Sunday lunches that brought together thirty people—aunts, uncles, and cousins—all feasting upon produce that came directly from the kitchen garden, river, or farm of his Renaissance Château de Lude. He described the family chef, Maret, and his overwhelming *bombes glacées*. Each year, on exactly the same date, white

My family was fortunate enough to live the elegant and formal, yet close-knit, family life that is represented in so many of the houses seen in this book. (Above) My maternal grandfather, the Baron de la Grange, is holding his son – and my uncle – Henri Louis, who became one of the most respected scholars of Gustav Mahler. This group portrait was taken in the family house at 16 rue Saint-Guillaume, now the home of the distinguished international banker Michel David Weill. (Left) Left to right: my father, the Marquis de Nicolay, his brother Aymard, and friend. The Nicolay family became owners of one of the most beautiful monuments in France, the Château de Lude, through marriage to a daughter of the Marquis de Talhouet-Roy. It lies in the Sarthe region, in western France, and is open to the public.

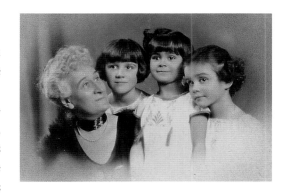

(Left) Here is my mother's family. Left to right: My great-grandmother, the Baroness de la Grange, my mother Amicie, and my aunts Mimi (who married a distinguished American lawyer, Henry Hyde) and Anne. The sisters were also photographed at the rue Saint-Guillaume (below). (Below right) Left to right. Christian de Nicolay, who was to become France's ambassador in many of the world's great capitals, and his

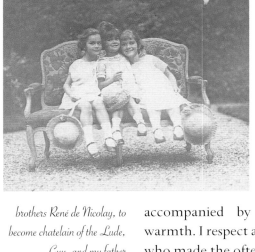

brothers René de Nicolay, to become chatelain of the Lude, Guy, and my father Aymond. As yet unborn was François, a renowned racehorse breeder and the first husband of Marie-Hélène de Rothschild. (see pps. 10-41, the Hôtel Lambert).

slipcases were put over all the furniture in the house and the family returned to the country.

Today, the town house on the rue Saint-Guillaume belongs to an important banker, while the house on the avenue Bosquet is an embassy. Everything is different. People live in Paris all year round, and apartments are more simple and comfortable. But there still remain a few of those old seventeenth-, eighteenth-, and nineteenth-century mansions, or *hôtels particuliers*, imbued with the fragrance of times past.

As I remember these family tales, I want to once more open the doors of such dwellings, beloved, warm, inhabited houses in the heart of Paris that still resound with the shouts and laughter of children, with barking dogs in the garden, the comings and goings of all sorts of people. Before they disappear, are transformed, or become institutionalized, we can visit together these magnificent private mansions, masterpieces of beauty, elegance, and taste, where each generation has tried to leave its mark in a place rife with history. Some owners held literary salons, others hosted historical personalities, others were queens of fashion or fantasy, and nearly all organized great balls and parties.

Along these walls passed Madame du Châtelet, Madame de Staël, Pauline Borghese, and Juliette Récamier. Each generation left behind a part of its heart, its special talents, and past owners often seem still present today in order to make sure that elegance and majesty are still accompanied by happiness and warmth. I respect and ad-mire those who made the often difficult choice of conserving or acquiring these large dwellings, which require great sacrifice. Often, these new owners draw no special glory for themselves; under decorated ceilings they are sooner inclined to be humble, like temporary curators serving the cause of beauty, mere links in a chain. I warmly thank all those who opened their doors in order that this book could be a witness to the French art of living.

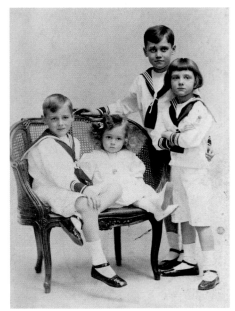

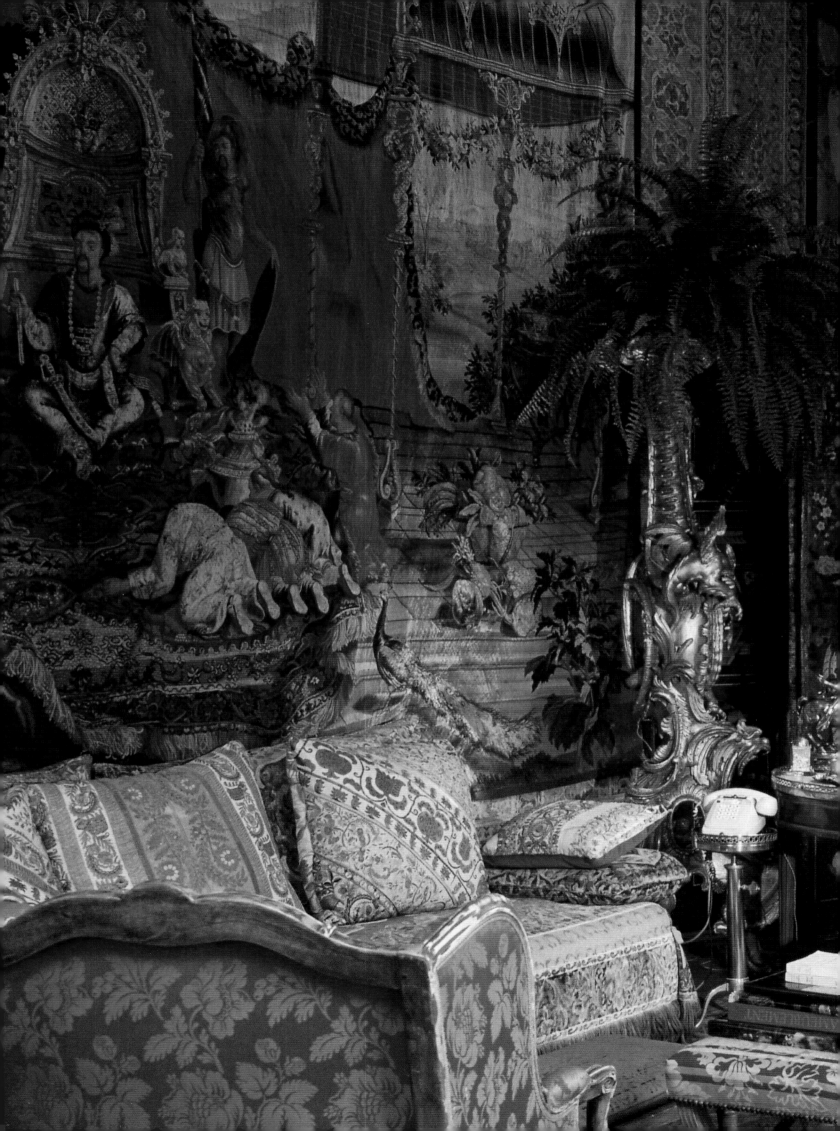

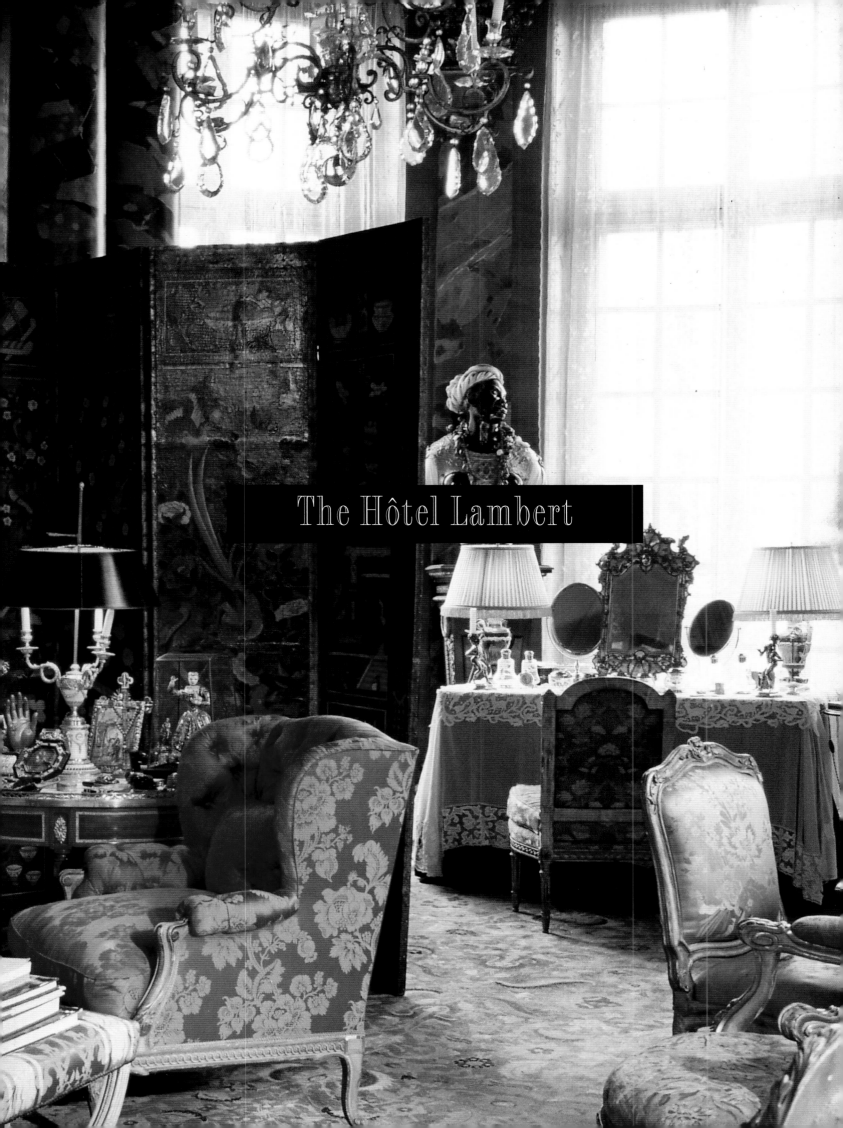

The Hôtel Lambert

With Baron Guy de Rothschild

When the young King Louis XIII, supported by his very powerful minister the Cardinal de Richelieu, seized the reins of power in 1610, many nobles left their country estates to come to Paris and accept the new official positions that were offered. It was then that a young architect, Christophe Marie, decided to purchase two small islands lying as yet fallow upstream from the Île de la Cité: the Île de Notre-Dame and the Île aux Vaches. The

space between them was filled in, giving rise to the Île Saint-Louis, on which he decided to build.

In a few years great private houses arose, their facades aligned along the Seine. At the promontory of the Île Saint-Louis, dominating the river, lay a large plot occupied only by a windmill. In 1639 it was bought by Jean-Baptiste Lambert de Thorigny, adviser and secretary to Louis XIII. He turned over the task of building the town house to a young, twenty-seven-year-old architect named Louis Le Vau. This was the starting point for a fabulous adventure that would bring together all the greatest talents of the time to create the Hôtel Lambert, a masterpiece of French architecture and taste that, thanks to the determination of several proprietors, would fulfill its destiny as an exceptional palace.

At number two of the present-day Rue St. Louis en l'Île, a monumental doorway opens onto a paved courtyard, semicircular in form, which leads to a pavilion with a pediment bearing a coat of arms. The ground floor on this side housed everything needed for service: kitchens, pantries, food storage areas, servants' quarters, and, naturally, carriage sheds. The stables themselves were located on the back courtyard, which opened directly on to the quays. Two asymmetric wings were foreseen, one for living rooms on the left, and another for reception rooms

The Hôtel Lambert stands like a fortress guarding the Seine. On the left can be seen the bay windows of the Grande Galerie, decorated by Charles Le Brun.

(Opposite) The grand staircase, a masterpiece of Baroque architecture, is crowned by a rock-crystal chandelier and embellished with Gobelin tapestries. This leads to great rooms of state on the étage noble.

(Previous pages). The main bedroom of the house was redecorated by Baroness Marie-Hélène de Rothschild after her husband bought the house in 1975. It bears out what Elisabeth de Gramont wrote about the banking family, "The Rothschilds have the gift of grandeur, and of generosity. They are always attracted to the best, and France is indebted to them for conserving her finest treasures. Old Master paintings, fine furniture, tapestries, and precious silver would have long ago crossed the Atlantic if not for the protective taste of the Rothschilds."

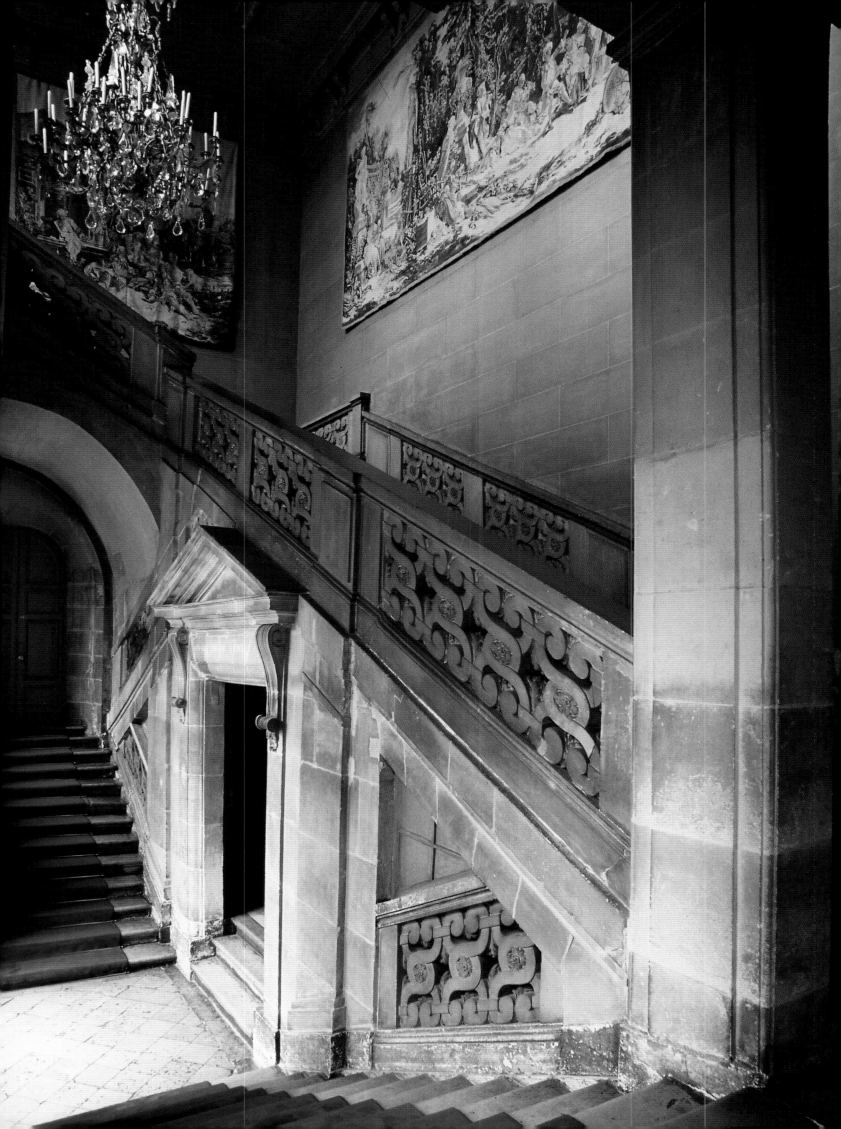

on the right, overlooking the garden and river.

When construction was finished in 1641, Lambert de Thorigny believed that at last he could enjoy his magnificent palace. But he died suddenly, at the age of thirty-six. His brother Nicolas summoned three great French artists—Eustache Le Sueur, François Perrier, and Charles Le Brun—to decorate the house; finishing the Galerie d'Hercule, the Salon de l'Amour, the Cabinet des Muses, and the bath cabinet would take fifteen years.

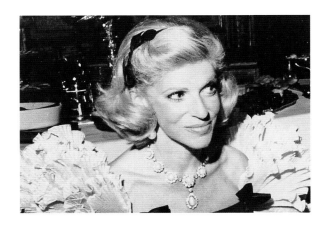

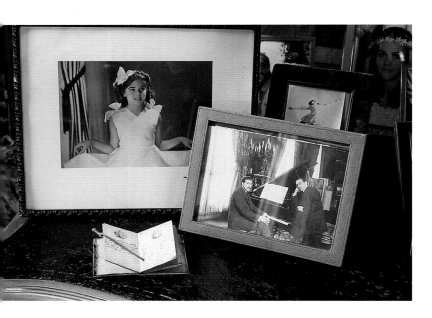

Le Brun was twenty-four and had just come from Rome when he received the commission to decorate the imposing Galerie d'Hercule. At right angles to the garden, it terminates in a rotunda whose windows are embellished with a cast-iron balcony. Its vault is 23 meters long by 7 meters wide and

was the first major work of a painter who would be known for "his very light brush and the most delicate tones." It looks forward to the great works of art he was later to execute at the Louvre, at Versailles, and at Vaux-le-Vicomte. At the same time, Von Opstal was entrusted with the creation of a series of medallions in stucco, varnished to imitate the greenish brown patina of bronze; these were upheld by cupids, sphinxes, and caryatids, all covered in gold leaf.

In 1726, the Hôtel Lambert changed hands: Madame Dupin, a

The late Marie-Hélène de Rothschild was the queen of French society (above right). A woman of unusual intuition and flair, she was herself one quarter Rothschild thanks to her grandmother Hélène, a daughter of Baron James, founder of the French Rothschilds.

(Below) On a book about a Dutch relative is a newspaper clipping of Marie-Hélène's sister, who died in childhood. (Center left) Her father, the Dutch Baron van Zuylen van Nyvelt, is seen seated at the piano.

(Opposite) On the desk of Marie-Hélène de Rothschild's bedroom is a collection of photographs of friends and family. Her husband's grandfather, Baron Alphonse de Rothschild, is seen in an oval portrait on the far left.

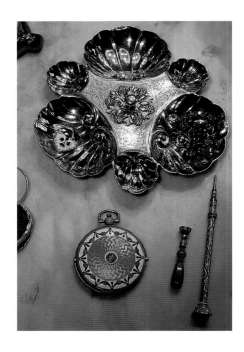

dukes, ambassadors, and highly decorated officials, the Princess de Rohan, Madame de Mirepoix, M. de Fontenelle, and M. de Buffon." Voltaire wrote to her as follows: "The Chamberlain of the King of Prussia wants to find out what makes up the glory of our country. I advised him to start with you, an advantage for which he is quite worthy. Your house will not give him a bad opinion of France."

literary figure associated with the finest minds of her time, became the new owner. According to Jean-Jacques Rousseau, she was one of the most beautiful ladies in Paris. Her secretary, who was also a writer, had this to say about her: "She loved to have around her people who had charisma, the great of this world, people of letters, beautiful women; at her house one only saw

In 1739 the house, which had a reputation of being devoted to sheltering brilliant minds, was given over to Madame du Châtelet, who herself organized brilliant evenings. Plays were performed, and there was gambling for high stakes. Voltaire lived there on several occasions. He wrote about this house, which, he said, "was made for a sovereign who would become a philosopher"; and he wrote, "How happy is The Hôtel de Châtelet, the Cabinet des Muses, the

Marie-Hélène de Rothschild's bedroom overlooks the Seine, which can be seen through a lovely screen of trees in the house's garden. Her dressing table (opposite) reflected in the afternoon sun, is enhanced by an eighteenth-century silver gilt dressing set, and scattered around in studied disorder are precious treasures collected by her and her husband's family. Overlooking the treasures is a rare Venetian marble blackamoor. The baroness was a great collector and connoisseur of modern and antique jewelry, both of which she collected in abundance.

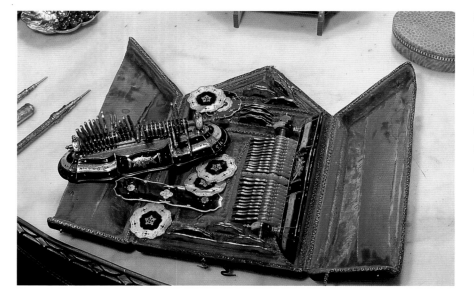

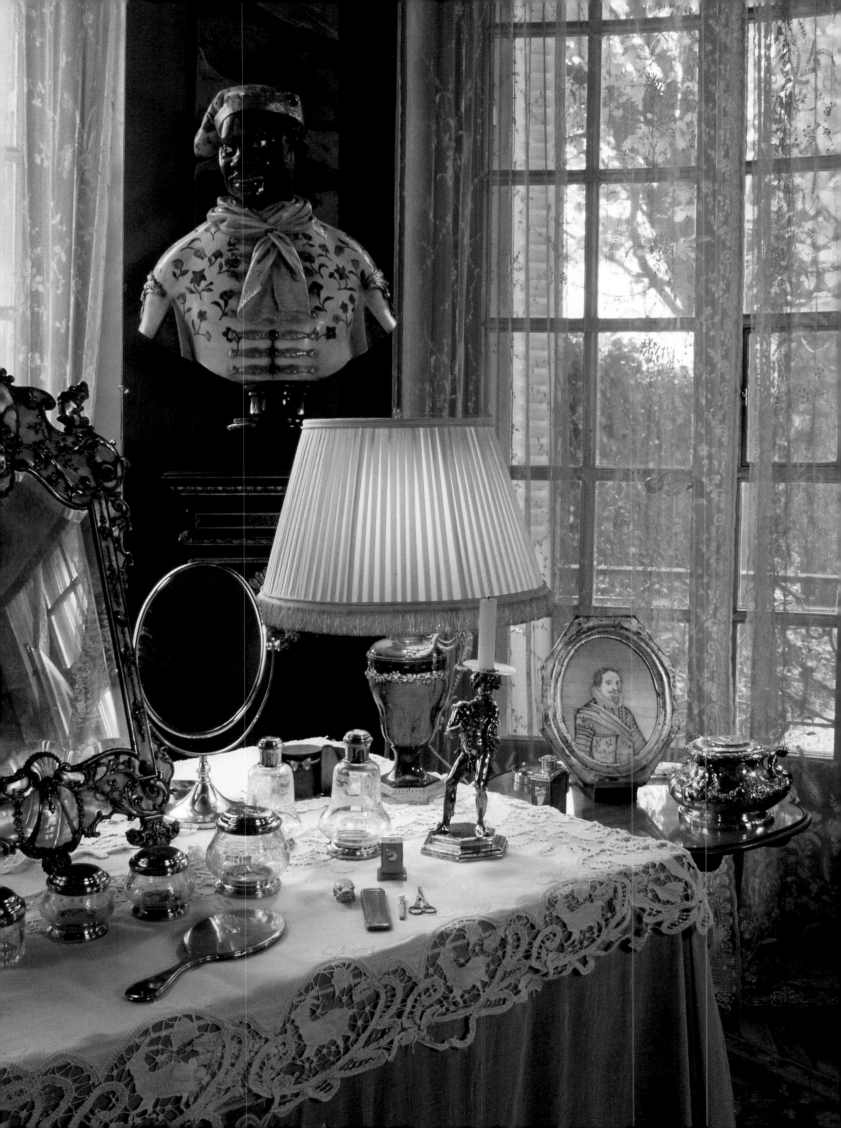

Life at the Hôtel
Lambert is, evidently,
extremely refined and
luxurious.

(Above) At the ready is a
long list of rooms, servants,
and services with their
corresponding telephone
codes.

(Right) A gilded
washbasin that turns the
most humdrum routine into
an elegant activity.

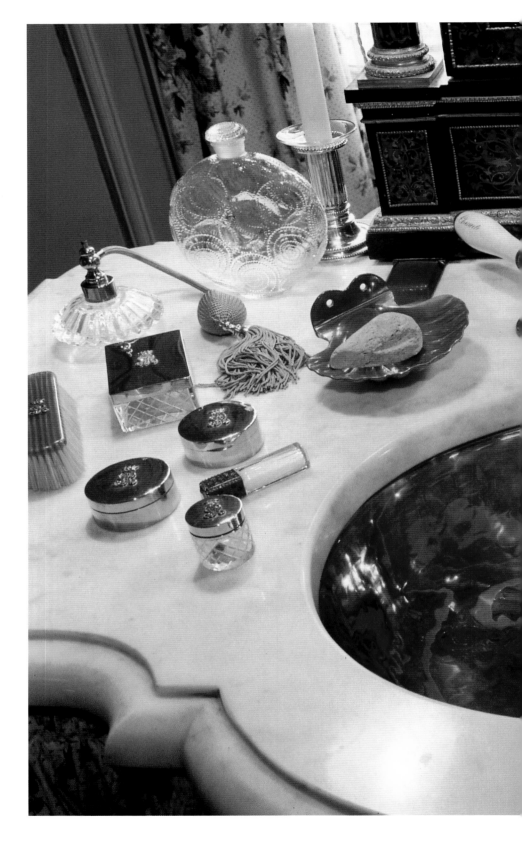

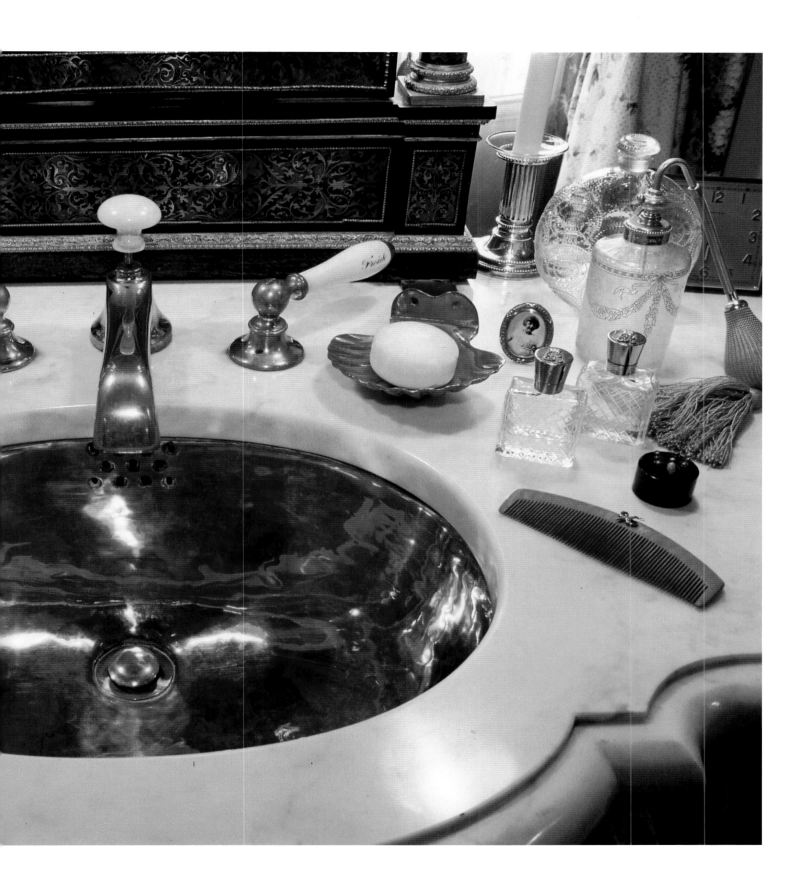

17 · With Baron Guy de Rothschild

Galerie d'Hercule, the Salon de l'Amour. Our rivals from antiquity, Le Sueur and Le Brun, and our renowned Arpelles, have spread beauty over this charming place."

In 1789, the French Revolution broke out and the ancien régime died. The palace changed hands several times until, one day in 1843, a large yellow poster was seen on walls all over Paris, stating that on May 23, 1843, a vast property, known as the Hôtel Lambert, would be auctioned, and that it would be appropriate for housing a rich man. "It has the possibility of being a good speculation or could be transformed into a factory. The asking price is 180,000 francs." A

"candle auction" was organized, in which the final bid had to be received before the candle burned out. No one made an offer.

Three weeks later, on June 10, 1843, an offer was made in the name of Prince Adan Czartoryski, a great Polish nobleman. In February 1844, *L'Illustration* wrote, "The Hôtel Lambert, by a miracle, escaped the prosaic mentality of our times. Hardly a year ago, this precious monument was offered up on a billboard to the caprice of the highest bidder. One could have bought the right to set up shop, or build a forge or workshop on the ruins of Ceres, Flora, Apollo, Venus, and the Muses." The

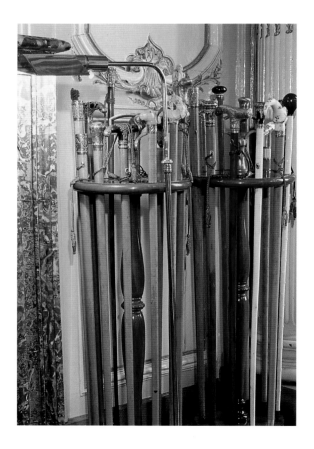

The Hôtel Lambert was redecorated by the renowned Italian set designer Renzo Mongiardino; the late decorator was a virtual encyclopedia of decorative styles, and in the baroness's bedroom, he evoked the Second Empire of Napoleon III, in whose reign Baron James de Rothschild, the founder of the French branch, built the Château de Ferrieres, an immense country house.

(Opposite) The family arms are embroidered on the chair next to the gilded tub in the bathroom. Very Ritzy, the room is flooded with light and shielded from the outside by lace curtains.

(Right) A collection of old walking sticks might inspire a refreshed bather to take a walk along the enchanting, ancient streets of the Ile St. Louis.

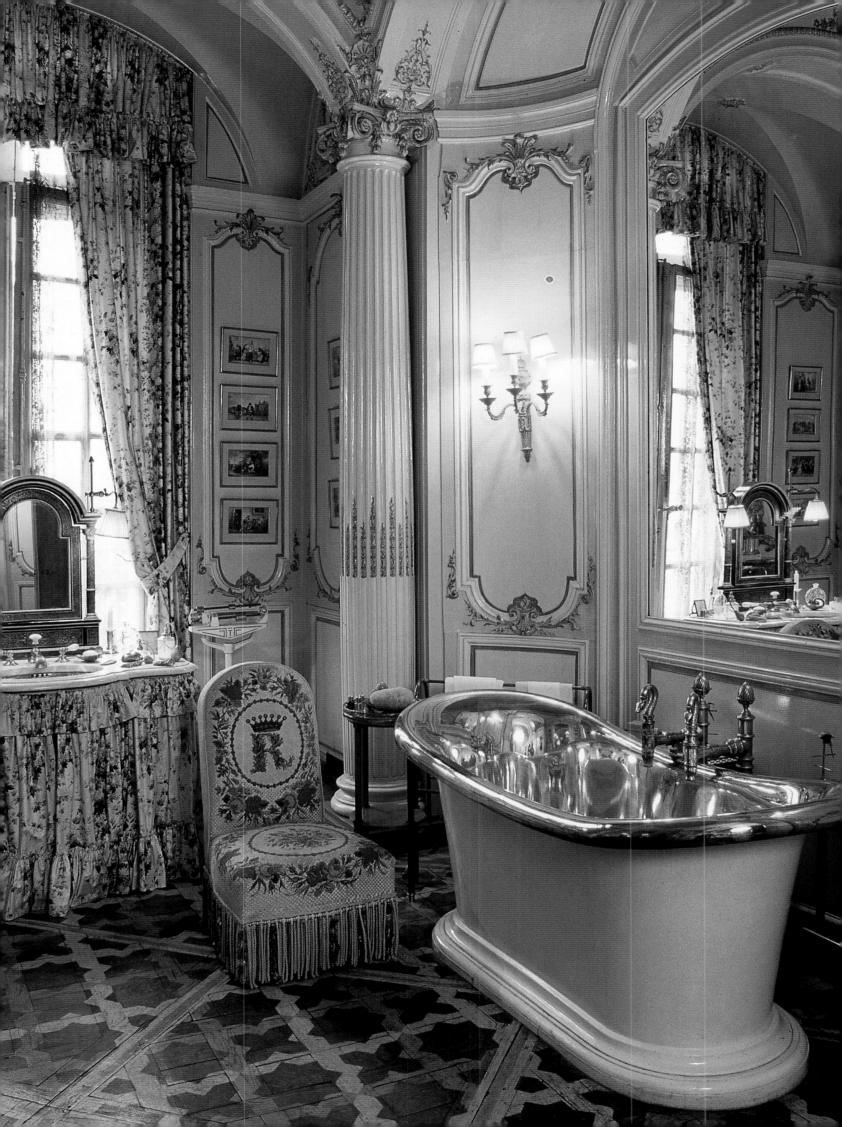

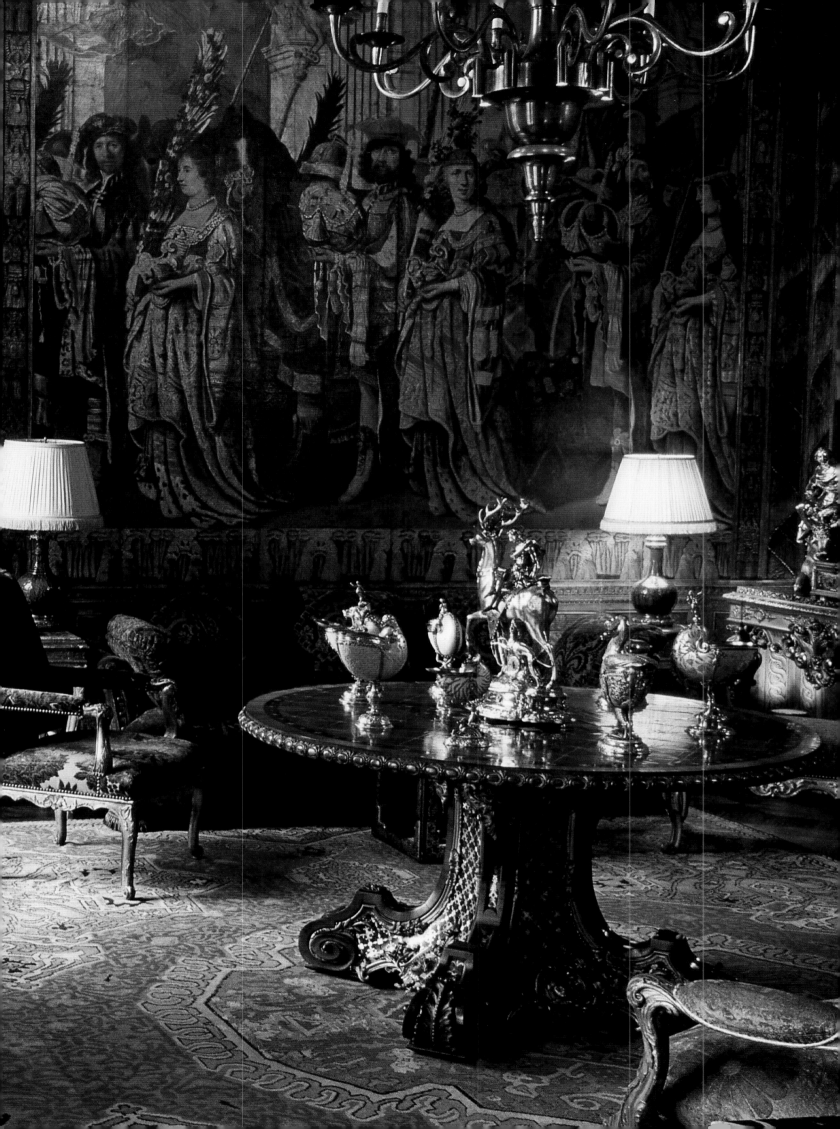

22 · The Hôtel Lambert

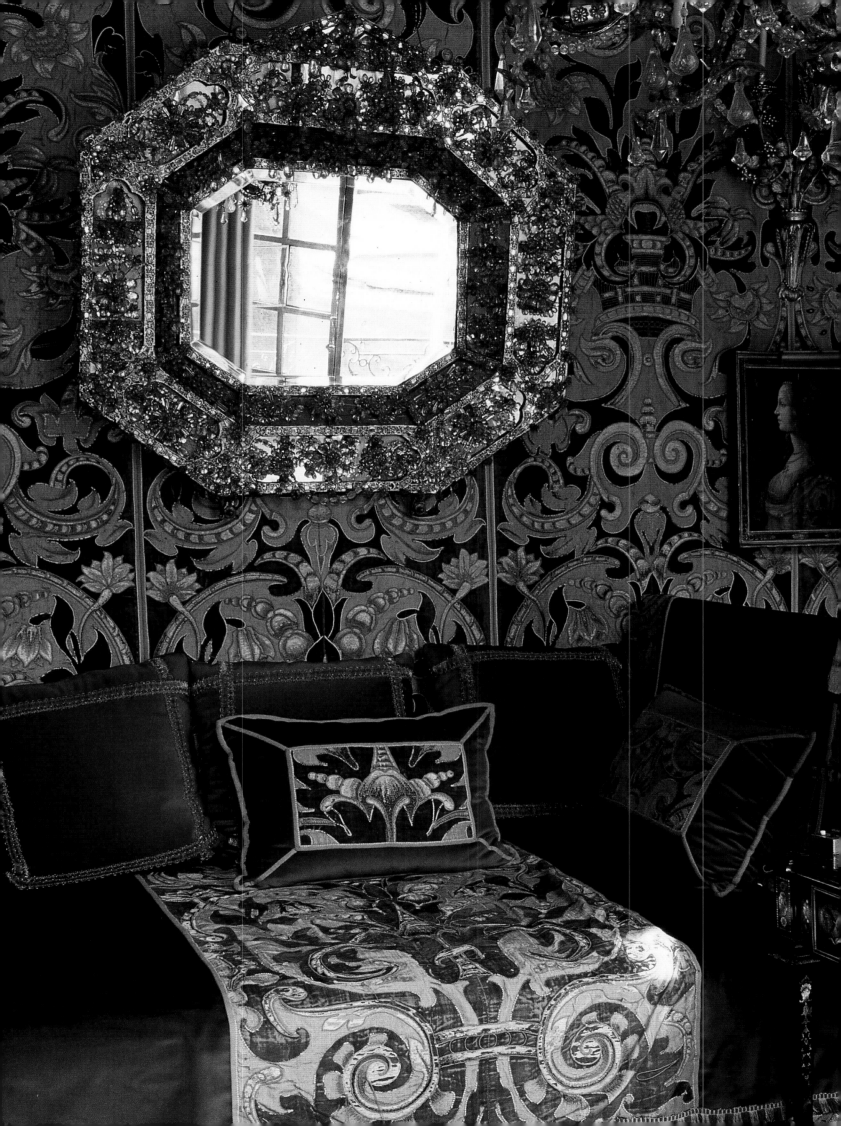

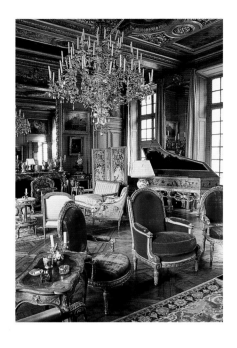

(Pages 20-22) A general view and detail of the Leather Salon. This is one of the most extraordinary rooms in all of Europe, named for the seventeenth-century tooled Cordoba-leather Old Testament scenes of King David that cover the walls, a priceless family treasure of which there is no similar example. On the table can be seen some of the German Renaissance and Baroque silver, favored family collectibles, following the example of Germany's Electors and Princes, many of whom were family clients. Several nautilus shells and a silver drinking cup featuring Diana on her stag are particularly noticeable and elegantly laid out. Through the doors can be seen the French furniture that embellishes the Louis XIV salon, and in the distance is the portrait of Baroness Betty, Baron James' wife and the family matriarch.

(Previous page) Precious Genoa velvet dating from the seventeenth century and embroidered in silver and gold covers the walls of the boudoir that leads into the bedroom–living room of the Baroness.

Czartoryskis would turn their beautiful domain on the banks of the Seine into a little Poland, a haven of beauty, charm, and philanthropy. Parties were given once more; one above all remained famous because of its splendor. This took place on January 25, 1845. A parquet floor was put over the paving stones of the entrance, and a cloth tent was erected, from whose ceiling hung immense crystal chandeliers. In the garden overlooking the Seine, the trees bent under the weight of garlands of flowers, and chandeliers made up of leaves with luminescent balls glowed while the house itself shone in the light of innumerable candles. This was a fantastic palace, one of a thousand and one nights, Sleeping Beauty's palace that, a hundred years later, was once

more to awaken. The Czartoryskis returned to Poland at the end of the century and rented out parts of the house; post-war tenants included the actress Michèle Morgan, the Chilean millionaire-collector Arturo Lopez, and the elegant Princesse de Polignac.

(Above and opposite) The great Louis XIV salon is dominated by an astonishing, period rock-crystal chandelier that might have come straight out of a fairy tale. The ceiling paneling and painting date to the original decoration in the seventeenth century.

(Far left) A detail of a monkey on an Aubusson tapestry screen, and (left) eighteenth-century embroidered silk embellishes a Louis XVI chair.

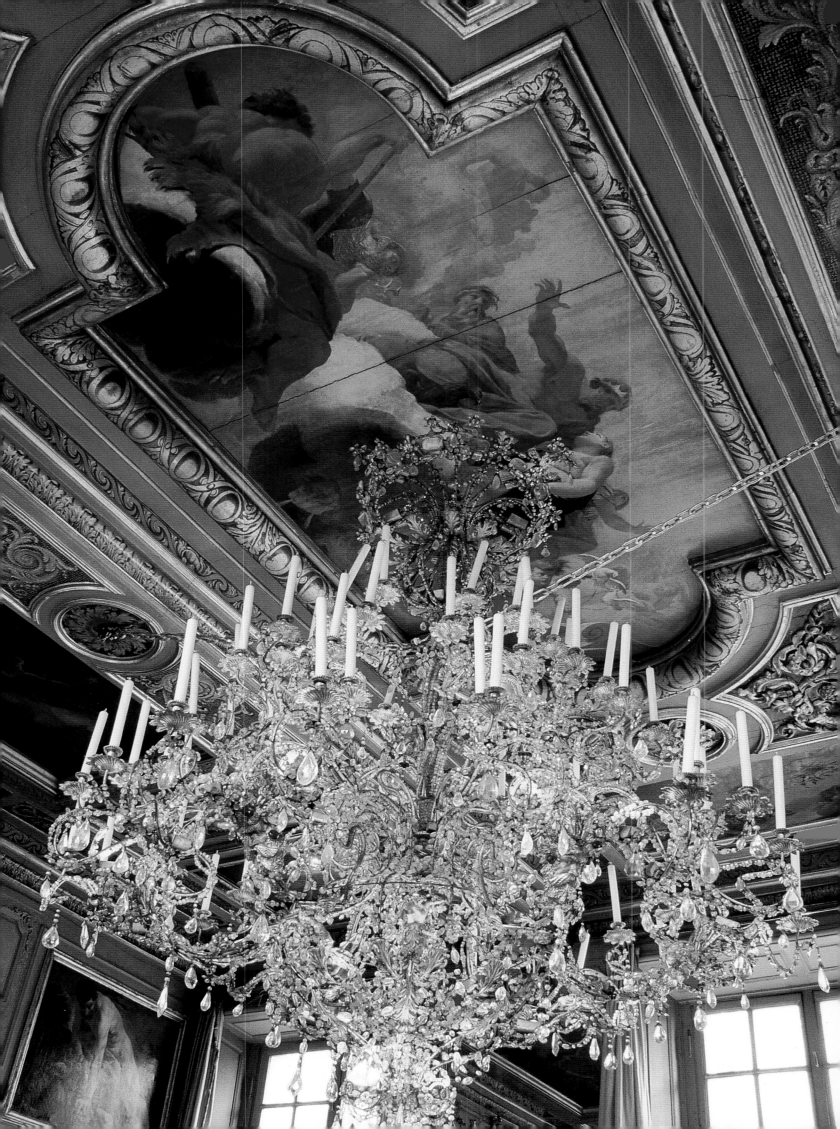

(Right) The Galerie d'Hercule, overlooking the Seine from the bay windows and the house's garden from the side (below), is seen in its present state and (center) in a period view. This is one of the most intriguing rooms in Paris from an artistic point of view, and embodies all the grandeur of the Sun King's reign. Charles Le Brun painted the ceiling here before undertaking major works at Versailles; in consequence, his work at the Hôtel Lambert was as much an inspiration for Versailles' decoration as Le Vau's at Vaux-le-Vicomte's was for its architecture. When originally built, there was no furniture in the gallery; today it contains extremely rare chairs and girandoles from the period.

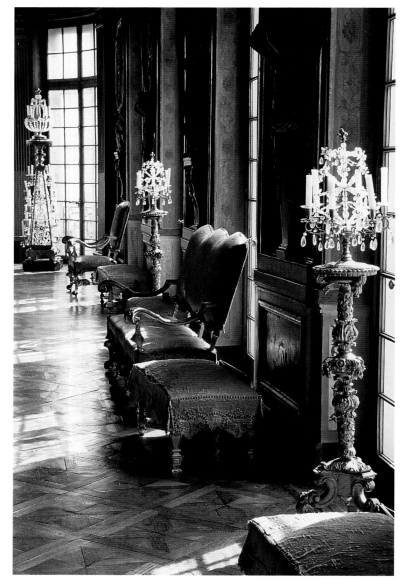

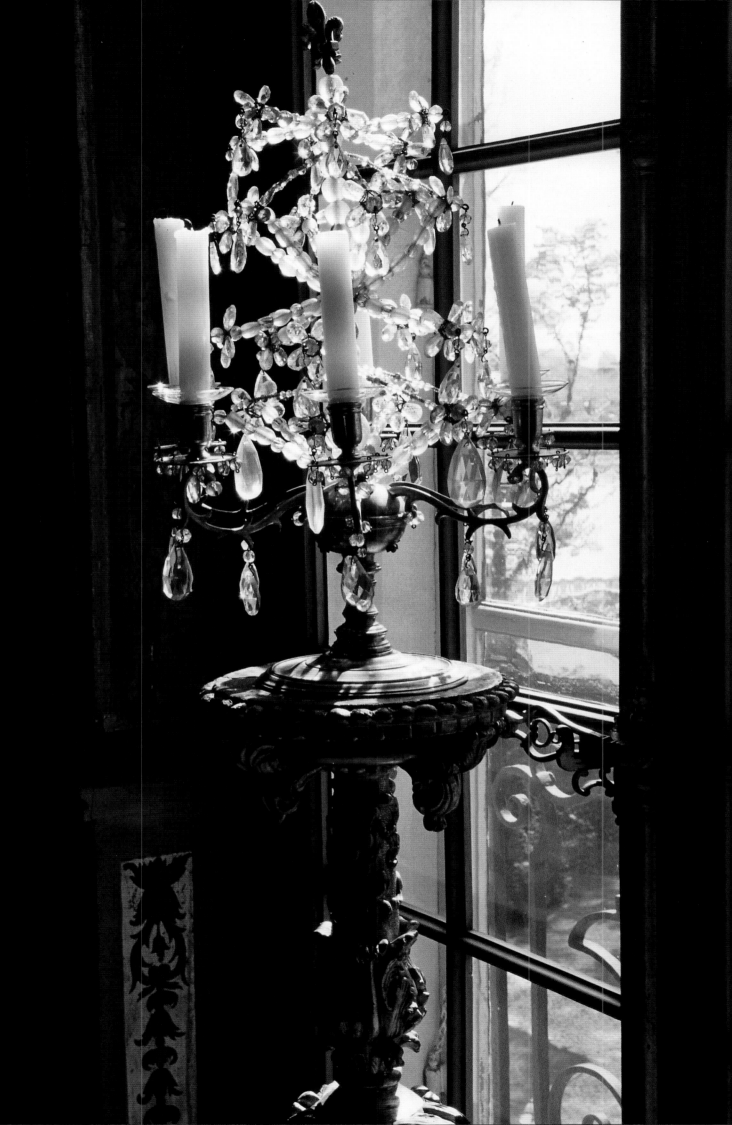

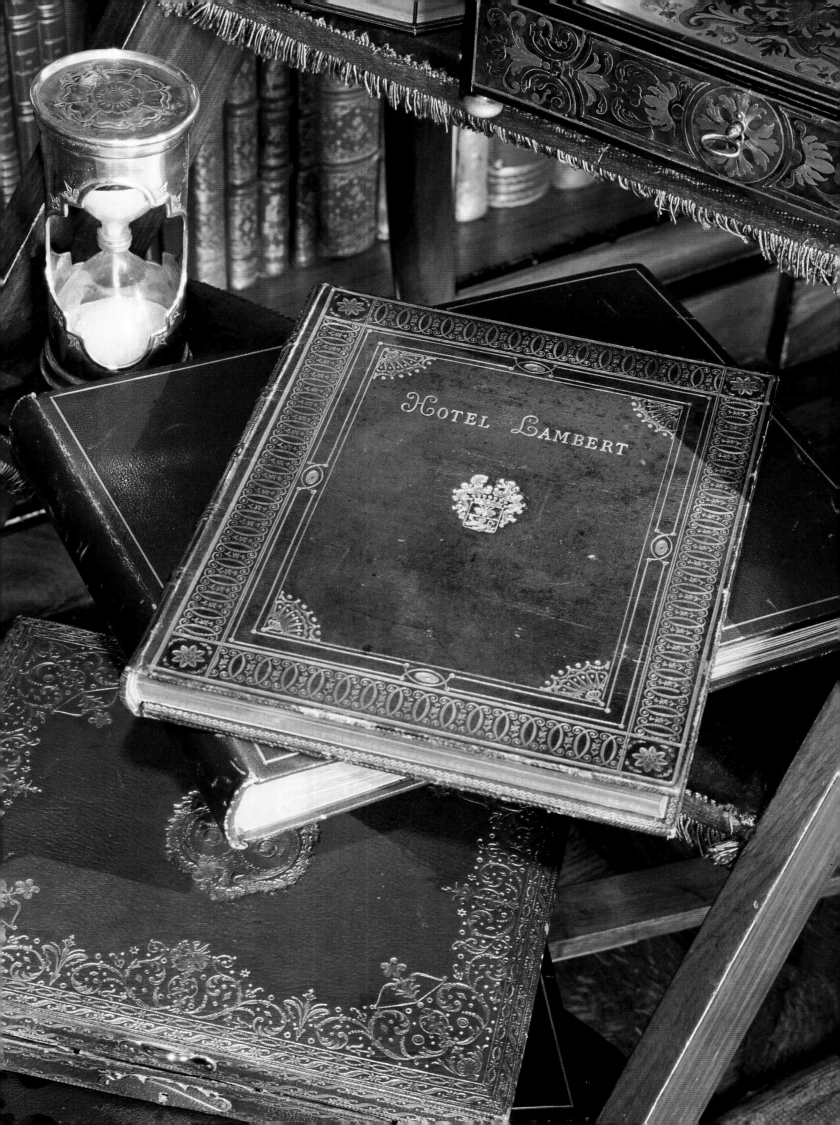

One day in 1975, Baroness Guy de Rothschild called her husband on the telephone: "Do you still feel young? Young enough to change the course of your existence in just two hours?" And so Guy de Rothschild learned that the Hôtel Lambert was for sale and that his wife Marie-Hélène was eager to embark on this extraordinary adventure.

Various period styles mix in the library. (Below) A Directoire chair is placed on an eighteenth-century Savonnerie carpet, part of a series made for Versailles. (Above) Old red velvet and (opposite) a leatherbound book dating from the period of the construction of the house create a refined atmosphere.

Who was this unusual personality who was willing to get involved in such a vast enterprise? "She had an incredible zest for life," says her husband about her, "a thousand-sided spontaneity and an indescribable charm." Beautiful, seductive, imperious, explosive, impertinent, passionate, and full of talent, she loved fantasy, the unexpected, was afraid of nothing. Simultaneously a great Maecenas and a character from a novel, she was wide open to art, music, politics, aristocracy, and also to Hollywood, as represented by her friends Grace Kelly, Audrey

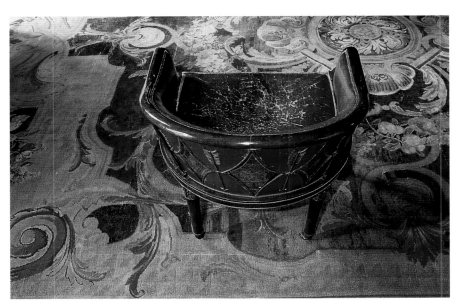

Hepburn, Richard Burton and Elizabeth Taylor. Above all, she liked to turn her dreams into reality and had the daring to do so. What she intended to do to the Hôtel Lambert bore witness to all of this.

Baron Alexis de Rédé, an art collector of great taste and refinement and one of the closest friends of the baron and baroness, was then the primary tenant of the house. He occupied the floor that housed the most beautiful salons and the Galerie d'Hercule, and for thirty years had brought life back to this palace, had restored it, put the paintings back in place, found pieces that had been lost or substituted other artworks of the period.

For Guy de Rothschild, the house was quite familiar; had not Chopin played there? Perhaps he had even performed a ballade or waltz dedicated to Rothschild's great-grandfather Baron James, or to Charlotte, James's only daughter, who was one of Chopin's most talented pupils. The composer was the protégé of Rothschild ancestors, who had received him into their homes, and had helped make him famous.

There was another weighty argument. Since the death of his mother a few months before the house was put on the market, Baron Guy had been searching for a setting worthy of housing the

While the Rothschilds occupy a large part of the house, their good friend Baron Alexis de Rédé occupies the equally splendid second floor. A great connoisseur and collector of French furniture, as can be seen (left) in these Louis XVI chairs and candelabra, he lived here before the house was sold. (Opposite) The furniture is enhanced by grisaille panels on a gold background.

(Overleaf) The Muses Cabinet was painted by Eustache Le Sueur who, like Le Brun, was a premier peintre du Roi. Against his painting is a Louis XV bureau de pente (left) covered in inlaid gilt. This is very much in the taste of the electors of Saxony or the Wittelsbachs, and was surely of German royal origin. On the right, Baron de Rédé's silver gilt is laid out in preparation for a dinner party.

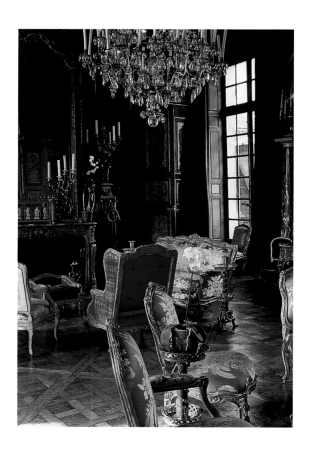

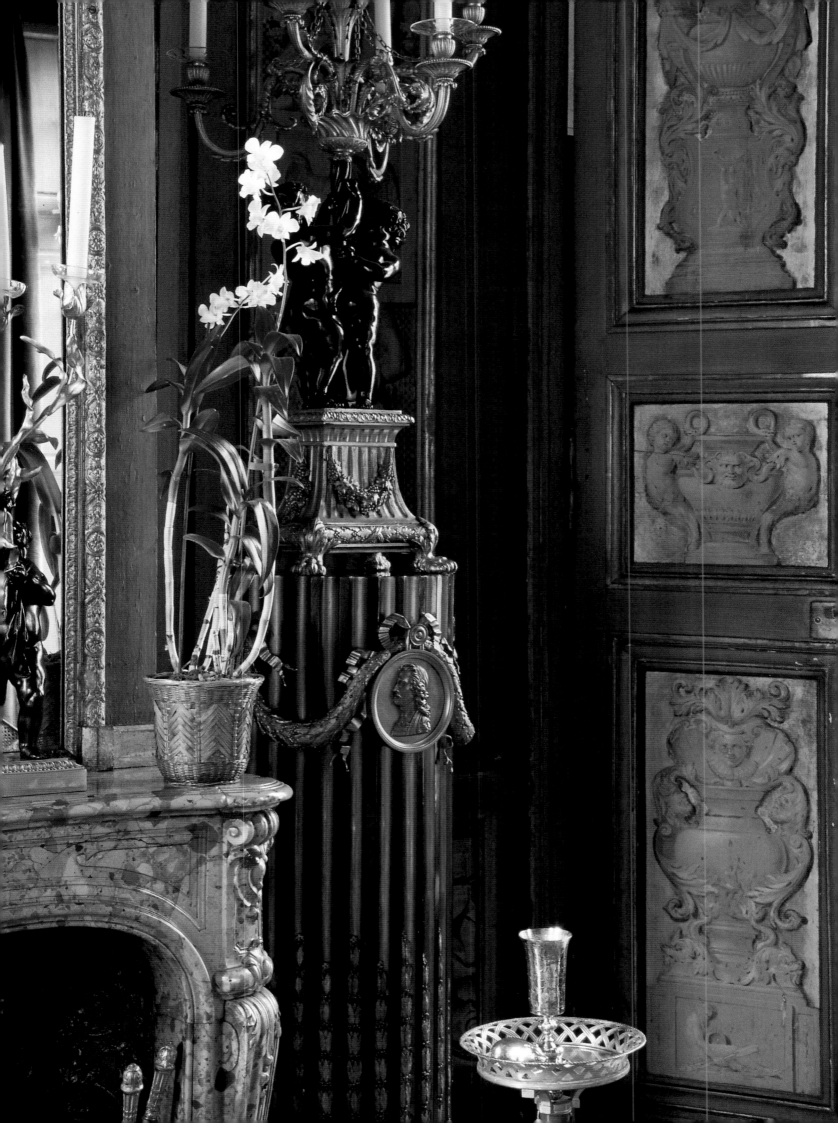

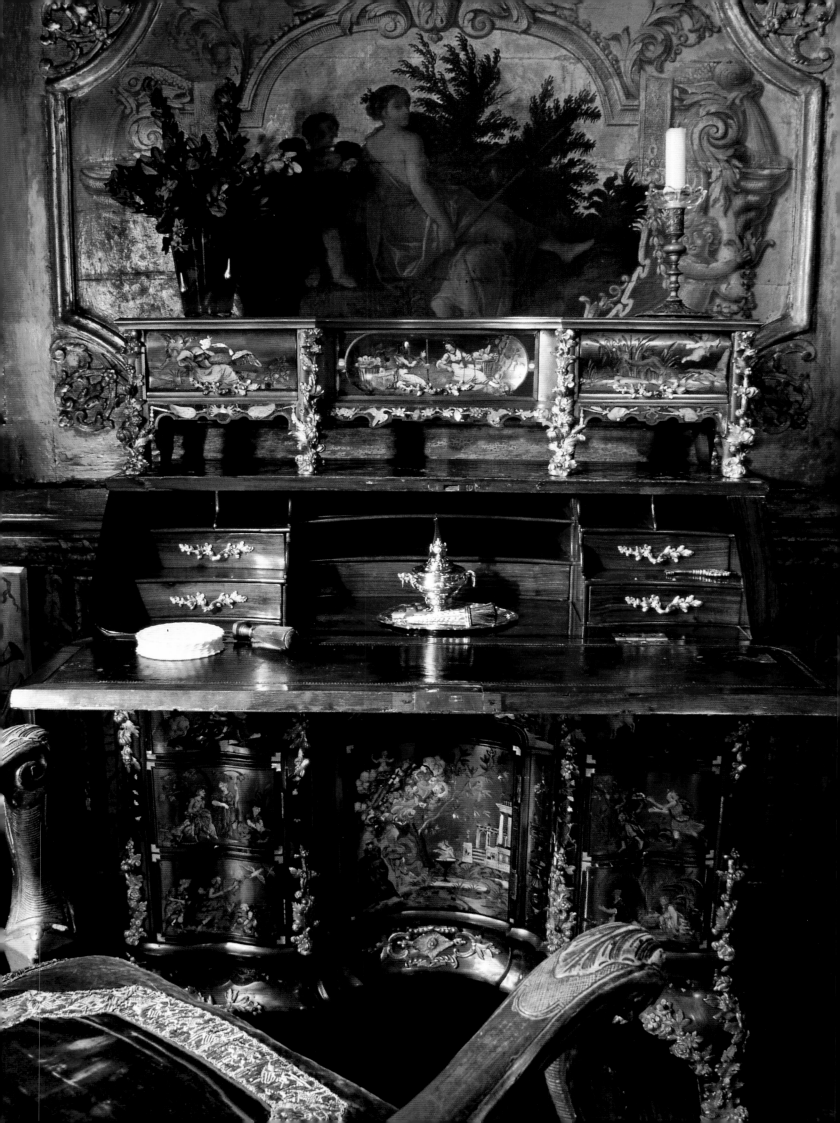

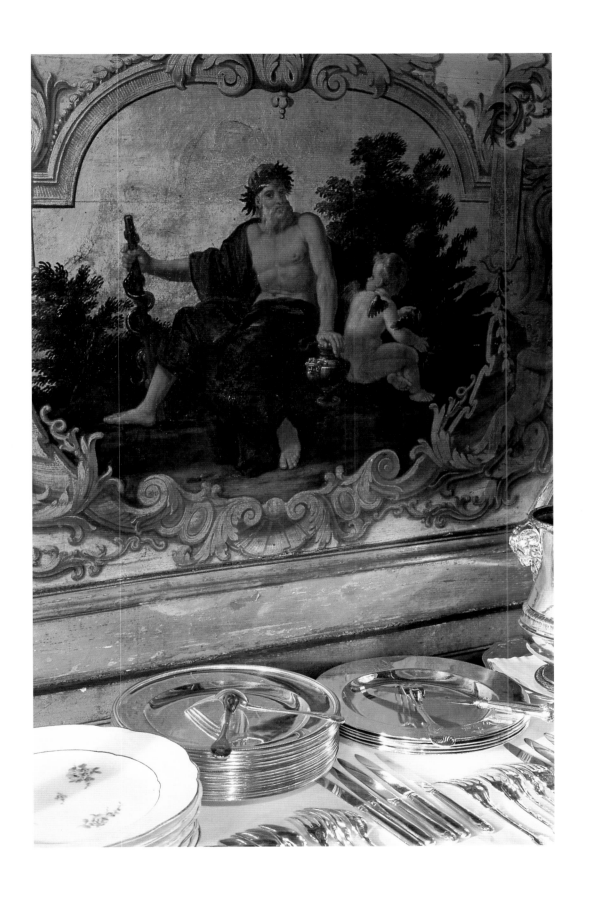

33 · With Baron Guy de Rothschild

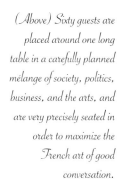

An invitation to dine in the Galerie d' Hercule is something that is looked forward to for weeks, discussed for months, and remembered for a lifetime. (Opposite) The Sèvres tureens and vases are placed along the table. The food is magnificent, with many dishes invented by Rothschild chefs over the centuries.

(Above) Sixty guests are placed around one long table in a carefully planned mélange of society, politics, business, and the arts, and are very precisely seated in order to maximize the French art of good conversation.

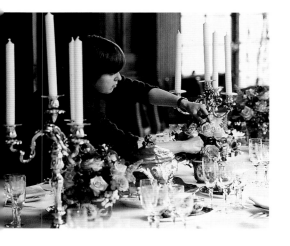

(Above) The table is covered from one end to the other with lovely flowers prepared by the talented Marianne.

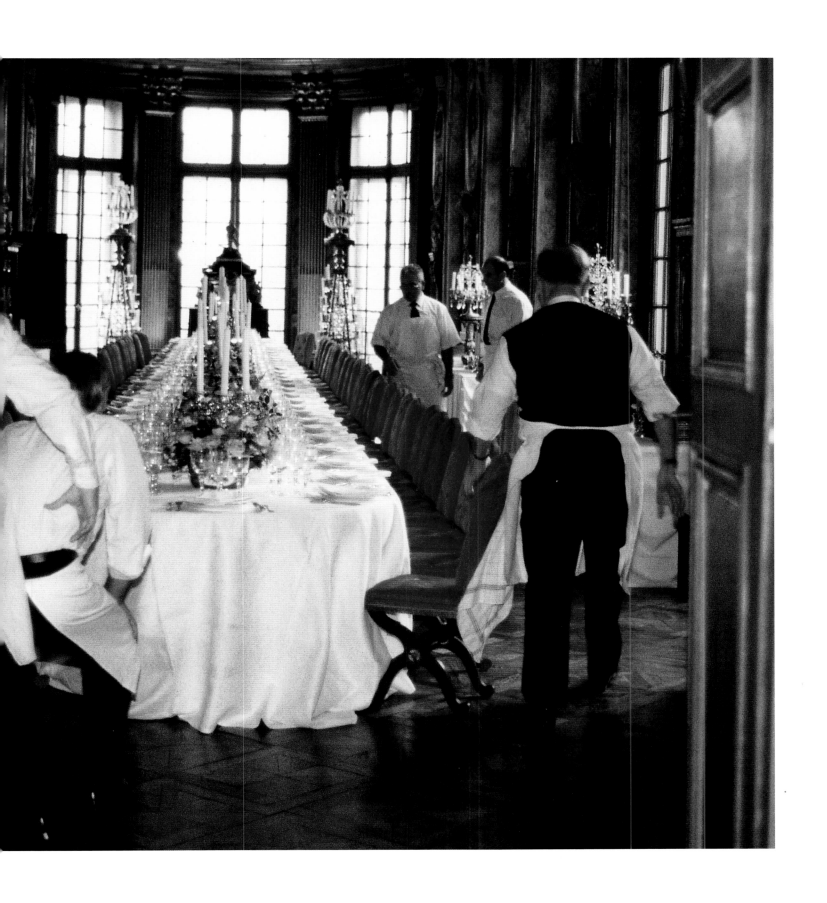

35 · With Baron Guy de Rothschild

(Opposite) One of the great family treasures is a complete green Sèvres dinner service made for Queen Marie Antoinette; there are enough plates to serve three courses to sixty guests. Washing them up must be done the next morning in the presence of a representative of the insurance company!

(Right) There are also more than enough eighteenth-century silver salt cellars to go around.

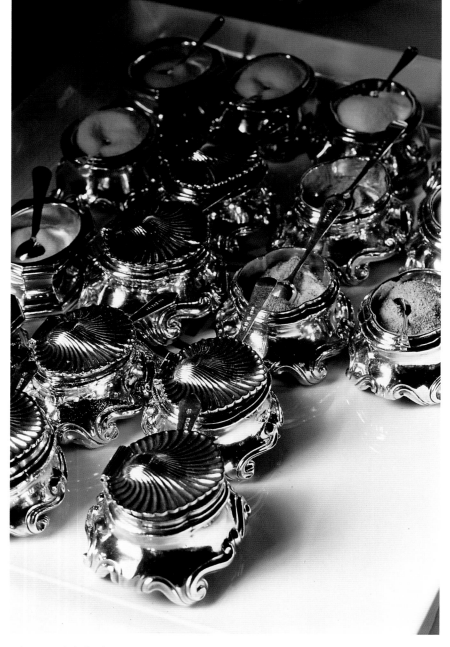

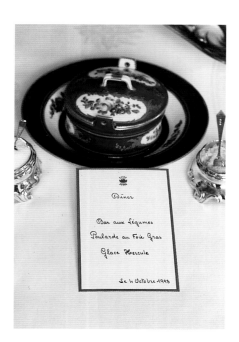

A menu, with the family's crest, made up of five arrows, leans against one of the Sèvres dishes.

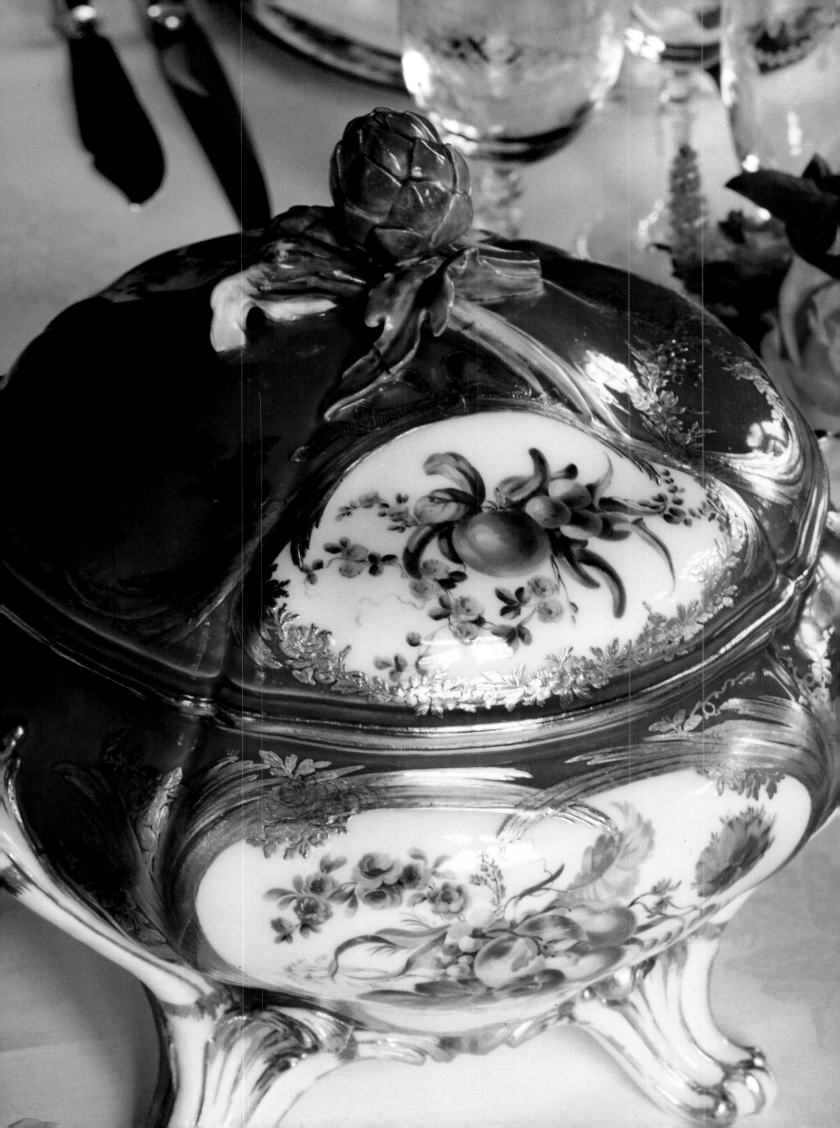

great art collections of his grandfather Alphonse. At the time, he was closing the large house built by Baron James at Ferrières near Paris, and thought it might be wise to exchange his house on the Rue de Courcelles and his flat on the Avenue Foch for the Hôtel Lambert on the Île Saint-Louis. After long discussions with the owners of the palace, Czartoryski descendants, an agreement was finally reached.

While the Galerie d'Hercule and the salons on the main floor had been restored, this was certainly not the case with the rest of the house. Baroness de Rothschild leaped to the task with the help of the renowned Italian decorator Renzo Mongiardino. In the space of a single year, they performed a miracle in resurrecting the age of the Sun King. Baron Guy enjoyed comparing this accomplishment to what Baron James had done to

the house of Queen Hortense, creating "a poetic dwelling more like the palace of a poet than a millionaire." The decoration of the reception rooms was especially created to display the family's treasures, and each piece seemed to be resting in its original case.

The baroness wanted all this to be a complete surprise for her husband, who was asked not to go near the Rue Saint-Louis-en-l'Île while work was going on. Finally, the "official" invitation arrived; Baron Guy was expected. The palace was ready, candles lit in all the chandeliers. Everything was set in a framework unique yet familiar; the great paintings, the porcelain of Bernard Palissy, the majolica and Limoges enamels with which he had lived as a child at Ferrières. What emotion the baron must have felt to see the figures moving once more in the famous

Before the guests enter, rows of silver candelabra are lit on the table, as are the candles on the Louis XIV girandoles, and blue-liveried waiters take up their positions. The priceless Sèvres plates are put out on serving tables (opposite) while candles illuminate the decoration of Van Opstal and Le Brun. "Monsieur le Baron est servi."

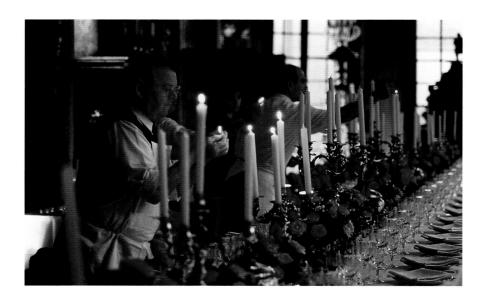

painted Cordoba leather procession of "King David and his Court." "And then Betty, my grandmother, was there, and seemed to be plotting with Vermeer's Astrologer in the Salon de l'Amour. How many lives she had lived, in so many rooms, in so many houses. To how many of my ancestors had she flashed the somewhat sad smile captured by Ingres? Was she astonished to find herself in yet another family house? The life of objects is curious indeed. It is true that the Betty of Ferrières didn't resemble the same lady in the rue de Courcelles, and was not the same lady that could now be seen in the Salon de l'Amour. Not quite the same, and yet not quite different . . . another attitude, another look, another half smile."

Like a magician, Marie-Hélène de Rothschild had woken up the

sleeping palace. She loved giving parties for their own sake. Among all the balls she organized at Ferrières and in Paris, the one that still lives in everyone's memories is the Fairy Tale Ball given for her niece Vanessa. Great white rabbits from Alice in Wonderland greeted the guests in the courtyard, ballerinas made graceful curtsies on the steps of the fog-filled great staircase, and fairies seemed to fly through the illuminated salons. That was in 1987; fewer than ten years later Marie-Hélène de Rothschild left this world. In her bedroom, birds and butterflies seem to be awaiting her return.

As guests prepare to alight the staircase (above) they can see where they will be seated at the long table (opposite). The Hôtel Lambert has always been famous for its balls, such as "The Oriental Ball" (right), given by Baron de Rédé in 1969. Marie-Hélène de Rothschild gave balls both at the Hôtel Lambert and at the family's Château de Ferrières outside Paris. Most remembered at the latter were evenings around the themes of Marcel Proust and Surrealism, with all the guests in fancy dress.

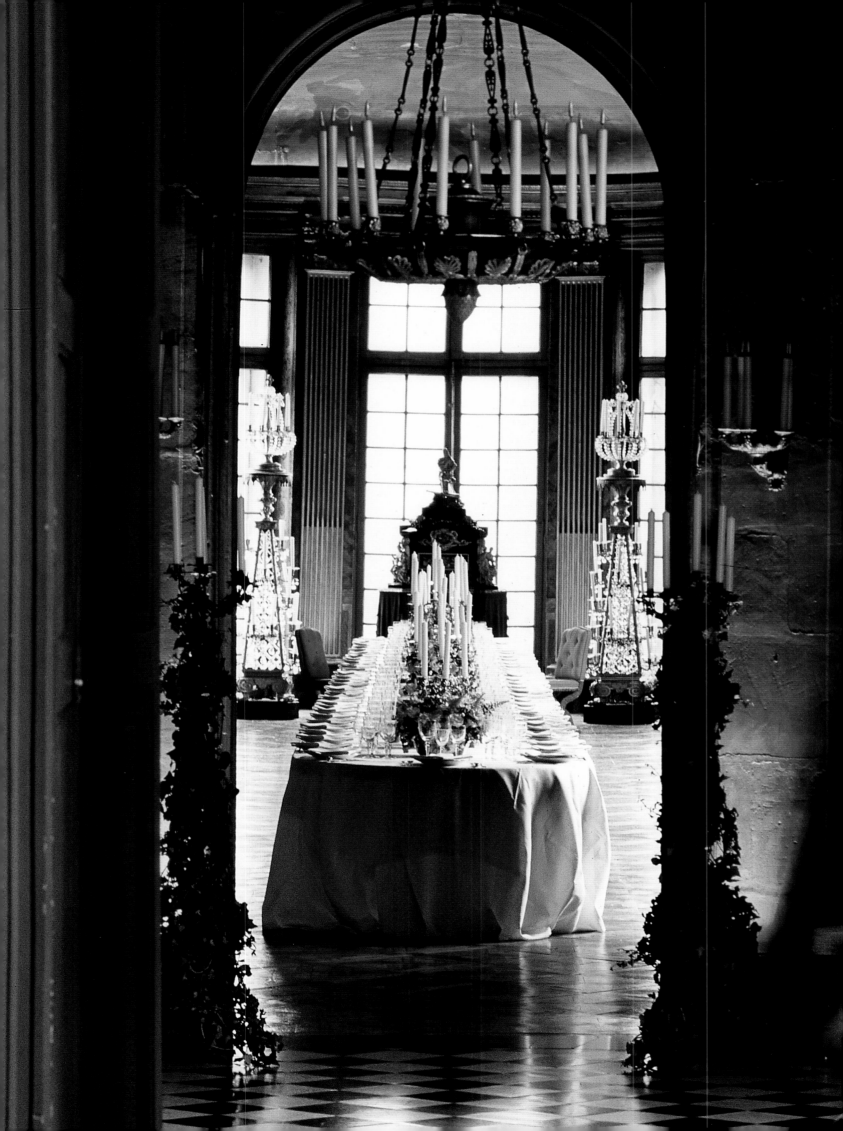

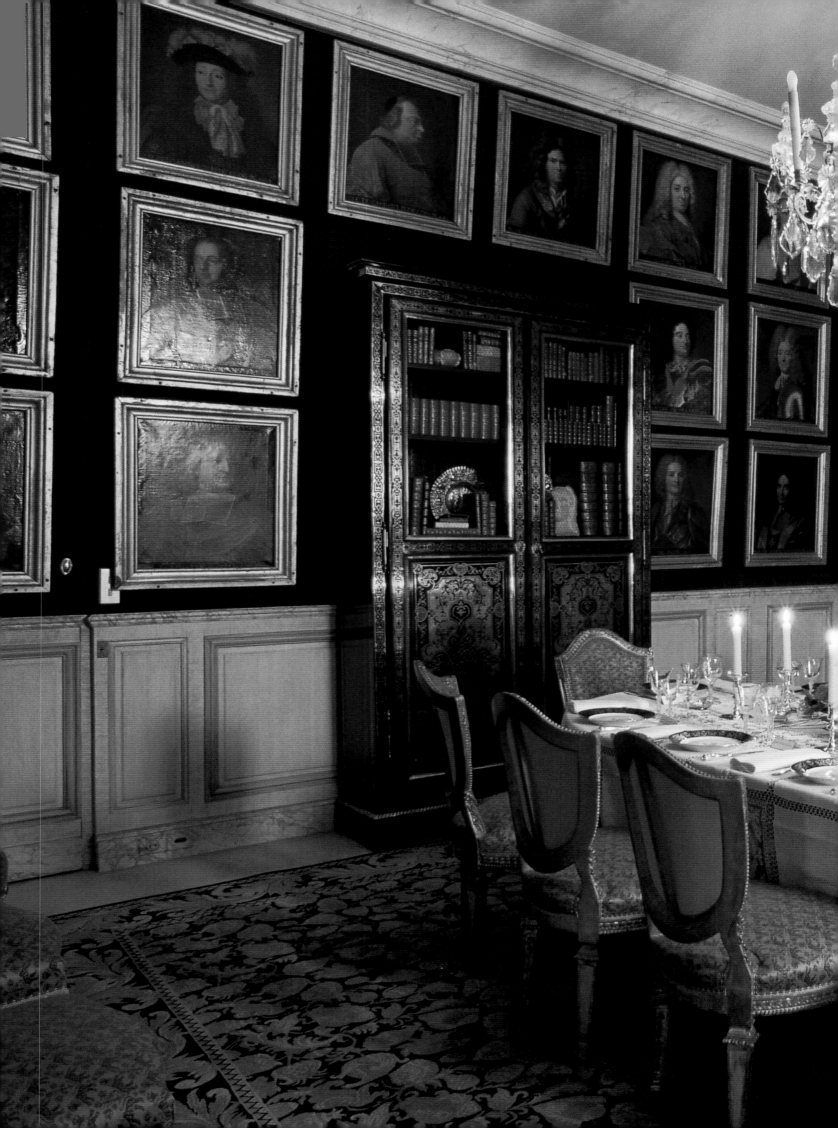

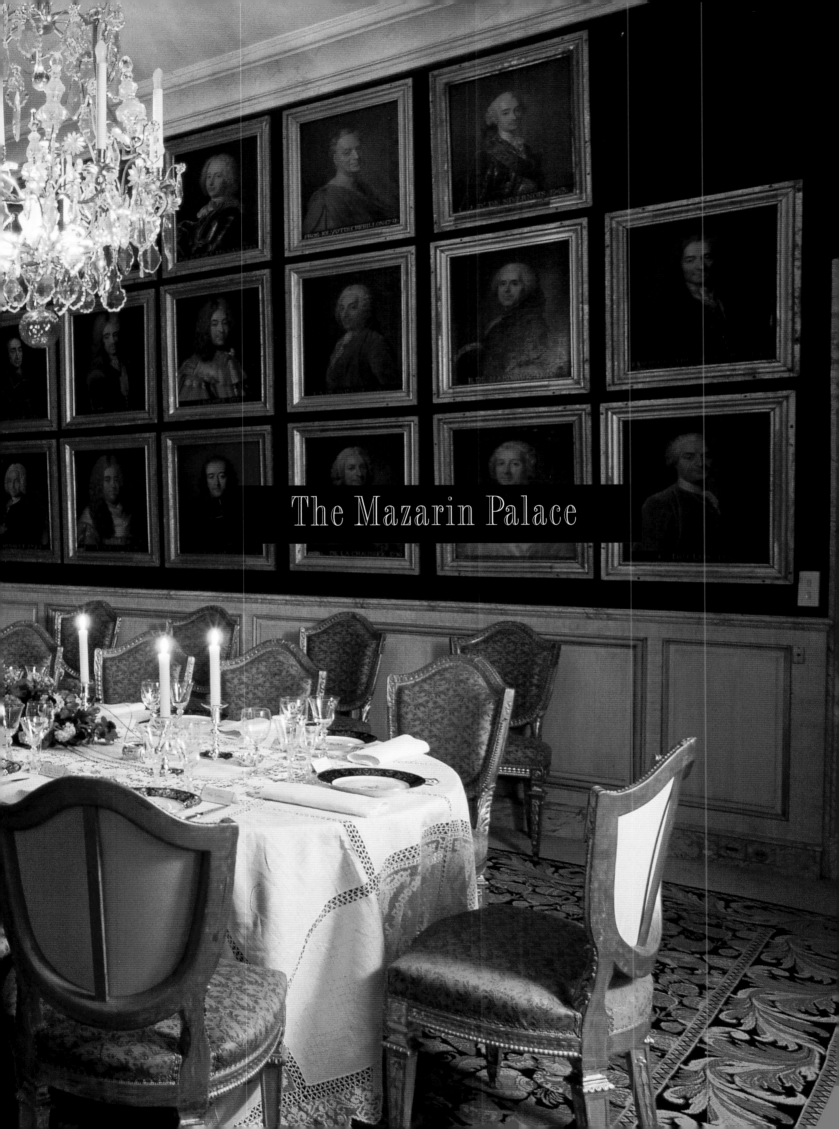

The Mazarin Palace

With the Perpetual Secretary of the French Academy

In 1661 Cardinal Mazarin died at the age of fifty-eight, after governing France for nearly eighteen years. He left behind a large fortune, and in his last will and testament designated a considerable sum (two million livres, to which was added an annual income of forty-five thousand livres) for the building of an institution that would comprise a college, library, and "riding academy" where the sciences, horsemanship, the martial arts, and dance would all be taught. The college was intended to house sixty young scholarship students, sons of gentlemen, born in the four provinces just linked to France: Alsace, Artois, Roussillon, and Pignerol (Piedmont).

A commission of seven, including the statesman Jean-Baptiste Colbert, was to decide where to build this tripartite institution. The choice was a piece of land on the left bank of the Seine opposite the Louvre, near the Hotel de Neslé. Louis Le Vau, the architect chosen for the project, started working in 1663, and the work was finished in 1684 by his disciple François d'Orbay. The earthly remains of Cardinal Mazarin were transferred with great pomp to the chapel, whose elegant cupola was later set in the very middle of a semicircular façade. The west wing contained the academy, the east wing housed the library, and at the back—divided among three courtyards—were buildings with classrooms, refectories, and apartments for students.

Four years later, in 1688, classes started. For more than a hundred years, thirty pupils (rather than sixty, as originally planned) were chosen by the king and gathered in. Many, such as the mathematician Jean le Rond d'Alembert, and Antoine Laurent Lavoisier, one of the founders of modern chemistry, were to become famous.

Then came the Revolution of 1789; the College of Four Nations, founded by Louis XIV, became the College of Unity, until 1793, when

(Left) The renowned Académie Française on the quai de Conti overlooks the Seine and the magnificent façade of the Louvre.

(Opposite) The majesty of the Academy is absolutely striking. Maurice Druon, the Perpetual Secretary, has made a point of harmonizing the interior decoration with the superb architecture of this institution, which reflects not only the unlimited nobility of the reign of the Sun King but also the sober ornamentation of his era. Renaissance bronzes, period portraits, Old Master paintings and drawings, as well as Regency furniture, create a distinguished, warm, elegant atmosphere.

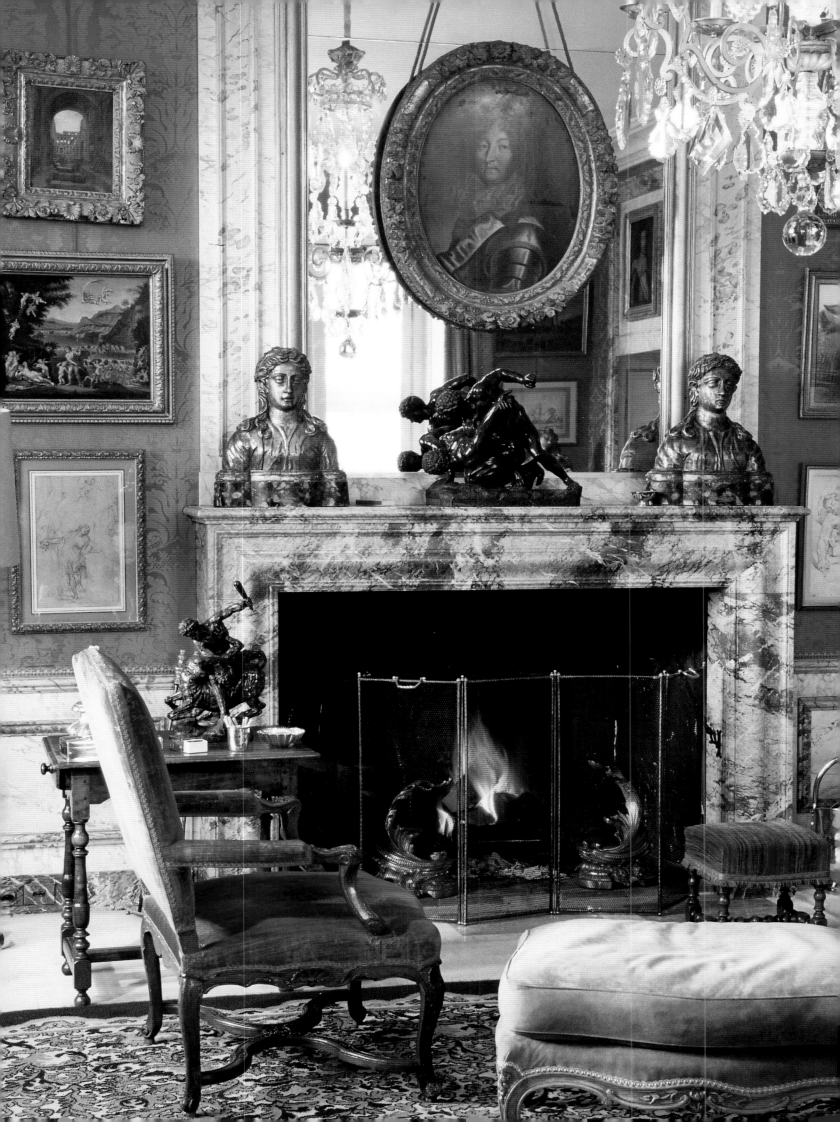

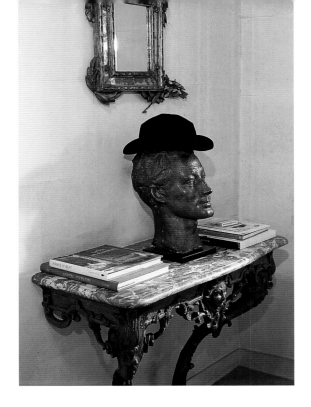

the Convention decided to close it. That same year, all the academies were also closed, and the chapel was transformed into a storage area for salt, and part of the building became a jail.

In 1805 there came an official decision to house on the quai de Conti the "Institute," created by a 1795 decree of the Convention merging the remains of the five royal academies founded by Louis XIV, which were then meeting in the Salle des Cariatides of the Louvre. The architect Louis Vaud-royer was put in charge of the transformation of the old college. The chapel became a meeting room; a cupola masked the drum of the dome. In 1816, the Institute

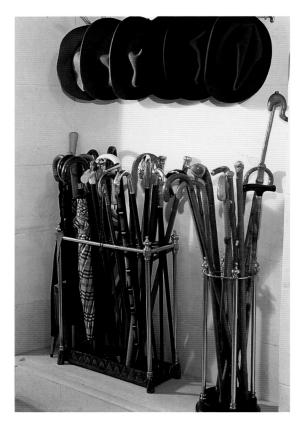

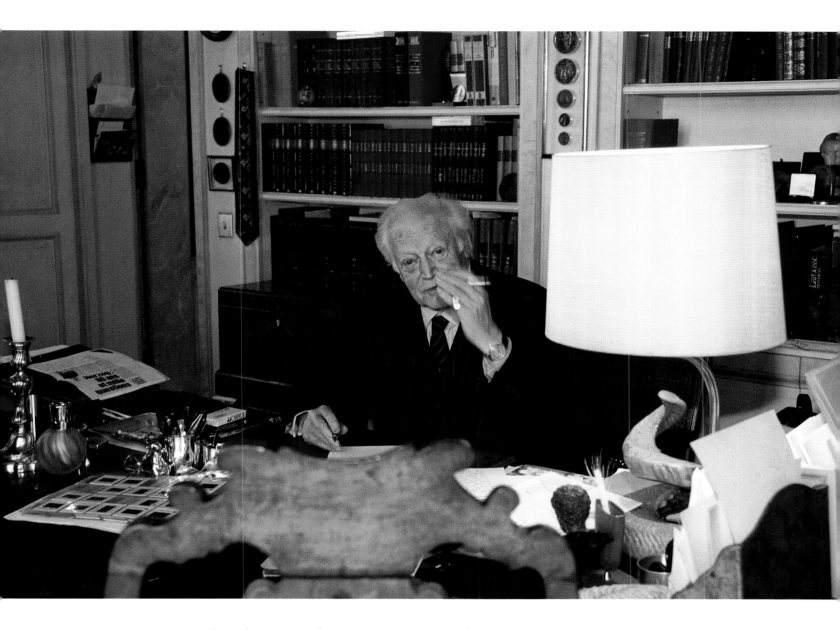

adopted its present form, regrouping the five academies into one known as the Académie Française.

The contents of the Mazarin library, now part of the Institute, were of course made up largely of the cardinal's books. In addition to the extraordinary richness of the Mazarin Library, the Institute possesses an astonishing collection of portraits, assembled on the initiative of the Maréchal de Villars, who had been elected to the Academy in 1714. As he found it quite difficult to be among his fellow members as often as he desired, Villars begged them to allow him to be present at least in a painting, and presented them in 1726 with his portrait "as witness in their eyes of his zeal for their company." In a meeting on August 31 of the same

(Above) A humorous note from
Maurice Effel to Druon.

(Right) The elegant and classical
architecture of the French Academy is one
of the great sights of Paris. Says Druon,
"I believe that I preside over an embassy of
the French language on the Seine. The
Academy is France's finest façade, and all
its windows must shine."

(Left) Maurice Druon was
a friend and admirer of
General de Gaulle, of whom
he wrote, "I still see, on
British soil, the elegant figure
of a medieval knight, with the
Cross of Lorraine hung on his
very heart. He walked with a
long and regular step, which
no ordeal could interrupt. He
was France, and that's it.
Thank you, de Gaulle."

Racine, Fontenelle, Fénelon, La Bruyère, Montesquieu, Voltaire, Buffon, d'Alembert, and La Harpe.

During the Revolution, these portraits were hidden by the Abbé Morellet in one of the tribunes of the public meeting hall, and the keys hidden. The abbot wanted the paintings to become part of the Museum of French History at Versailles. They were shown to the public for a short time before being placed in storage at the museum.

It was Maurice Druon, the present Perpetual Secretary of the Academy, who brought them back from oblivion after his election on November 7, 1985. "Knowing of this collection," he explains, "I had the Ministry of Culture and the directors of the National Museums place the portraits in the French Academy as of 1987." The paintings of the academicians were hung in both the office of the Perpetual Secretary in the Academy and in

year, the Academy invited all its members to give their portraits to be hung in the general meeting hall. In addition, the Academy implored "those who could recover portraits of dead academicians to present those as well." This is how, through time, this historic collection was assembled. Starting with the image of Valentin Conrart, the first Perpetual Secretary, elected in 1776, there are portraits of seventy-seven of the ninety-two academicians who were members before the Revolution. Among the most famous were Bussy-Rabutin, Colbert, Corneille, Bossuet, Perrault,

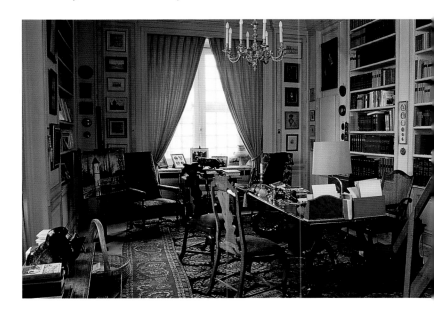

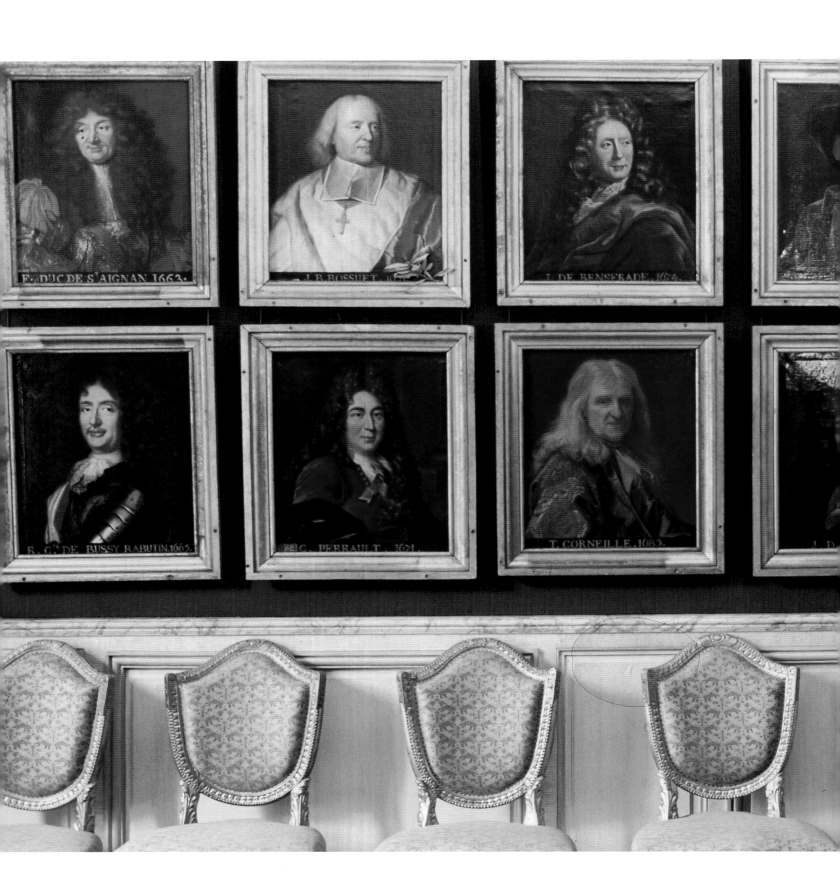

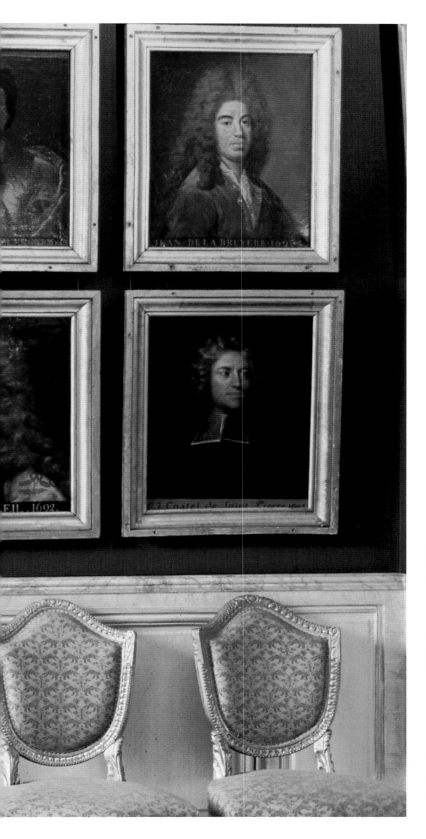

the reception rooms of his lodgings in the right wing of Mazarin's palace. They constitute a historic ensemble, particularly noticeable in the dining room, where fifty-nine of them presently hang.

A magnificent wooden door on the rue de Seine is the entrance to the rooms reserved for the Perpetual Secretary of the French Academy. These are on the second floor of the right wing of the Institute. The windows look out onto the Seine and, beyond that, onto the long façade of the Louvre.

Maurice Druon decided to open up the doors in order to reestablish the original symmetry. The simplicity of wood can be seen again in contrast to the brilliance of marble, the splendor of gold discreetly lending its highlights. Louis XIII and Louis XIV furniture, in all its grandeur, now impresses the many visitors.

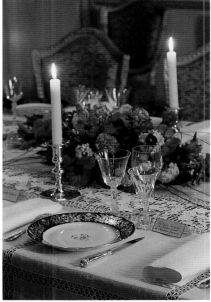

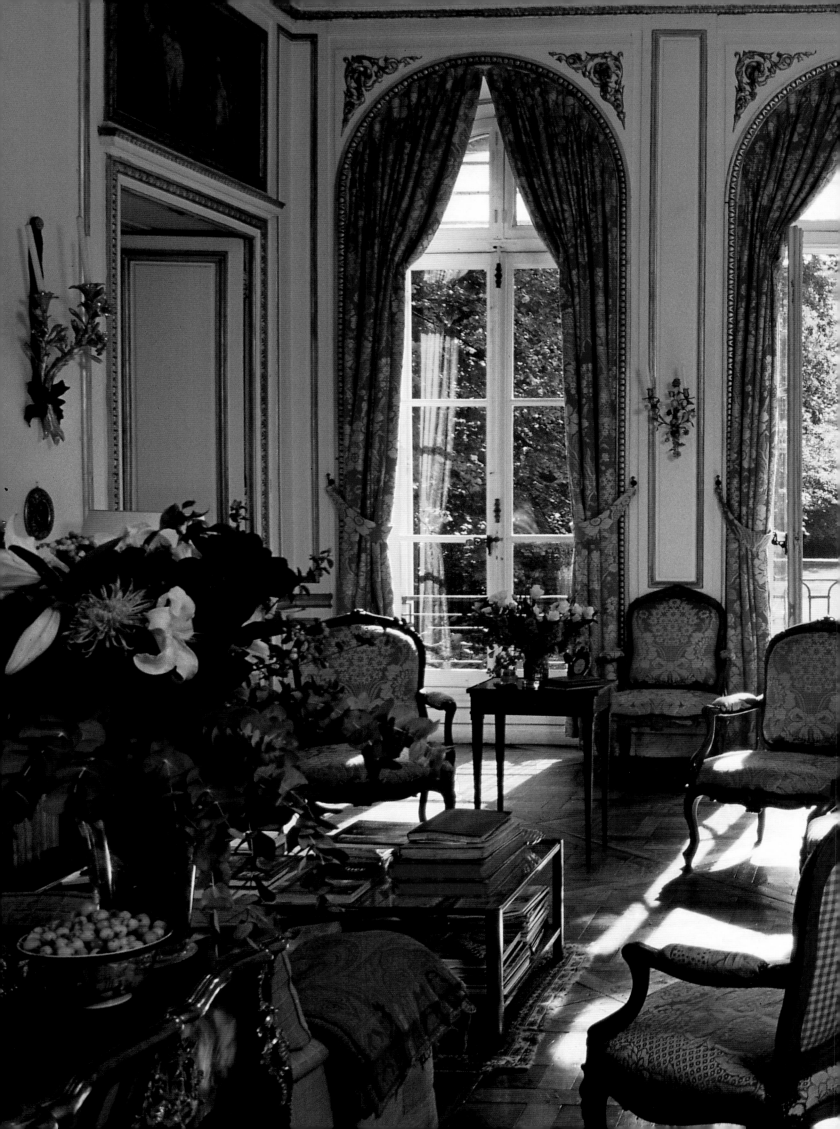

The Hôtel de Montmorency-Luxembourg

With a Surviving Dynasty

At the end of the seventeenth century, the land where this house was eventually built was made up of swampland and the occasional garden. The house originally consisted of a ground floor and one paneled room upstairs.

In 1754 the house was extensively renovated. The Comte de Montmorency-Luxembourg added a floor, completely changed the interior decoration, and built servants' quarters. Parterres replaced the vegetable garden. The house is thus part of an ensemble of two mansions built several years apart, joined and separated on many occasions to fit the needs of different generations of owners. The Marquise de Tourzel, once Governess to the Children of France (the royal descendants) and a confidante

and friend of Queen Marie Antoinette, occupied the larger of the two houses in 1823. The smaller one—the building now under discussion—was then known as "the house of the dowager marquise."

The atmosphere is truly grandiose in the state apartments, which open on to a beautiful garden with two rows of linden trees. The white and gold paneling, the eighteenth century Versailles parquets and the splendid Louis XV furnishings seem always to have been there, and there is the feeling of visiting a grand country house.

The main living room is lit by three French windows. The chairs are covered in silver and raspberry damask, and there are pretty miniatures on the antique tables, along with small books in eighteenth-century leather bindings. A lovely silver platter is placed on a Louis XIV table encrusted with tortoise-shell, ebony, and ivory. On the platter is a ravishing goblet embellished with the ducal crest of the owners, and three lovely footed red glasses engraved in gold.

In the dining room, overflowing in silver wine coolers, are enchanting bouquets of ivy and hydrangeas. White and gold porcelain plates decorated with palmettos, and small bread plates painted with roses interlaced with leaves, enliven a plain white damask tablecloth. Gold-engraved crystal carafes cut with a diamond motif also bear the ducal arms belonging to the oldest branch of the family.

The French like to speak of a house "entre cour et jardin," that is to say, one like this that is situated between the courtyard and the garden, a residence hidden from public view by an imposing façade with a large wooden door that opens onto a noble residence. The Faubourg Saint-Germain is filled with such palaces, though at the end of the seventeenth century there was little here but marshes and vegetable gardens. In this aristocratic house, a rustic atmosphere still reigns; dogs feel fully at home (opposite) and sense that they are far away from the noise and bustle of a big city.
Here, they are looking in at the imposingly serene salon (previous pages) as if awaiting the guests.
The owners still leave most weekends for their country estate in western France.

(Left) A hatbox for a country wedding and the obligatory aristocratic hunting rifle await their owners in the hallway.

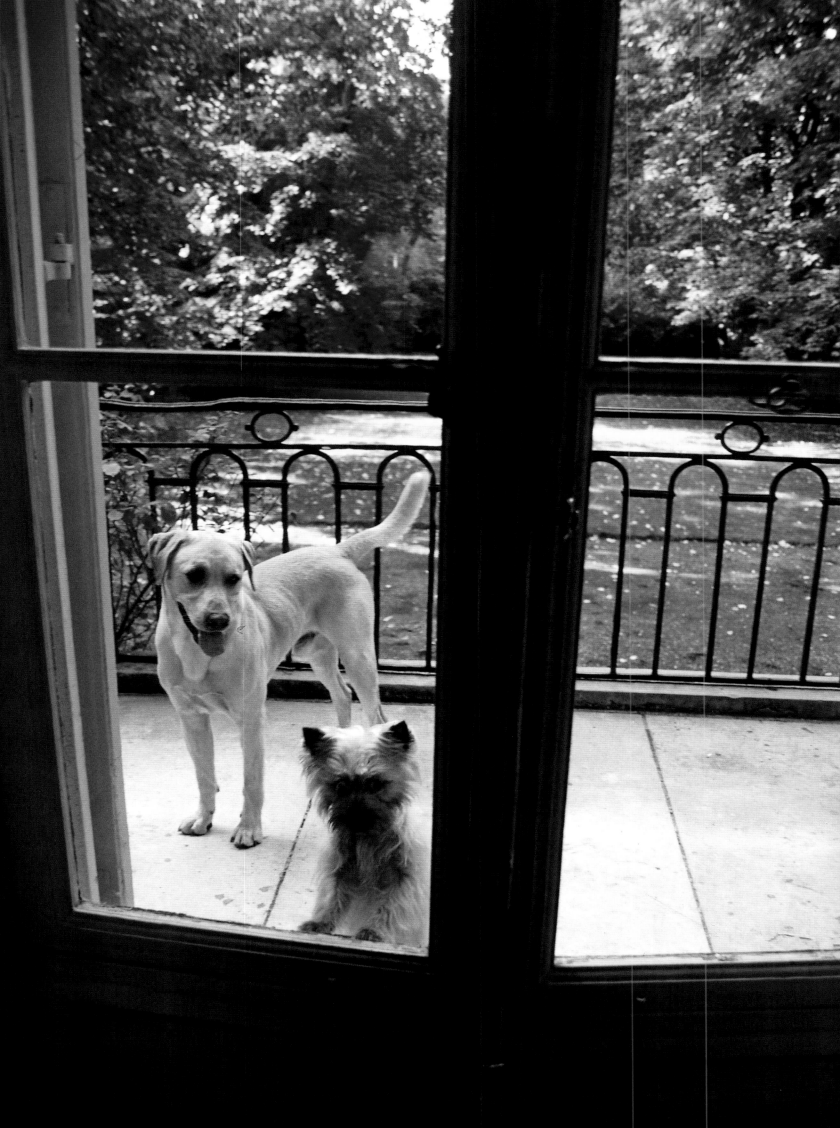

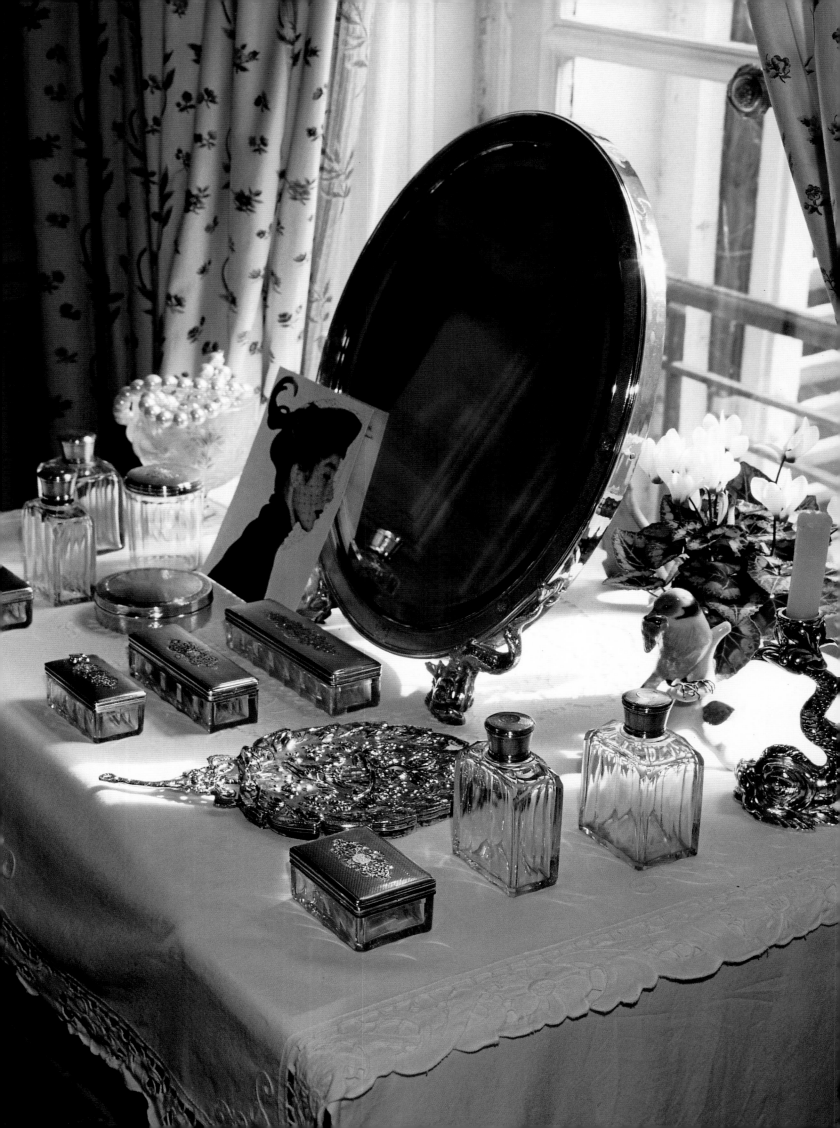

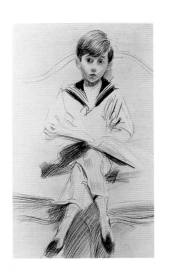

The master bedroom leads directly to the garden. The Louis XVI furniture is upholstered in Aubusson tapestry on which rose-colored draperies frame scenes from the Fables of La Fontaine. On the bathroom dressing table, there are crystal flagons and an unusual silver mirror, supported by dolphins, that was given to the family by Queen Marie Antoinette to mark the birth of her son, the Dauphin of France.

The present owners of this splendid house, great travelers and gentlemen farmers, love to return to this peaceful atmosphere, a timeless setting sheltered from our hurried times; the bustle outside hardly stirs the house's tranquillity and makes one forget that one is in the very heart of Paris. There were, notwithstanding, disturbing moments. The grandfather of our host often used to tell how he happened to hear on certain very dark nights "the barking and wailing of Madame de Tourzel's small dog in the garden next door, and the grating on the pavement of the wheels of the carriage bearing condemned prisoners." Even at the beginning of the twenty-first century, the sad ghosts of the Revolutionary period are still roaming about this place.

The Comtesse de Pange, a friend of the family, describes the passing of a day in the life of her mother, the Princess de Broglie, in her book *Life in 1900.*

"At the turn of the century, a well-established member of French society used up at least a thousand or fifteen hundred visit cards a year. Each day, an overflowing

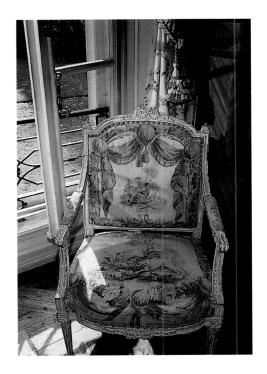

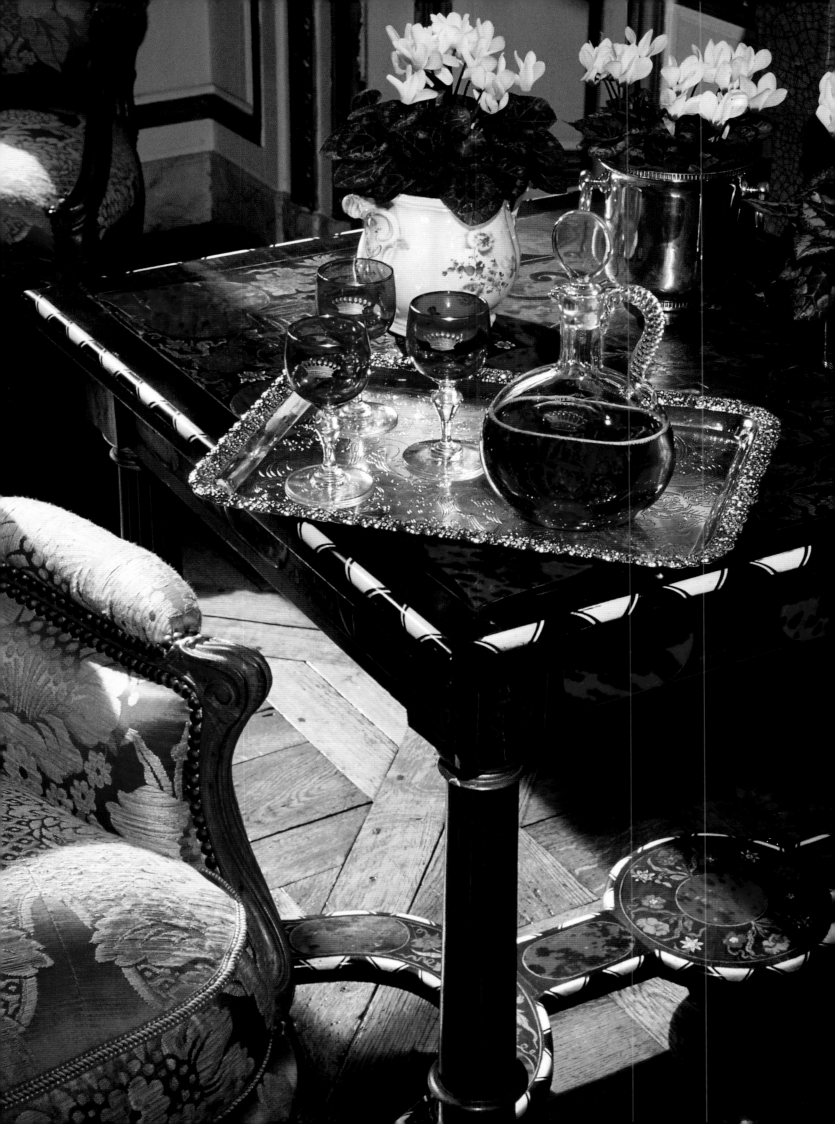

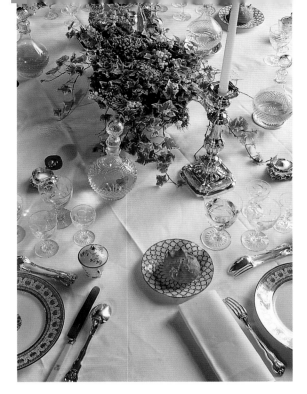

Previous pages
(Right)

A carafe filled with Baume de Venise and three glasses on a silver tray all bear the princely crown of the hosts. Neatly placed on a Louis XIV table inlaid with tortoiseshell, ebony, and ivory, they await the arrival of friends in the main living room.

(Left)
A Louis XV bergère is covered in red and silver flowered damask, whose elegance is offset by the simplest cyclamen planted in silver and porcelain vessels. Orchids would be too ostentatious here.

avoided all the visits of those who left their cards, there was still the over-hanging threat of reciprocating the courtesy. Sending back cards through the mail was unthinkable! This silly formality of receiving and dropping off cards couldn't even be excused as an ancient ritual. At the beginning of the nineteenth century, when the friends one intended to visit were not at home, one inscribed one's name on the back of a playing card; collectors still have these in their possession.

"My mother carefully noted in a small book the visits she intended to make herself. Her coach stopped

Entertaining is an art in France, and hostesses take great pride in the originality of their table settings, which, more often than not, reflect their lifestyles. Here, simple bouquets of ivy and carrot flowers, representing the country atmosphere of the house, form a background for fine crystal, porcelain, and silver appropriate for a grand dinner in town.

mass of such cards filled an elegant basket or silver platter placed to receive them on a table in the entrance hall of every elegant house. Happy as one might be to have

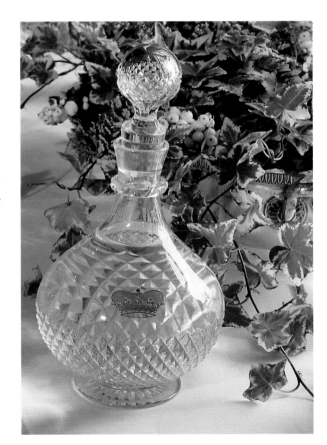

muff the cards whose corners had previously been folded, the footman ran to drop them off in the concierge's alcove, and then they departed together to leave cards elsewhere. My mother always returned before dusk, that is to say before 4:00 pm in winter. That was the custom. She strictly observed every decorum and protocol and never went out in the afternoon unless she were accompanied by a valet in full livery, wearing a top hat and a long frock coat that reached to his heels. This servant, seated next to the coachman, came down from his perch to open the coupé's door, then followed my mother at a respectful distance when she took a few steps in the Bois de Boulogne or on the Champs-Élysées. And she rarely entered a shop, since that was not considered as elegant as suppliers coming directly to the house."

in the portal of the house, and the footman alighted and went toward the door. My mother lowered the window, pulled from her otter

The aristocratic eighteenth-century façade looks out on a seemingly endless garden, filled with linden trees and paths where the children of the house (below) run, ride their bicycles, and play as their parents take leisurely walks or have drinks on the lawn. In season, there is no need to visit a florist as bouquets are made from flowers picked in the garden (left). The mistress of the house is seen (opposite) with her Labrador.

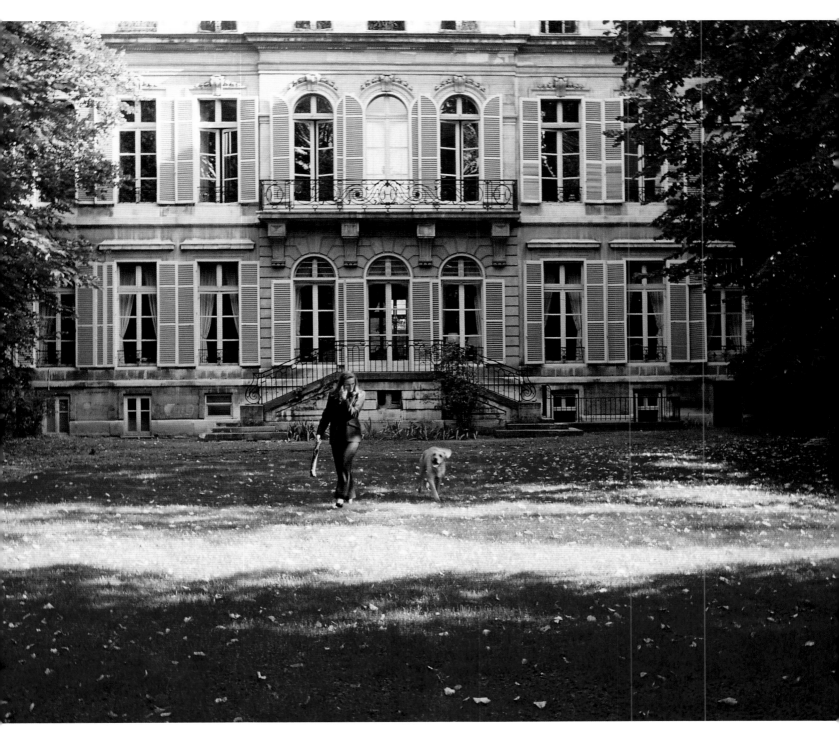

Today, of course, there are taxis, and appointments are made by telephone; ladies of fashion spend their days shopping and servants stay at home. The refined turn-of-the-century atmosphere has survived in this lovely house, however, still inhabited by the descendants of its original owners. And the ghosts feel quite at home.

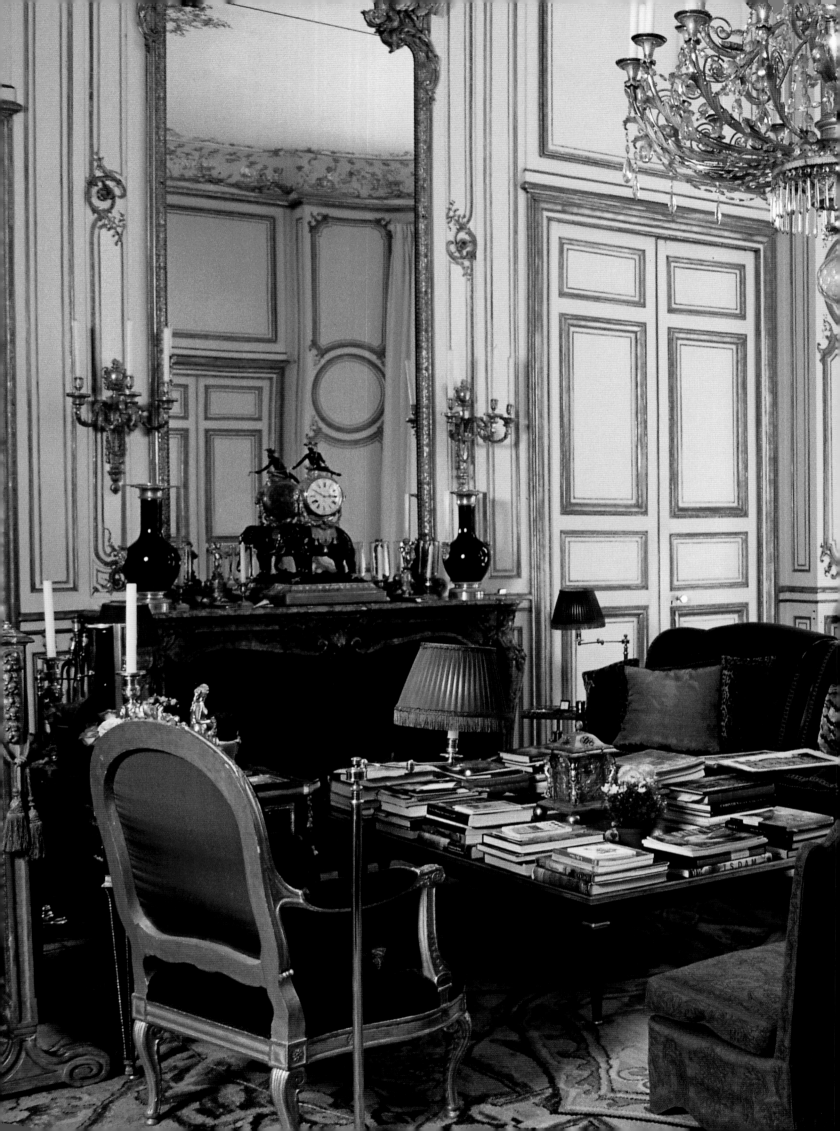

The Hôtel d'Orrouer

With Hubert de Givenchy

The Hôtel d'Orrouer is one of the best preserved private palaces in the Faubourg Saint-Germain. The history of this house, which passed through several owners, is similar to many of these old dwellings over the past two centuries.

In 1721 the Comte d'Orrouer commissioned the architect Pierre Boscry to build a palace on an ancient and marshy piece of land. The work was finished in 1736 and, as was quite common in the eighteenth century, the owner was obliged to take on heavy debt. At that time architects, contractors, and decorators often had to wait twenty years to be paid.

In 1756, the house was sold to the Marquis de Brunoy, and in 1799 it passed through the elegant hands of the Comtesse de Boisgelin before being acquired, very rapidly, by the archbishop of Bourges, who in turn left it to his niece in 1786. This cascade of owners continued until 1841, when the property was purchased by the Duc de Montmorency for 300,000 francs. It was then inherited by his daughter, Anne-Elisabeth, the wife of the Prince de Bauffremont, and her family lived there for over a century.

Passing through its history, the Hôtel d'Orrouer enjoyed a particularly brilliant period between 1850 and 1861, when it was the Austro-Hungarian embassy. Prince von Metternich, son of the great statesman and chief arbiter of Europe, together with his beautiful and fashionable wife Pauline—who was very friendly with the Empress Eugenie, wife of Napoleon III— lived there for a time. In her memoirs, Pauline von Metternich tells in considerable detail of her departure in an elaborate horse and carriage on the day that marked the official presentation of the Metternichs to the Imperial French couple.

"I had just finished putting on my dress, which had an old mauve

The courtyard façade (opposite) and the garden façade (left) of Hubert de Givenchy's house are of the most extreme classical simplicity. The elegant boxwood trees in the courtyard and formal trimmed hedges in the garden are in the grand tradition of the French garden established by Lenôtre in the eighteenth century. The main living room overlooks the garden (previous pages) and its magnificent white and gold Louis XVI paneling sets off the many treasures collected by the great designer. De Givenchy is a leading connoisseur of the French decorative arts, highly respected by dealers, collectors, and museum curators. The depths of his interests are reflected in the piles of books on his coffee table. All this is the epitome of what Baudelaire called "Luxe, calme et volupté." The lunch table is set overlooking the garden on a hot summer's day.

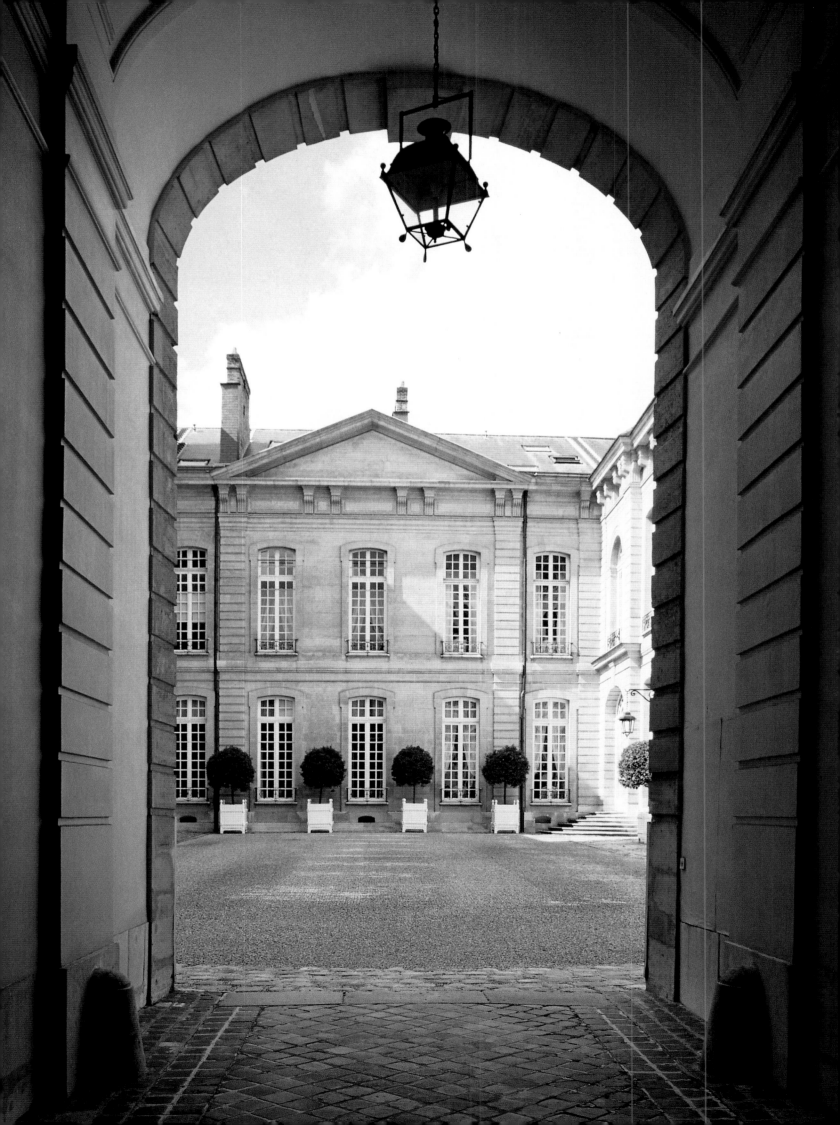

(Below) Amazingly, Hubert de Givenchy's compound still contains the original stables. The atmosphere that once must have reigned here was delightfully described, in the nineteenth century, by the owner of a neighboring "hôtel particulier," the Duc de La Force. "Occasionally, after lunch, my father crossed the courtyard to visit his horses. He took my sister and I with him, in turns. In one of the stalls, he hoisted us up onto a horse. When he held me as I straddled the horse on a yellow blanket with a red border, I was filled with pride. I also loved visiting the carriages: the large and small brougham, the Victoria, dog cart, and the others were all fascinating. All the coaches were painted a green-bronze, and they bore the green family crest."

(Opposite) On a summer's day, Albert, one of de Givenchy's footmen, brings out cushions for the garden chairs.

moiré train embellished in lace. I had put on lots of jewelry, including a diadem, and around my neck were rivers of diamonds from which pear-shaped emeralds were hung. Hardly had I entered the salon when I heard the carriage door open noisily as carriages arrived in the courtyard. A few moments later, the double doors opened and the lady in waiting, the official in charge of presenting ambassadors to royalty, and two chamberlains of the Emperor entered the courtyard of the Hôtel d'Orrouer. There we were at the foot of the staircase, and I must admit that I was delighted to get into one of those magnificent carriages."

Pauline von Metternich was one of the leading personalities of the Second Empire: not very pretty, she was funny, original, and exuberant, "thin enough to make a matchstick jealous," as she liked to say. There were many witnesses to her legendary elegance. According to one: "When the Princess von Metternich entered the Tuileries for a ball, very thin, quite tall, with bare shoulders, her forehead covered with diamonds, carrying long skirts in her wake, it would have been difficult to summon up anything grander." One evening, however, she turned up at one of these balls in a dazzling white tulle dress with silver thread, decorated with

white daisies that had rose-colored hearts. She had been disappointed by the dress that had been made for her for the occasion and had called upon a newly established English designer, Frederick Worth, to replace her dress in a hurry. The empress was dazzled, and a trifle astonished, to hear of a male dressmaker, and British to boot. However, this launched the career of the greatest couturier of the age. The next day, the designer was summoned to the Tuileries, and

De Givenchy is a master gardener with a fine sense of understatement. He has created a magnificent classical garden at his Château du Jonchet outside Paris, and a splendid garden at Le Clos Fiorentina, his house overlooking the Mediterranean at Cap Ferrat. In Paris, elegant white Iceberg Roses highlight the trimmed hedges.

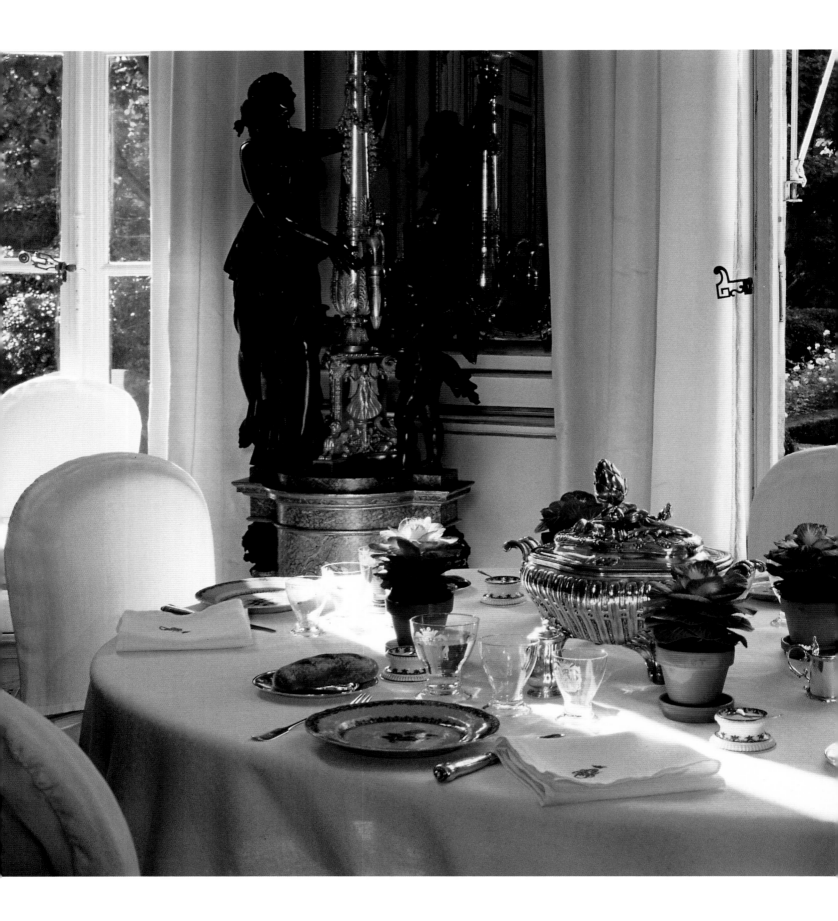

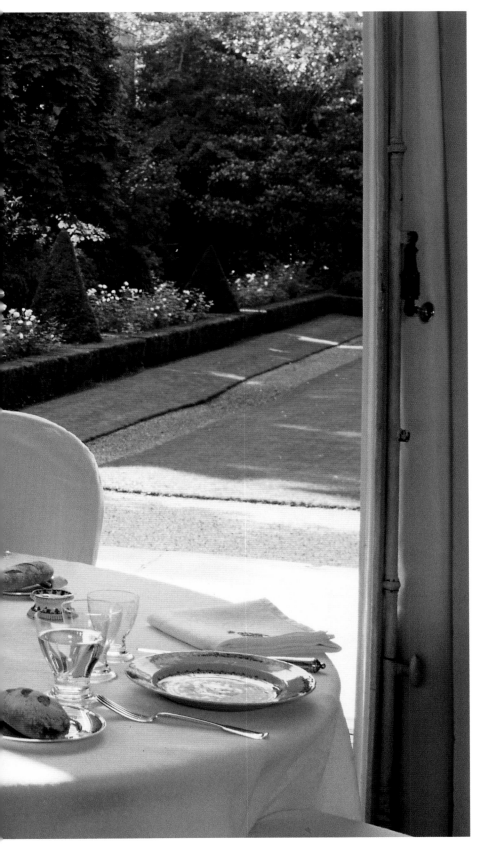

(Opposite) On this September morning, de Givenchy had set up a table in front of the center French door of the living room, bathed in light; white and blue plates from the Compagnie des Indes, damask napkins embroidered in blue, and engraved crystal glasses.

shortly appointed supplier of formal and evening dresses to the empress. As of then, he set down the law in *haute couture* both in France and throughout the world. When he wanted to establish a new fashion, such as crinolines, it was to the Princess von Metternich that he turned.

(Right, above and below) The most minimal blue designs—initials on napkins and flowers on eighteenth century plates—highlight an otherwise totally white lunch table overlooking the garden on a warm autumn day. The simplicity is belied by a magnificent eighteenth century soup tureen.

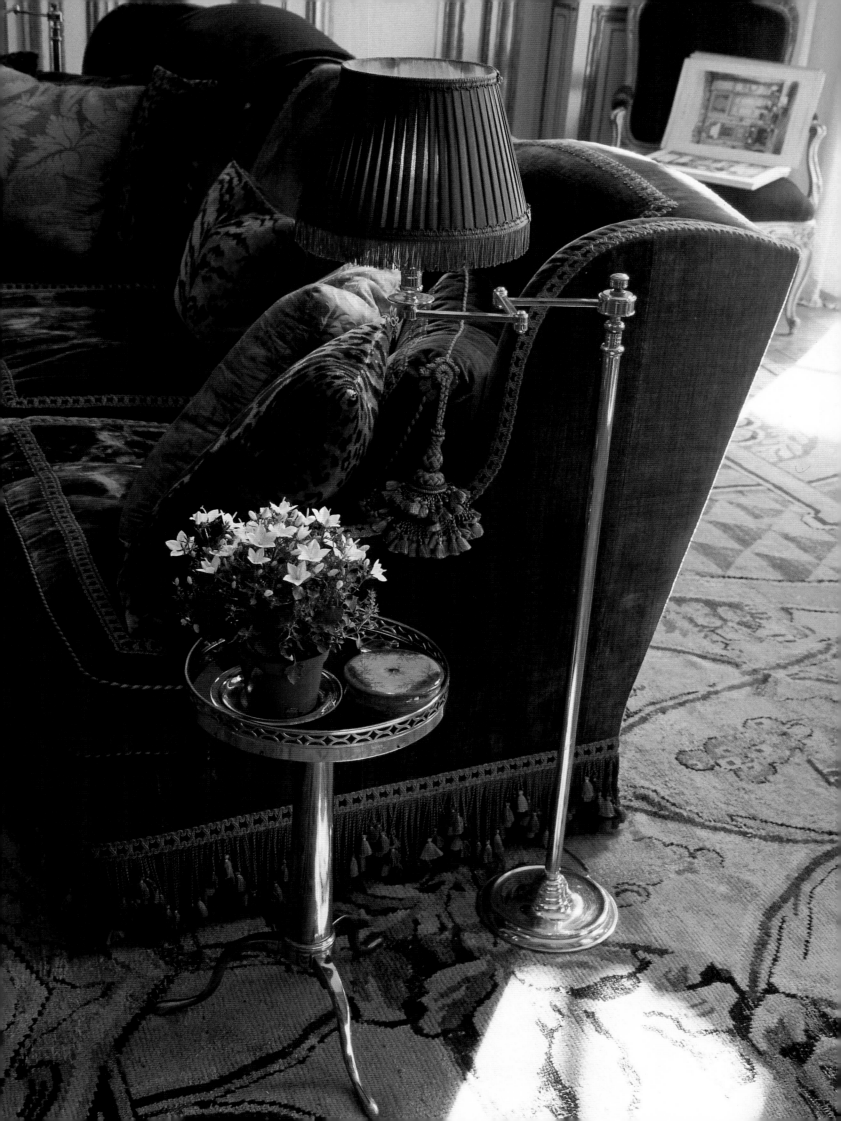

It is quite easy to summon up the excitement that reigned at the Hôtel d'Orrouer during the reign of Princess von Metternich; there was one party after the other, brilliant musical soirées organized around Richard Wagner and Franz Liszt, as well as literary discussions that included Alexandre Dumas and Prosper Mérimée. And it was the ambassadress who invented the fashion of receiving after the theater. The Empress Eugénie could not get along without her; she soon was put in charge of organizing the festivities at the Château de Compiègne, and became known as the "ambassadress of pleasure." Once she returned to Vienna, the court of the Emperor Franz Joseph must have seemed extremely dull!

The atmosphere around 1900, as described by Élisabeth de Grammont, when she visited her Bauf-

fremont great aunts at the Hotel d'Orrouer, is hardly as joyous. "When I went to see my grandmother in that enormous mansion, lacking all comfort, where the so-called reception rooms with ostrich-feather-clad canopies were housed in a wing of the house, the old lady could be found wearing white gloves and flanked by her daughter-in-law; both were seated

(Above) De Givenchy is seen here walking along the banks of the Seine with his friend and inspiration Audrey Hepburn. Her elegance, beauty, style, and aristocratic bearing were an ideal foil for his beautifully designed clothes, which she wore in many of her films. After their walks, they would chat sitting on the green velvet chairs in the designer's living room (opposite), sipping perhaps a glass of white wine while watched over by a woman with an umbrella (left).

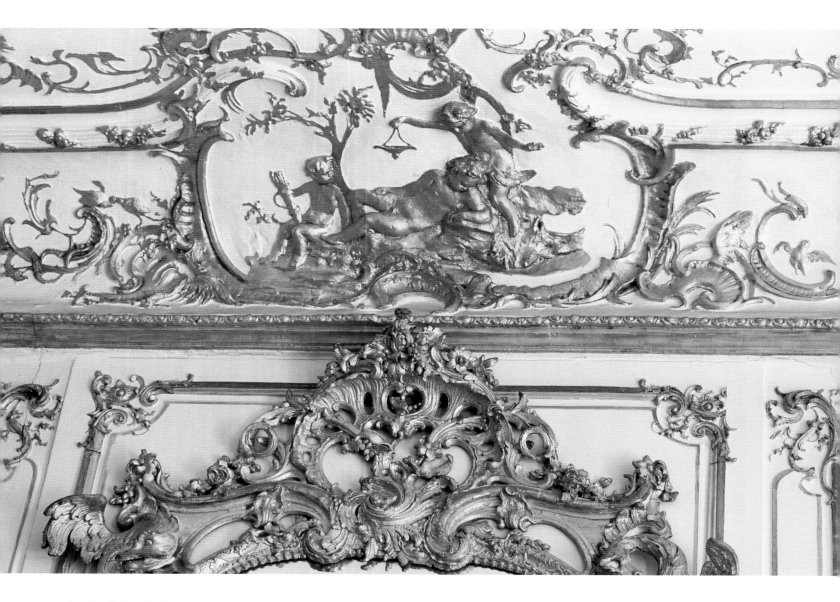

Putti play all along the ceiling molding, making light of the menacing dragons that embellish the mirror's frame. This is a perfect example of the "rocaille" style that spread like wildfire around Europe's palaces in the eighteenth century.

straight up on enormous Louis XIV armchairs. . . . One day, I was asked to invite my cousins and their young friends. The Prince de Beauffremont rang our doorbell at eleven o'clock in the morning and asked for my father. . . . Quite astonished, he thought that he was getting involved in a question of honor that might lead to a duel.

'Your daughter invited my daughters to lunch. I must tell you that my daughters never leave the house for meals elsewhere.'"

Today, Hubert de Givenchy lives here, and we enter through a monumental door ornamented with Ionic columns, and pass through the coffered vault that leads into the courtyard. Once upon a time,

The courtyard façade is classical, with orange trees lined up in front of the entrance door, which opens up onto a magnificent staircase. The garden façade, however, is entirely original; three French windows are crowned by arches that link up with the pediment. Ivory-white cloth shades enhance the sense of grandeur. When de Givenchy speaks of "his house" it is with passion. "I was immediately overwhelmed by the magnificent proportions, the height of the ceilings, which make everything more beautiful. I am convinced that my antiques are much happier in such a setting. When I open my windows very early in the morning, I feel unlimited happiness. I discover a new point of view, a new detail, a branch of a tree leaning toward the

here were the commons, the servants' rooms, and stables for up to twenty-five horses. What a strange impression these stables make today, unused in the center of modern Paris.

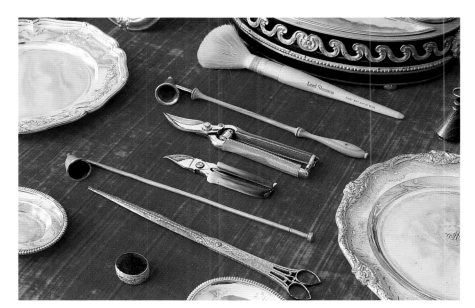

façade; every minute is a joy. It is in movement that one rediscovers a house. In my profession as a designer, which I adore, I used to have my dresses photographed from different angles. As I turned them, their movement gave me new ideas. Here, it is the same thing: I add a touch of white that introduces the missing note of light; I move objects round, introduce new pieces. I dream endlessly and appreciate each and every instant."

"I also like the way objects speak to each other; over there a book near a painting and, not far away, a favorite photograph. One must feel life, the very gestures of life, even in a static room. So I change. I am passionate about so many things. New plates? I immediately think about the table that I am about to set, about its centerpiece: white camellias, a soft-green cabbage, an art object? I love adding

details in order to create a harmonious whole, and the result gives me intense joy. I also love to work with artisans and, of course, with artists, to create together original objects. That is how Diego Giacometti created bronze tables for me, seeking inspiration from my Labradors or from glass lanterns encased by bronze stag heads."

An atmosphere of exceptional quiet reigns in the house, with its white and gold paneling on which musical angels play in the transparent light. Elegance, perfection, harmony are the words that immediately come to mind to describe the atmosphere. Yet with Hubert de Givenchy, harmony is never static: he has sought out beauty since childhood, and is always searching for a new idea, a new passion, to illuminate the dialogue between him and the world.

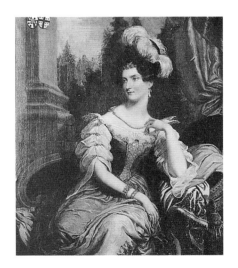

(Opposite) All the glamour of de Givenchy's life is laid out upon a table: a photograph of Audrey Hepburn, a replica of a Bentley imprisoned in a plastic case, a miniature of one of the very special piebald horses bred by the Prince of Liechtenstein on his estate in Pomerania, a golden heart and plate, and a favorite client, Baroness Gabrielle van Zuylen, making her way past serenading musicians at one of the great Paris balls that mark the spring season. The equally elegant Princesse de Bauffremont (below), in feathers and finery, would no doubt be very satisfied at having de Givenchy as successor in her house.

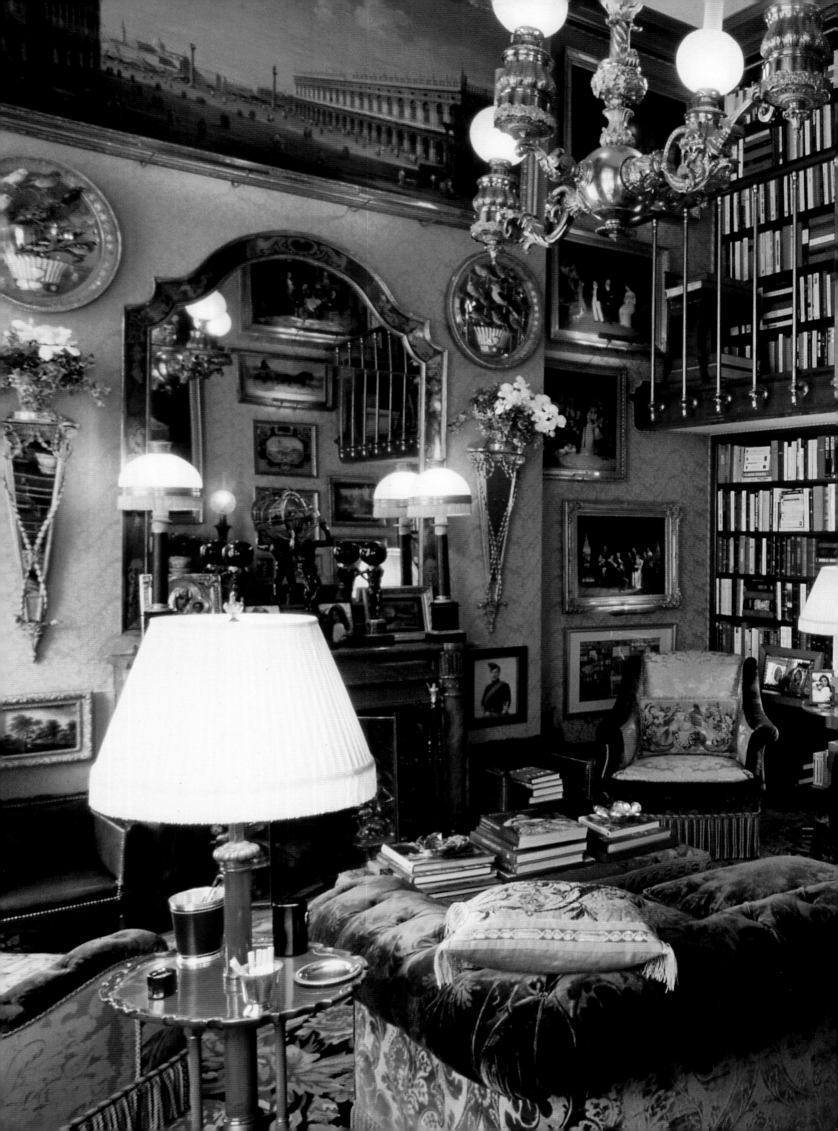

A Proustian House

In the Fabourg Saint-Germain

The house we are visiting today makes up one part of an ensemble of six large mansions. Built during the reign of Louis XV, it was first inhabited by Count von Starhemberg, a future Imperial Prince and the ambassador to France of the Austro-Hungarian Empire. In September 1755, Count de Bernis, an abbot and French ambassador to the Venetian Republic, returned to Paris and lived here while preparing a treaty, signed at Versailles in 1756, whereby France became an Austrian ally.

Like so many houses in Paris, these six *hôtels particuliers* had a great many owners and tenants. If country estates were conserved by their owners despite the vicissitudes of fortune, the same could not be said about Parisian town houses, which were left behind quite easily when an owner was no longer able to carry on in the style required. The fact is that building or maintaining a great town house required a large fortune.

In this particular example, there is a courtyard, a pretty porch surrounded by white stone columns, then a vestibule paved in black and white marble squares. Entering, a very large portrait attracts one's attention immediately. It represents a slender lady of extraordinary elegance, wearing a white evening dress, long kid gloves, and holding in her hand an ostrich feather fan which is mounted in pale tortoiseshell. On the staircase, one's eye lights on a slightly malicious-looking seven-year-old nymphet, who has a lovely flower placed in her auburn hair.

(Opposite)
Portraits painted at the end of the nineteenth century line the staircase that leads to the elegant reception rooms on the first floor.

(Previous pages)
The library is filled with books and paintings, with objects scattered on top of one another, very much in the fin de siècle taste.

(Left) The Countess Greffulhe, who was in large part the inspiration for Proust's Duchesse de Guermantes, would feel very much at home here. This portrait hangs all alone at the bottom of the staircase.

Glasses from Venice and Bohemia are carefully placed in a Boulle cabinet. Their very quantity reflects the hosts' passion for entertaining their friends from all over the world.

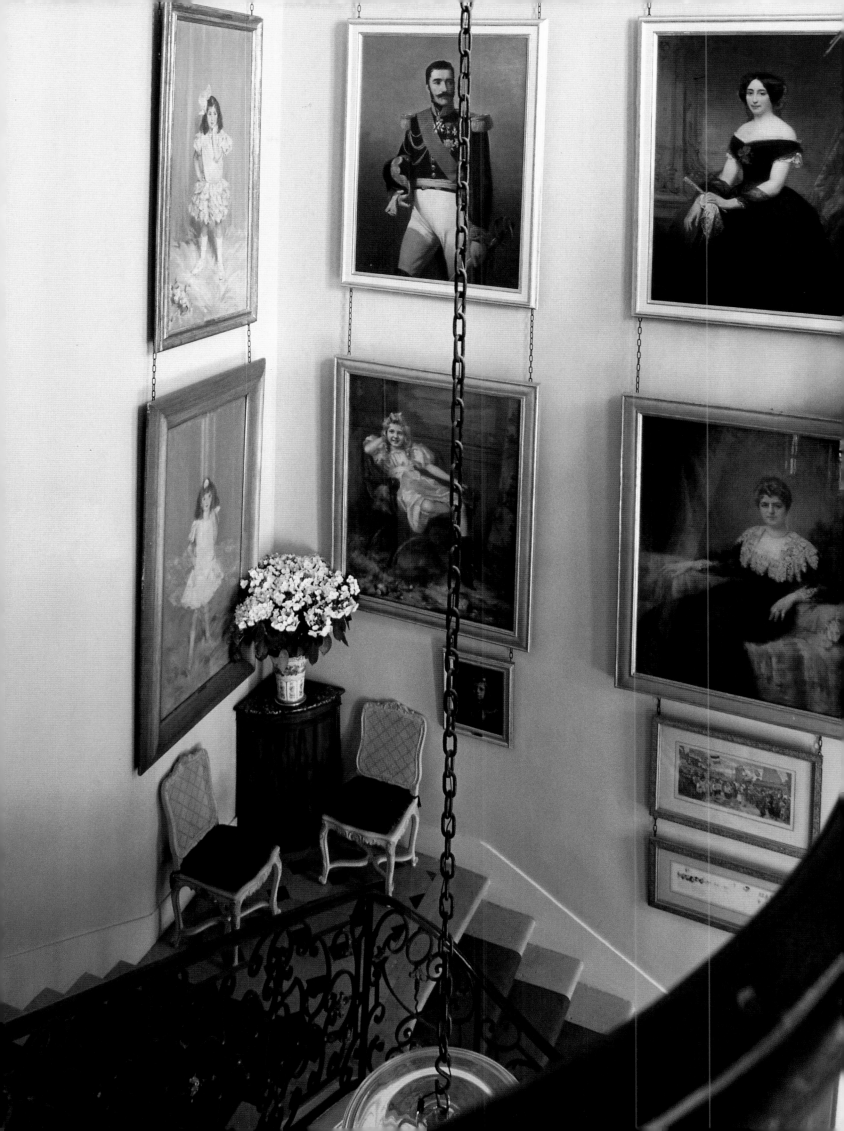

After alighting the staircase, one arrives at a landing still paved in the eighteenth-century black-and-white marble set when the house was built. Balloon curtains soften the light, and lovely furniture embellishes the entrance to the apartment. Here is a suite of rooms starting with the library–dining room, which is the first of a series created for entertaining. The entrance hall doubles as an extension of the library-dining room, and its Louis XV desk is used to bear anything from plates and glasses to lovely bowls of fruit (below).

Guests alight on the first floor, after walking up a grand staircase, watched all the while by the elegant, immobile figures of the Belle Epoque, painted in full regalia by artists at the turn of the century. The lady in white is, in fact, the renowned Countess Greffulhe whose spirit seems to inhabit the house.

The French writer Gabriel-Louis Pringué describes her in his memoirs as follows.

"For nearly fifty years, she was the unrivaled queen of Parisian society. Marcel Proust's portrait of the Duchesse de Guermantes in *Remembrance of Things Past* was largely inspired by her. . . . Hostess at every court, she constantly sought out artists and scholars, musicians and painters, whom she brought back to Paris and made famous. After lunch at Peterhof with Tsar Nicolas II and Empress Alexandra, she packed up the Ballets Russes, who were to transform scenes from the entire world into a fairyland. First, she insisted on their being presented at the Théatre de Châtelet, then at the Paris Opéra. She introduced Serge de Diaghilev to the director of the Monte Carlo Opera, and then got his company to play at the Théatre des Champs-Elysées.

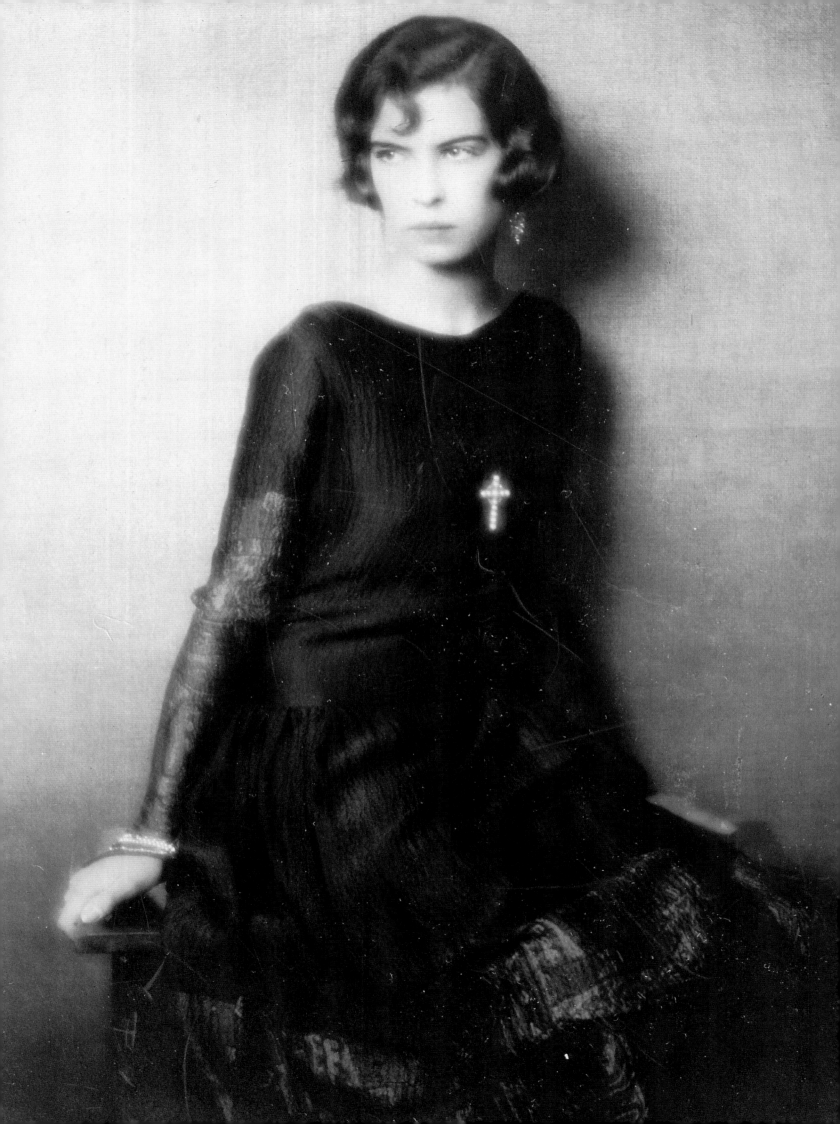

(Opposite) *The grandmother of our host, the Princess de F., was, like her husband, a very Proustian personality. This renowned English beauty, who was a star of Paris society, is seen here photographed by Cecil Beaton. She and her husband were well-known figures in the world of the arts and society*

"Elizabeth de Greffulhe was applauded, acclaimed, and photographed; poets sang her praises; the painter Helleu saw her as a swan and set her in elegant curves. When, agile as a young faun, she passed through an illuminated salon, those who missed her ran after the apparition. 'Where is she? Did you see her?' "

This wonderful figure is fully at home in the great house we are visiting. And it is no wonder. Two families share the house; they see each other regularly, enjoy each other's company, and the fathers are very much representative of the elegant, Proustian life that went on in the Faubourg Saint-Germain, now better known as the septième arrondissement, that was the favorite of the French aristocracy. Both gentlemen have very direct links to the world of Marcel Proust. The blood of the Countess Greffulhe runs in the veins of the older of the two. The grandfather of the younger knew Proust quite

The couple's love of decorative objects is seen in all these views of the lush interior of their house.

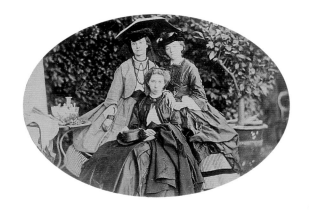

The hostess' mother is seen in a photograph taken in the 1930s; more distant relatives are seen above.

(Overleaf) The library–dining room is filled with illustrated books on art and travel, reflecting the couple's interests, as well as valuable leatherbound first editions and Orientalist pictures. This room leads directly into the main living room where guests gather before dining, or where they sit for dinner after serving themselves from a buffet placed on the large dining room table.

well and was a virtual encyclopedia of the cultural and social life of the great capital, carrying all the elegance and distinction of the Faubourg in his person. He was so distinguished that people stopped in their tracks as he passed them by on the street; he died only a few years ago.

The house is located on the Left Bank, close to the Seine. A stone's throw away are the offices of Proust's publisher, Gallimard. Within a short walk are all those grand houses where the world of the salon flourished until the beginning of World War II. There were, of course, literary, musical, artistic, and political salons, led by brilliant hostesses, where conversation was an art and ignorance a sin. It was, however, the aristocratic salons of the Faubourg St. Germain that were the most brilliant and became the inspiration for

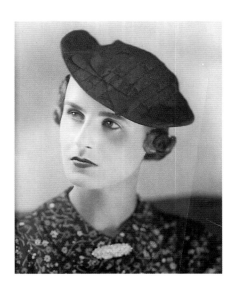

what Proust called "The Guermantes Way". The salon of the Comtesse Greffulhe was where everybody wanted to be, the summit of Proust's aspirations, since it was here that he could find the *beau monde*, which he transformed into the immortal Baron de Charlus, the Duchess de Guermantes, Mme. Verdurin, and St. Loup.

Today, the Faubourg is a wonderful melange of eighteenth-century Paris and the Paris of Baron Haussman, who created the grand boulevards and stately apartment buildings during the boom of the Second Empire. The apartment of our younger host is decorated in the opulent style of the end of the nineteenth century, and if true salons no longer exist, the conversation here is equally stimulating; people in the arts and society still mix happily, guests are beautifully dressed, the lighting is soft and seductive. If Marcel Proust might not always find here his Madeleine from Combray, he would have felt his usual sense of excitement and achievement as he mounted the

(Opposite) A neoclassical German desk is highlighted by marble columns and wood inlay. Paintings of Pekinese and an abundance of potted palms enhance the hot-house, *fin de siècle* atmosphere of these warm and cozy rooms where friends gather.

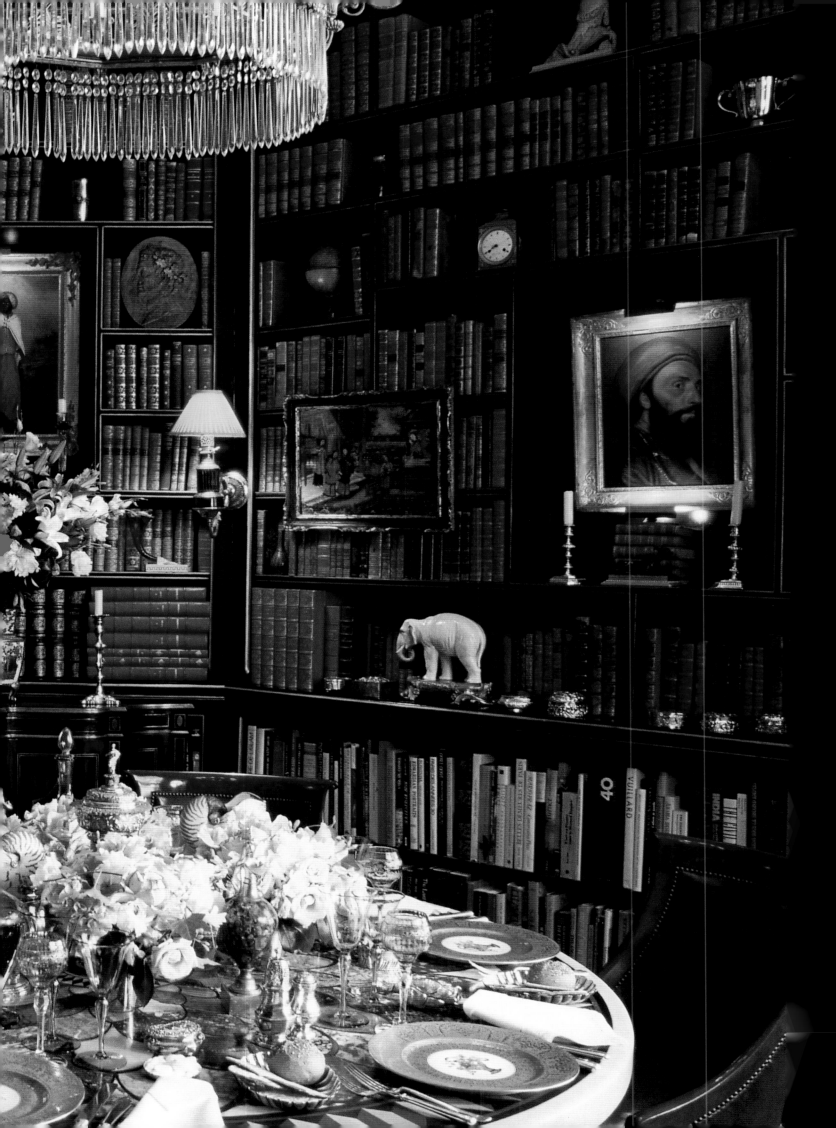

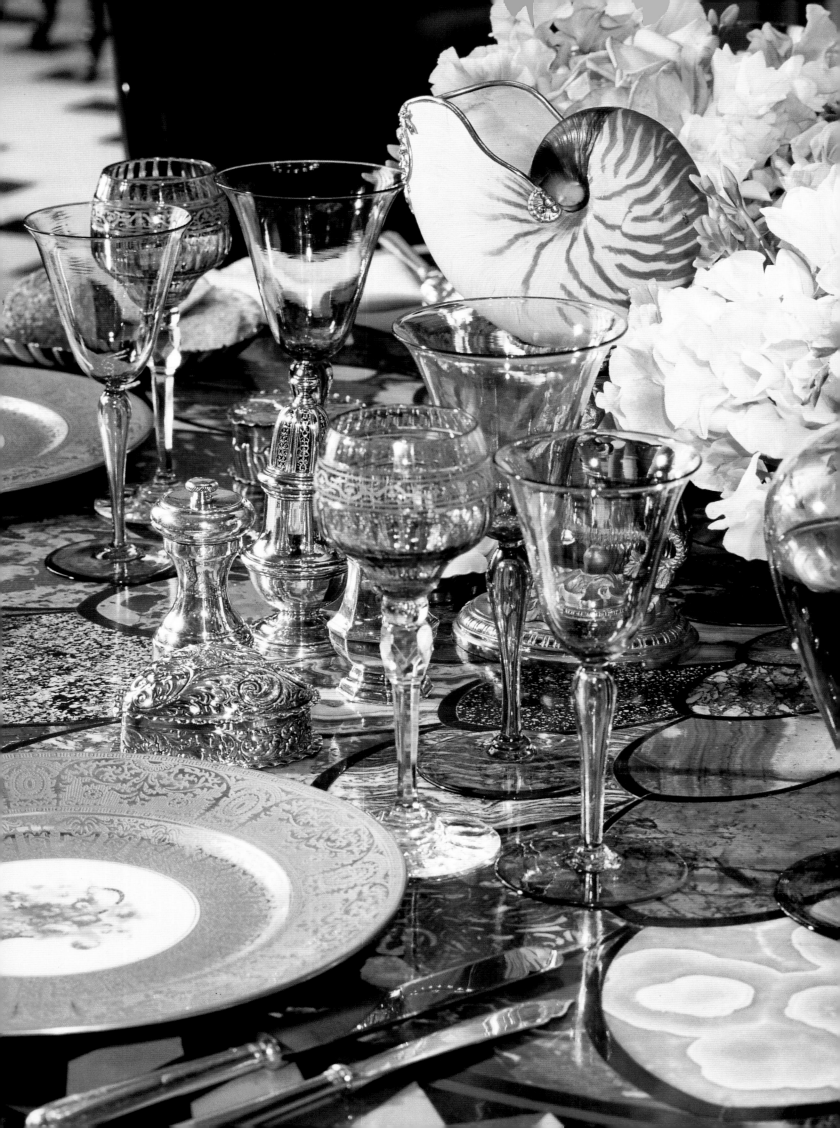

(Opposite)
The polychrome marble inlay of the library table is a perfect foil for green crystal glasses, nautilus shells, and a German Baroque silver-gilt presentation goblet—these could be possessions of a central European princely collector. Our hostess has a flair for lovely floral bouquets, which embellish this and many other tables of the house. The gilded porcelain plates are one of several dinner services neatly preserved in the pantry cupboard (below).

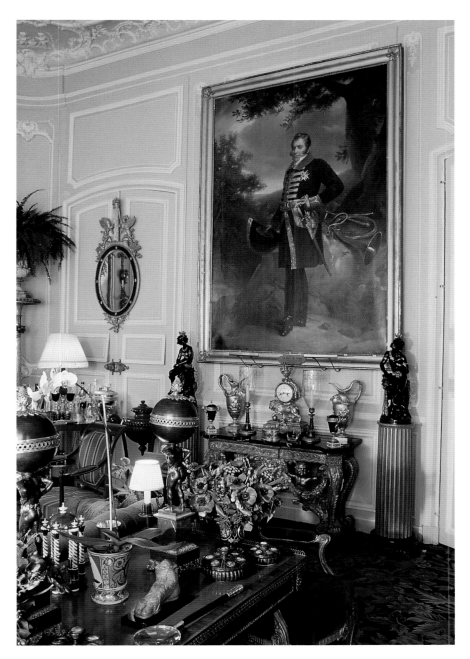

(Left)
A depiction of the Duc de Berry, an ancestor of our host, dominates the living room in his military uniform. The portrait was painted by Baron Gérard during the Napoleonic era. The blackamoors on Louis XVI columns, the gilded console, and an abundance of silver gilt treasures carry through the Schatzkammer effect seen on the dining room table.

staircase and confronted the best of French society. The social lepidopterist would at once have been taking mental notes in order to capture and transmute the hosts' guests into the personalities of another *Remembrance of Things Past*.

The staircase landing is flooded with a variable luster of colors. Light filters through white silk Venetian drapes. There are lush green plants, and a great ebony, copper-encrusted Boulle cabinet, which houses a collection of Venetian and

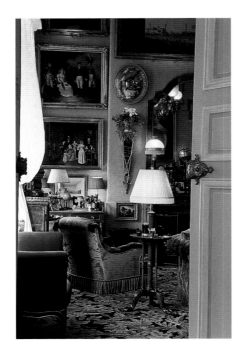

Bohemian glass. The inlaid, polychrome marble dining-room table has been laid with elegant, antique plates whose flower bouquets are set off by a patterned gold ground. A goblet, malachite urn, and sea shells, mounted in silver gilt, frame four dewy bouquets of roses. Flowers are one of the passions of the hostess, who always chooses them with exquisite taste; in this case, she has put together a delicate bouquet of sweet peas, roses, and freesia.

This table reflects the entire house: luxury married to spontaneity, classicism to fantasy, solid matter to materials of the greatest delicacy and fragility. In the living room, an ample measure of white cotton drapes embroidered with palmettos creates a sense of lightness and freshness, of youth and giddiness. Light gray Louis XV paneling, highlighted in white, dates

to the building of the house, and is a contrast to the large purple flowers on a black background that makes up the Napoleon III style carpet. Everywhere there are portraits in gilded frames; and many intimate conversation pieces can be found in the library.

Our host explains that, aged seven, he was dazzled by his visit to the magical Château de Groussay of Carlos de Bestegui, in particular by its grand tour atmosphere. Later, he was to become an enthusiast of the comfort and elegance of the English house, and was finally to discover the subtle refinement of Russian decoration. Both our host and hostess reminisce about the things they fell in love with when decorating the house, where a timeless atmosphere seems to defy the passing years. One feels the influence of a cosmopolitan and romantic European civilization in these rooms, a universe full of memories yet with no trace of nostalgia. Harmony is created out of diversity.

(Opposite) The delicate lace widow drapes and red velvet banquette are reminiscent of interiors that once could have been noticed at the turn of the century by passersby walking along St. Petersburg's Neva embankment on a spring day.

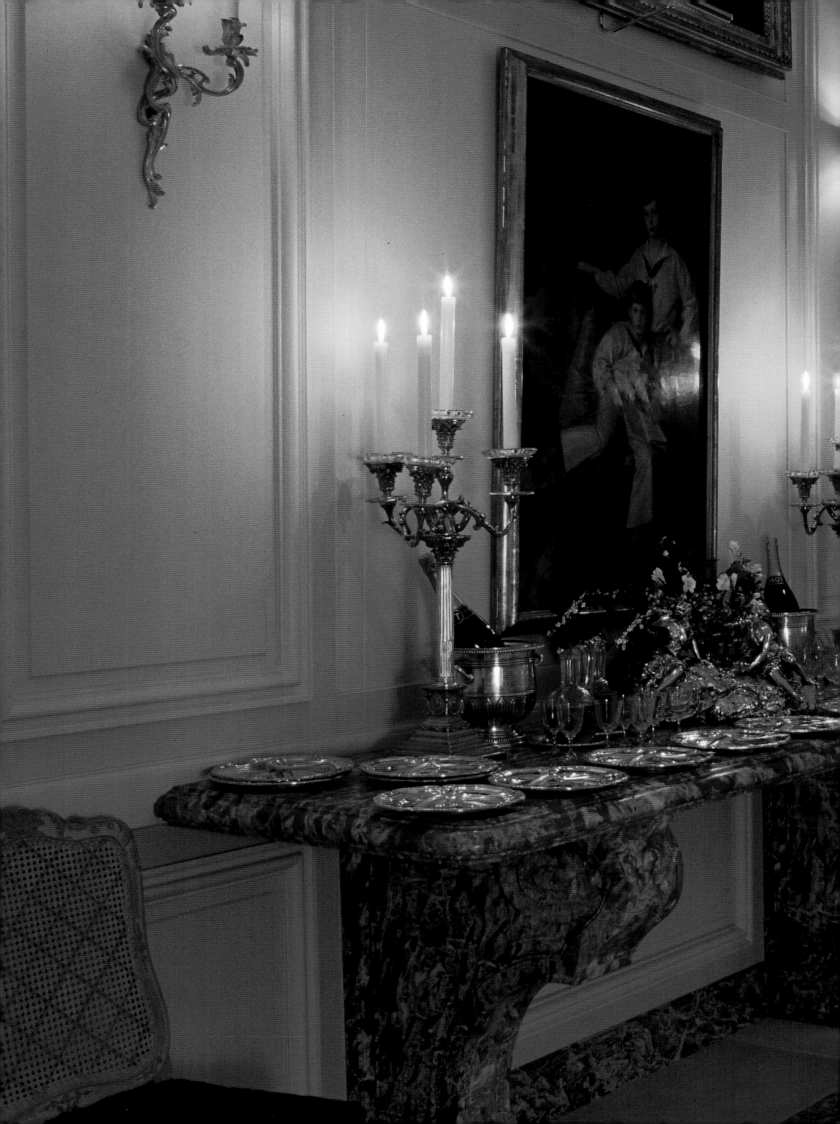

An Evening Entertainment

With a
Gentleman
Architect

Two parties seem to be going on in the same house: that of our host and, on the ground floor, a celebration in honor of his grandchildren. We are expected, and glide slowly down the elegant staircase, holding on to its magnificent cast-iron ramp, dating to the time of Louis XV. Silver plates, crystal glasses, and champagne buckets are put out on the red Languedoc marble table in the "antechamber of the buffet." Two large candelabras have been set up on either side of a beautiful display of old silver. Above, there is a charming family portrait of two young boys in sailor suits, watching over the scene around them.

All the furniture has been taken away from the center of the great neoclassical salon, upholstered in Indian silk, to make room for the dancing, and the gilt wooden Louis XV armchairs have taken the places they had originally occupied in the eighteenth century: against the walls of the room. A great bronze chandelier lights up the scene. The profile of Hebe, goddess of youth, is reflected in the mirror above the fireplace, as are the candles placed in an Empire bronze-gilt urn. Cherry-colored patterned damask covers the walls of the library, known as "The Monkey Salon" because of the extraordinary Louis XV molding, upon which malicious monkeys pursue stucco gilded parrots on an off-white background. Here we notice, among the many family portraits, that of the father of our host, painted in the 1930s by an English artist. He is pictured looking at us, his hand slipped nonchalantly into his pocket.

In the master bedroom, another grand portrait hangs above the desk where gentle disorder reigns; it is an image of our host's father and his uncle, then far younger, and in the background the coachman Alix is holding two mares, Tempest and Messenger.

Daylight is slowly fading, and we move out to the garden planted with Mexican orange trees and lavender; a beautiful

(Previous pages) On the red Languedoc marble side table of the dining room, silver, crystal carafes and glasses, and champagne in eighteenth century coolers all glitter in candlelight, awaiting guests for the evening entertainment.

(Opposite) The living room is now empty, but soon will be full as music enlivens the atmosphere.

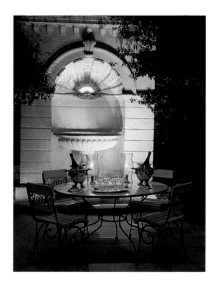

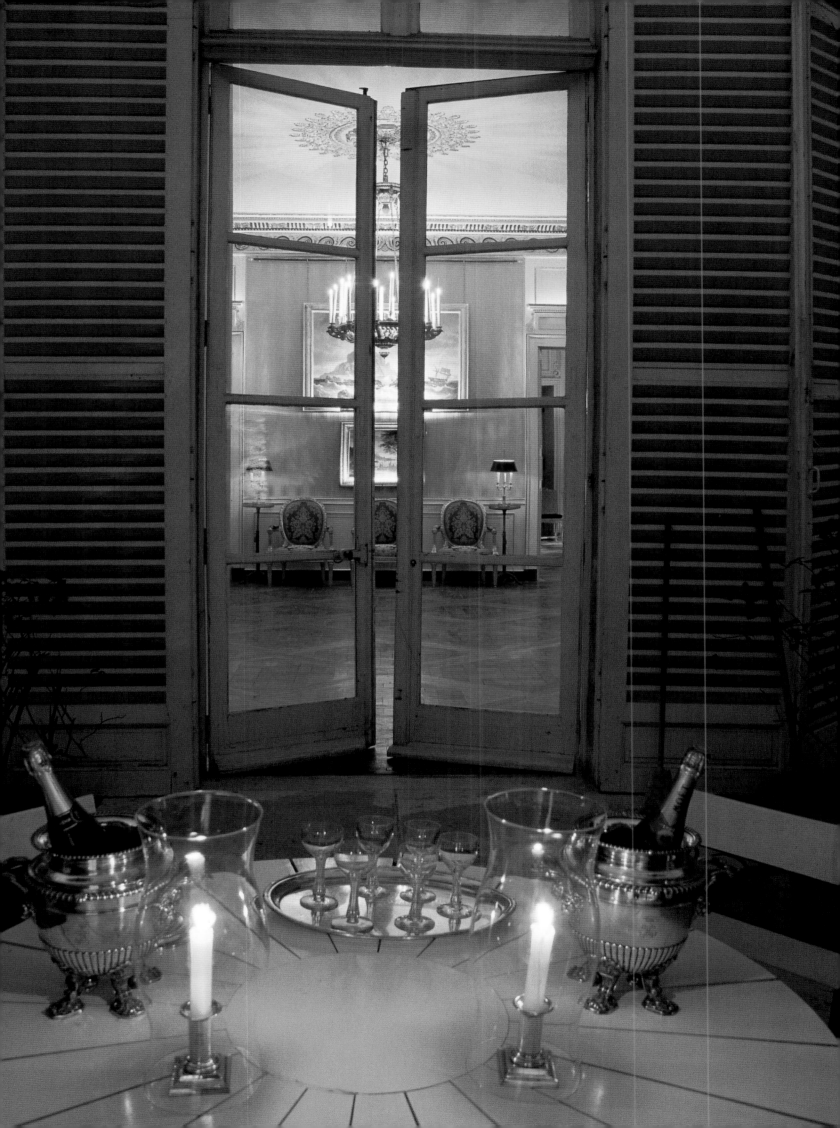

eighteenth century fountain near to us has just been lit. A table is brought out with silver ice buckets. It is dusk and we seem to be journeying rapidly into an earlier age, the atmosphere redolent with an evocation of the past.

Our host felt obliged to restore the ancient splendor of this lovely Louis XV mansion when he moved here nearly two decades ago. "We don't live with wigs on our heads, so we have to respect the spirit of a house while adapting it to our own time." Private houses of the eighteenth century, when they are not full-fledged palaces, have beautiful proportions. Imposing salons alternating with smaller rooms create a very pleasant atmosphere. The architectural plan of the interior as well as the decoration was almost

(Opposite) The owner's historic archives are carefully preserved in the house: family histories, illuminated crests, and genealogical trees delicately painted on parchment and large family seals all bear witness to the noble background of the host. He confronts modern life to the full as a skilled architect and decorator, and was largely responsible for redoing the Hôtel de Rothschild on the Faubourg St. Honoré when it became the United States Embassy.

(Right) These two young boys in sailor suits, painted at the turn of the nineteenth century, are forebears of the owner of the house. They seem to be admiring the imaginative silver centerpiece by Falize, made up of mermaids. Falize was one of the most popular jewelers of the Second Empire; his pieces were admired at the Universal Exhibitions in Paris, where style was set for the entire world.

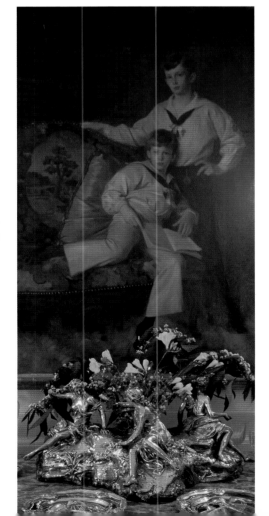

de rigeur. However, the house was very well set up to divide into separate floors when needed in order to house several families.

Originally, the bedrooms were on the ground floor and the reception rooms on the first floor, also known as the *étage noble*, which overlooked the garden. Until World War I, and even for a time afterward, comfort was very limited; there was one bathroom, or perhaps two, for the entire house. Foreigners visiting France were quite astonished. "I've come to the house of savages," a family member once exclaimed, arriving from Belgium. It is true that in France there was a fairly unhygenic upper crust that traveled very little, never realizing modern living had its good sides. For them, the portable tub was the paragon of domestic joy. Heating and bathrooms were a very new taste.

It would not be long, however, before kitchens were linked with the dining rooms on the different floors. Dumbwaiters disappeared along with the servants who operated them. Today, this venerable house is truly alive.

(Left) The office of the gentleman architect shows a studied disorder. All his papers, drawings and books are laid out under the portrait of his father and uncle with their coachman and horses.

(Below) The 'Monkey Salon' is named after the monkeys painted on the cornice. They are actually chasing parrots. The frieze, which is quite unusual, was made during the reign of Louis XV. On the walls are several family portraits; most noteworthy is our host's father's portrait, adjacent to the white and gold bookcase, painted by an English artist. This is where he enjoys receiving his friends at tea time, and often is asked about and can describe, with humor and perception, the elegant Paris life between the two wars.

(Opposite) The main salon is hung with striped yellow-gold silk in the Empire style. The mirror reflects a splendid Empire chandelier and a portrait of the Goddess of Youth, Hebe.

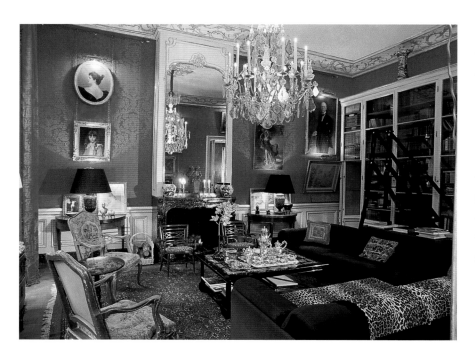

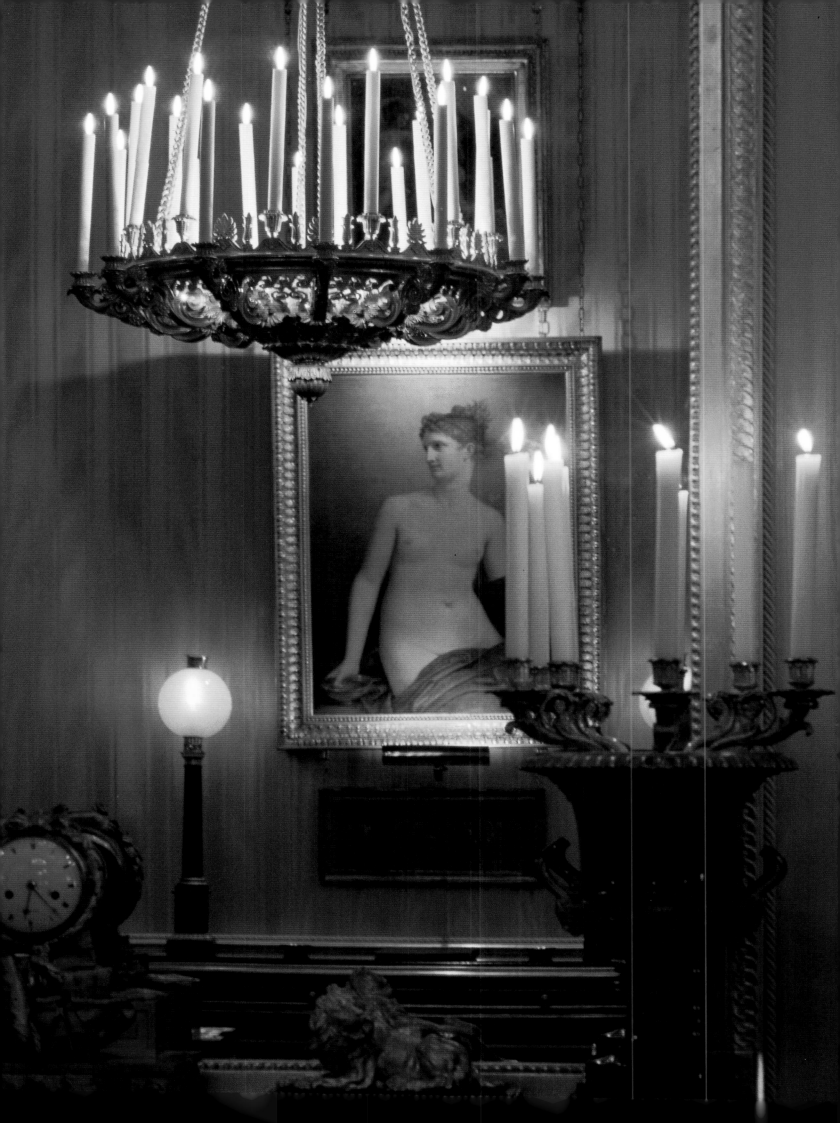

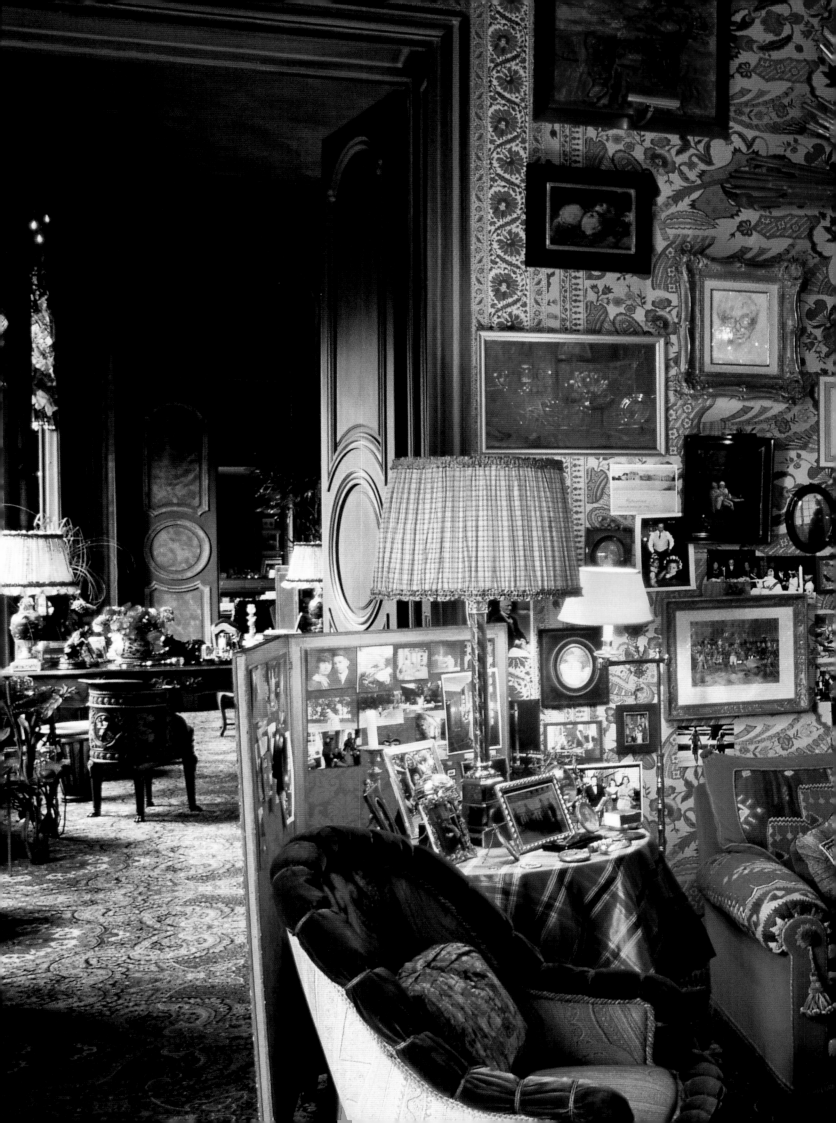

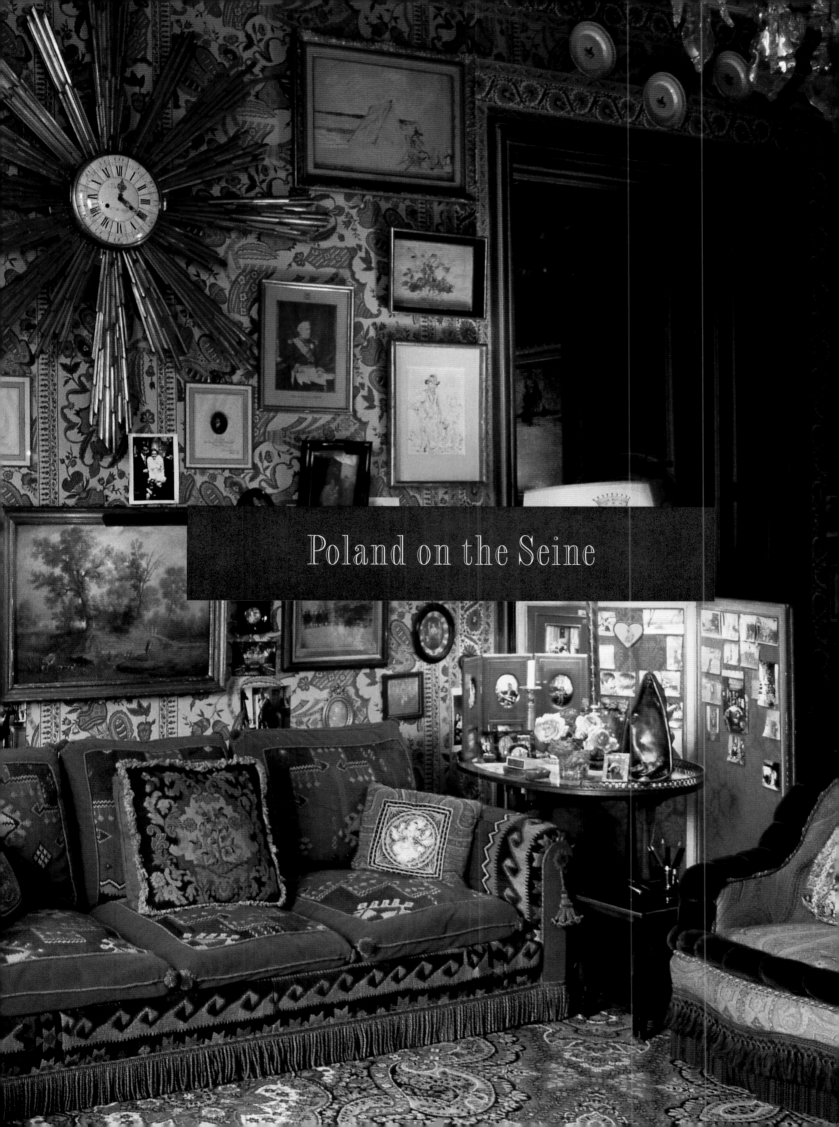

Poland on the Seine

With the Comte and Comtesse Hubert d'Ornano

Hubert d'Ornano is a master builder. After succeeding in his first business enterprise, the Orlane cosmetic company that he created with his brother Michel, he founded Sisley, another cosmetics company and worldwide success, "the fruit of a lifetime of work and tenacity." Hubert d'Ornano is convinced that business is very important in his life; his wife is vice-president of Sisley and three of their children work in the company. His family is sacred and he watches carefully over it!

As time passed, Hubert d'Ornano and his beautiful wife Isabelle, who is a descendant of the Potocki princes, one of Poland's noblest families, wanted to remake a family inheritance and bring to the world they were to create in their Paris apartment the magnificent conditions in which their two families had lived in Poland. And so they built around themselves the world they loved, simultaneously elegant and grandiose, yet still a family home. French and Polish influences stage a true dialogue in their magnificent living room, decorated with Louis XV paneling. One is taken into an imaginary, somewhat fantastic universe populated by queens, children, and strange animals at the very entrance; opposite the portrait of the mistress of the house is a royal Infanta by Spanish painter Manolo Valdes, as well as an alert stag, its ears standing straight up in observation.

The house fairly glows with color. Green and gold dominate the main living room. Isabelle d'Ornano explains, "It all started twenty-five years ago, when we found these large Louis XV doors from Versailles, painted in imitation

(Opposite) Overlooking the Seine is set a world of fantasy within a 1920s building that has but a few large, custom-built apartments, each with extremely high ceilings. In the flat of the Count and Countess d'Ornano the world of Polish kings and French nobility, antiques and modern art, the past and the present, the opulence of Louis XV and the Second Empire all mix together sumptuously. The portrait of Queen Barbara of Poland in a Regency frame looks down onto a boar's-head table created by the talented Polish artist Bronislaw Krszytof, who also sculpted the bronze angel looking out onto the river (below).

(Previous pages) One view of the long, liveable dining room that is "en suite" from the main salon.

(Overleaf, left) On the mantle of the living room's marble fireplace, a rustic candelabra of crystal and bronze, featuring deer antlers, cohabits quite happily with a blue Sèvres cachepot mounted in bronze gilt.
(Overleaf, right) A living room window banquette, with embroidered cushions.

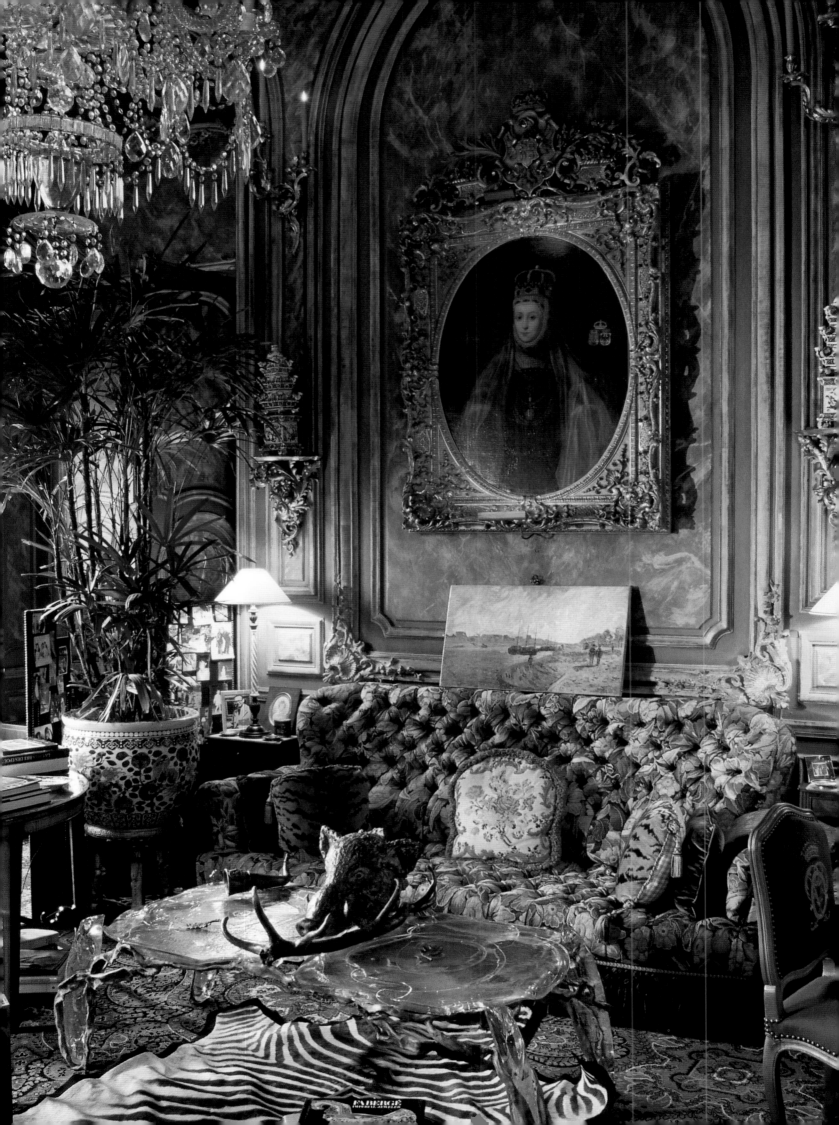

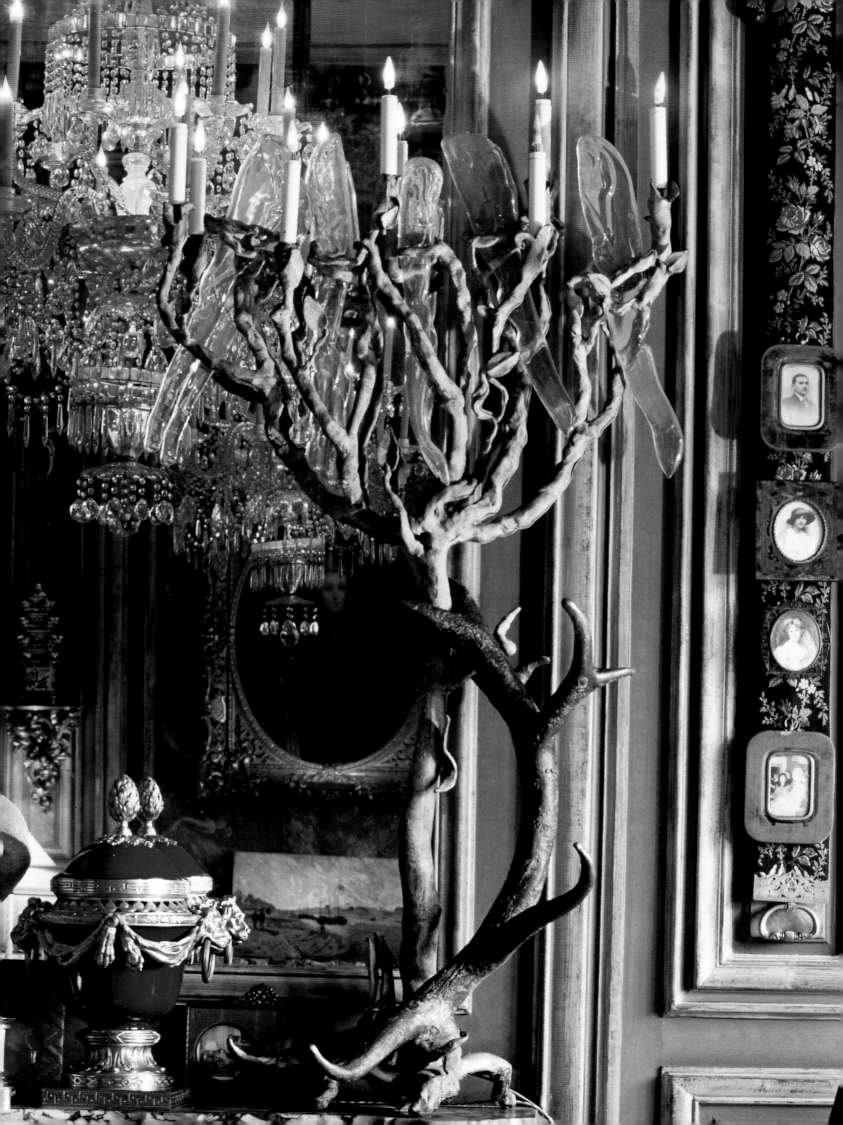

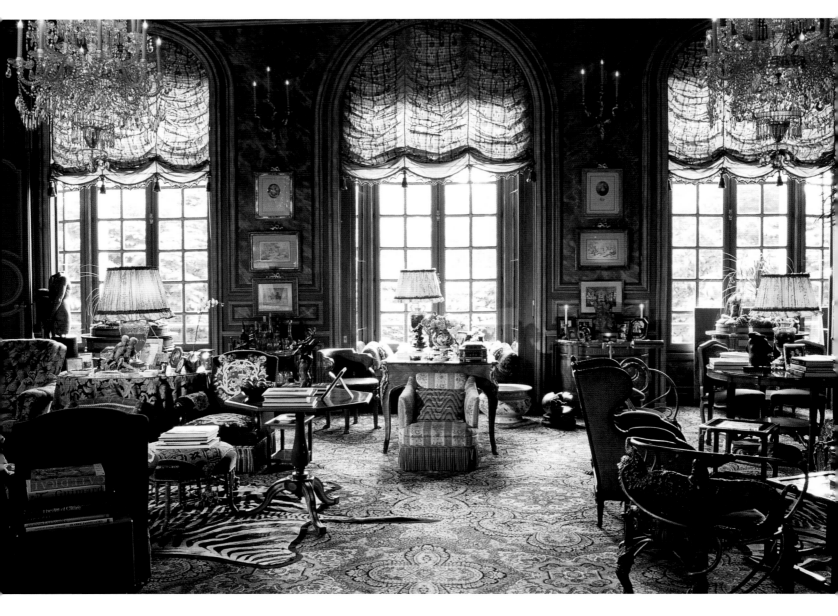

green marble, highlighted in gold moldings. Together with our good friend Henri Samuel, the decorator, we decided to base our scheme on these old colors."

The three large windows overlooking the Seine are highlighted by green and pink balloon drapes in silk taffeta. The ceiling is sky blue. "I love painted ceilings, obviously skies, but also the decoration

in the entrance. The idea came to me when I was crossing some corridors at the Vatican! Staircases and passages there also make use of trellises on which small monkeys play, and birds fly in the middle of orange trees, leaves, and flowers. In the end, I was far more conservative than the Vatican. And, can you imagine, when years later I visited the Lancut palace near Kraków,

which had belonged to our family, I found these same motifs in a grand gallery. I was never there as a child: these are the strange tricks of memory. Perhaps somewhere in my subconscious I had preserved a taste for painted ceilings."

If the worlds of France and Poland successfully mix in this superb room, two others also exist side by side: that of the eighteenth century and the art of today. In fact, Hubert and Isabelle d'Ornano specifically wanted the most contemporary art to find a home in this classical decor: magnificent crocodile chairs by Claude Lalanne, sheep and stags of Jean-François Fourtou, Mitoraj's portraits of women, "Young Women in Black" by Gromada and "Moses Revealing Himself Before God" by Georges Jeanclos are all here.

Once, on a trip to London, they discovered the work of Bronislaw Krszytof, a sculptor who lives near Kraków. He created several astonishing objects for them: a bronze and crystal table made up of a boar's head, a bust of an angel, and a lovely face of their daughter,

Letitia, seen from three angles and covered in three different patinas: pale green, black, and gold. On the Louis XV marble fireplace are two immense green bronze candelabras of stags' horns that sprout branches embellished with rock-crystal stalactites.

All this novelty lives in perfect harmony with ancestral portraits —a fine officer in red uniform, a painting of a great-grandmother by Franz Winterhalter, and the beautiful Barbara, a Lithuanian princess who became Queen of Poland in the sixteenth century, and who now looks out at us from an immense carved and gilded frame.

"After having raised our five children here," says the Countess

(Opposite) The entrance hall, so sumptuous and large that it serves as a second sitting room, sets the tone for what is to come. False wood and marble doors, molding, and archway, trellises painted on the vaulted ceiling, upholstered walls, and fabulous chandeliers create a background for family portraits and a fawn (right) covered with newsprint by Jean-François Fourtou.

(Below) Our hostess's aunt, Mogens Tude, née Princess "Dolly" Radziwill, sits in her more traditional 1930s Paris apartment. Poland and France enjoyed cultural and social links, and many Polish grandees came to live in Paris after the tripartite division of Poland ruined their homeland.

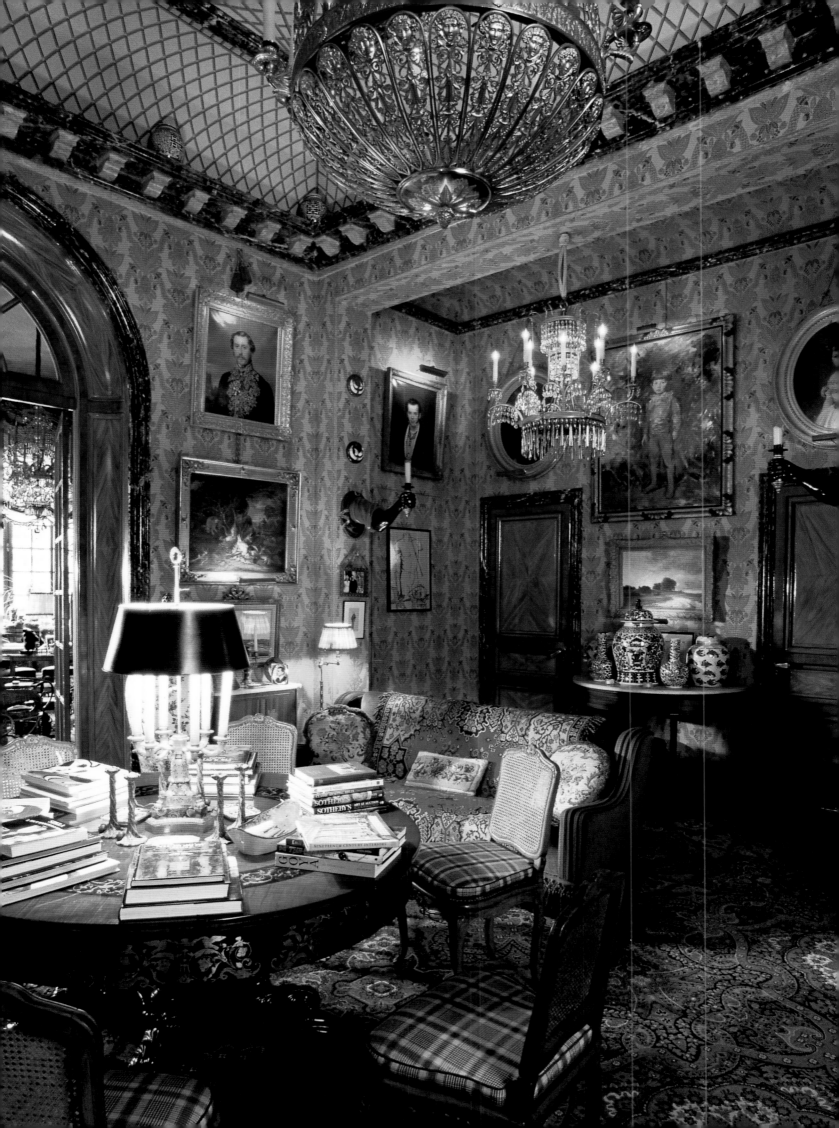

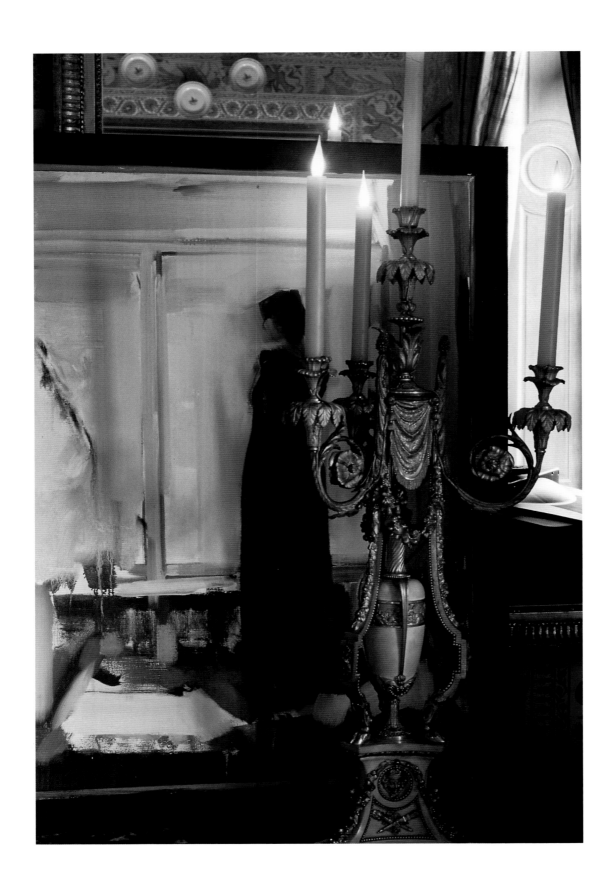

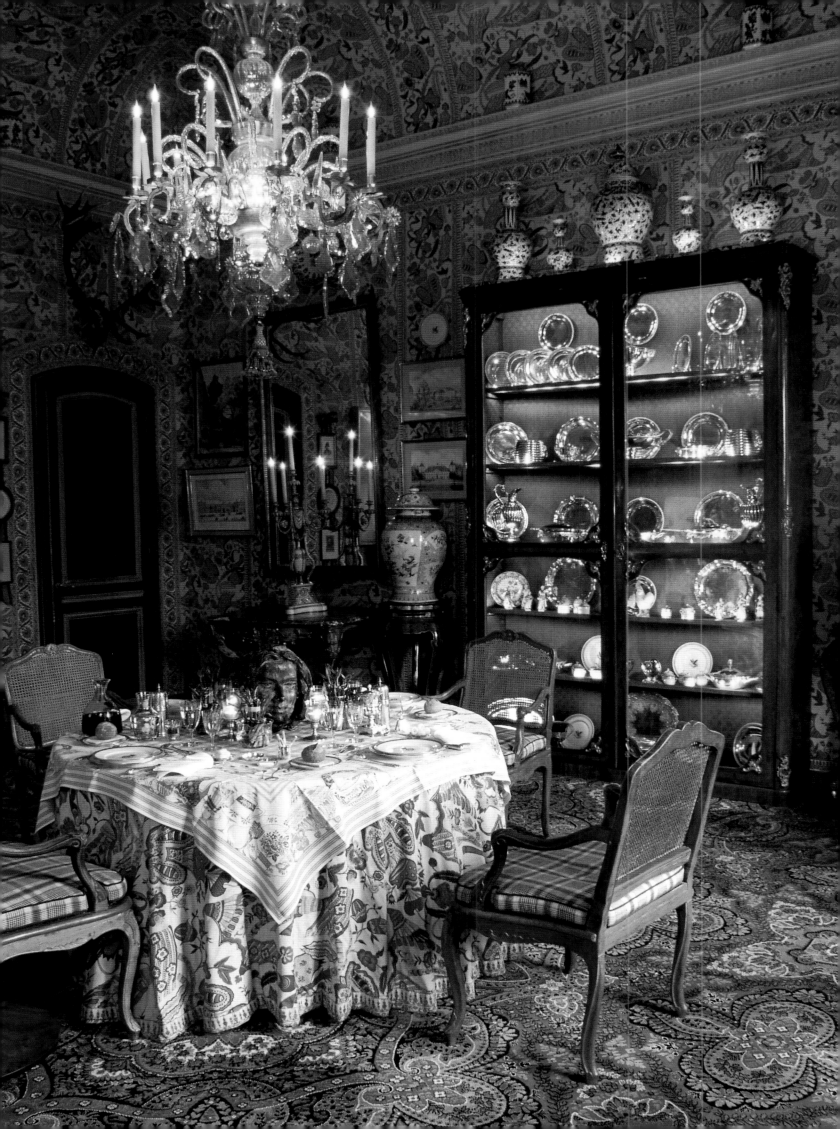

(Pages 104-105 and previous pages) The living room leads into a wonderfully lush dining room, whose walls and coffered ceiling are covered with Braquenié textiles. Rustic though it may be, the wall covering is a perfect foil for a Regency cabinet that displays the family silver.

(Below) A platter has been prepared for breakfast in bed; note the family coat of arms on the cup.

(Opposite) The bedroom is quite theatrical, the result of having cut the room's extreme height by a circular balcony, a sort of floating alcove that is accessed by a staircase. One tall window illuminates both levels, as can be seen in the shared curtain that covers the tall window. Thanks to this additional space, the room is simultaneously an office, living room, bedroom, dressing room, and a place to house family souvenirs.

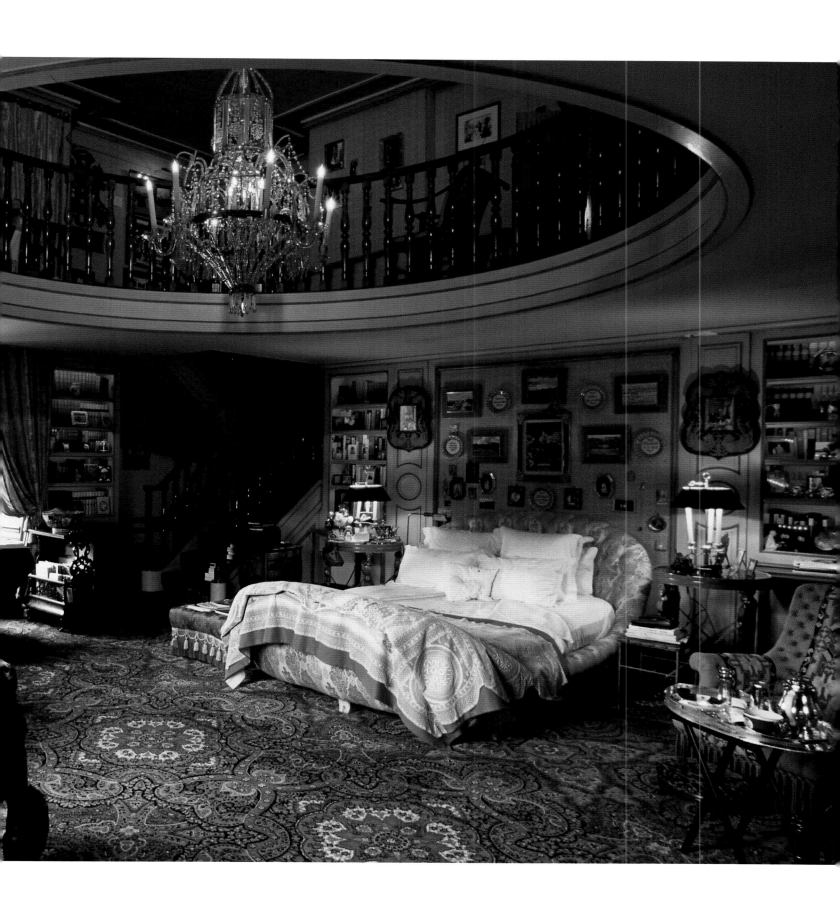

117 · With the Comte and Comtesse Hubert d'Ornano

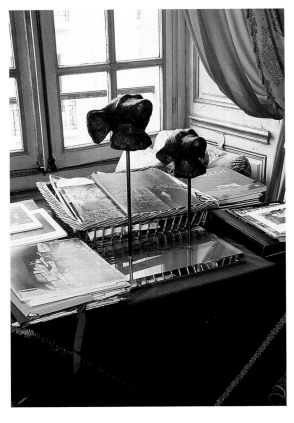

d'Ornano, "we needed a new impetus—life, warmth. Today we are absolutely fascinated by the creativity in today's artists. I love establishing a dialogue with an artist that gives birth to a work of art. And then that work of art becomes integrated into our everyday life, nurtures our life, becoming something with which we live. Of course, we have a wealth of history here, marked by our Polish ancestry, by our memories. But we love our own time and it is thanks to the work of contemporary artists that the future comes into our house, that our personal environment evolves. Not only that, we want our house to be welcoming and our door always to be open to the unexpected."

The d'Ornanos' interest in modern art is seen in two bronze dog heads (above), in a portrait of the countess as an Infanta of the Spanish royal family by the renowned Spanish painter Manolo Valdes (below), and, on a gilded console table, in two sheep made by Jean-François Fourtou (opposite). They are watched over by the Polish grandee Prince Potocki, bedecked in medals, jewels, and finery. Clearly no shepherd, the prince was a renowned soldier and ancestor of Isabelle d'Ornano.

*(Below)
Hubert and Isabelle d'Ornano as a young and handsome couple. The Comte d'Ornano is one of the most dynamic figures in the French cosmetics industry; his career has been aided by his beautiful wife as well as his children, who now work with him.*

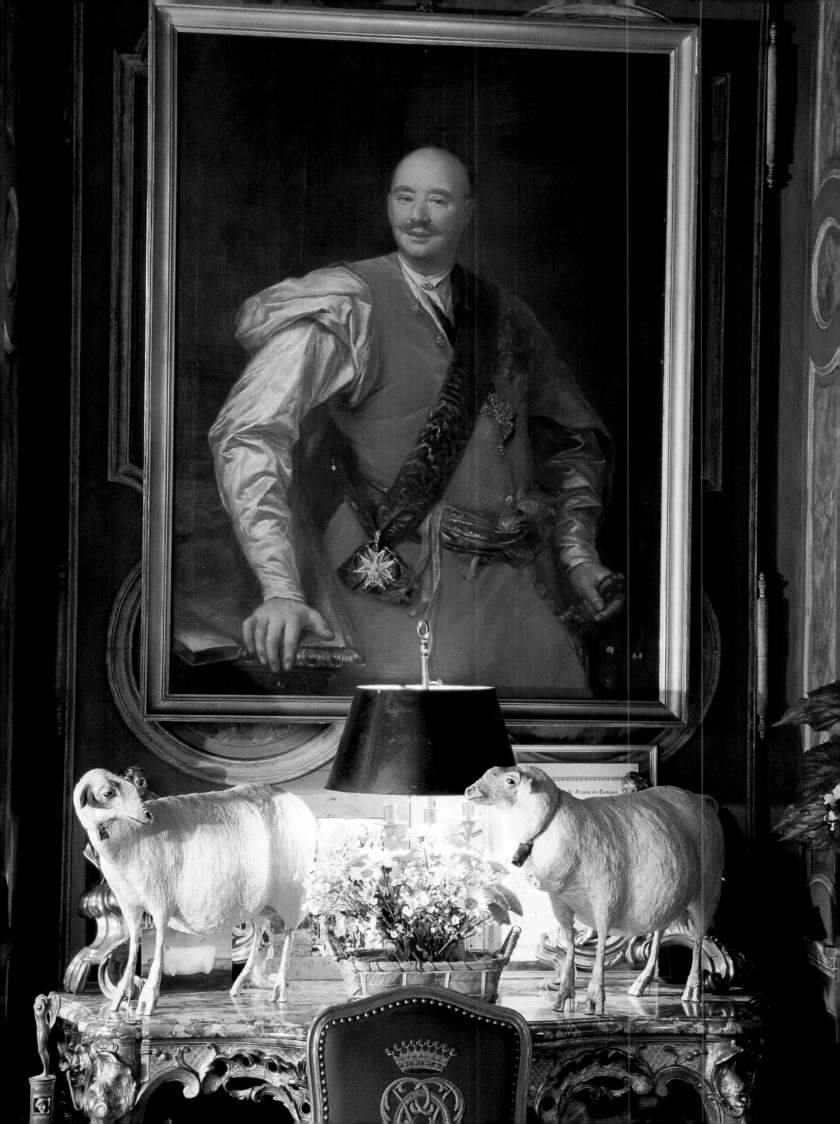

The Hôtel de Charost

At the British Embassy

Surely a dwelling preserves within it a memory of the people it formerly housed. If so, we can well imagine that the Hôtel de Charost, the residence of Britain's ambassadors, would have a lot to tell.

In 1722 Armand de Béthune, third Duc de Charost and governor of the young King Louis XV, decided to build a large house, presently located at 39 Rue du Faubourg-Saint-Honoré. Antoine Mazin, the architect who was just finishing the Hôtel Matignon, the present residence of France's Prime Minister, was chosen for the task.

Charost's grandson, the fourth duke, inherited the house in 1745 and lived there for some forty years, after which he leased it to the Comte de la Marche, who laid out an English garden and redecorated the ground floor salon; his designer may have been the renowned Victor Louis of the Bordeaux opera.

In 1803, the Duchesse de Charost sold the house to a twenty-two-year-old widow, Pauline Bonaparte, sister of the Emperor Napoleon I. Everybody remarked upon her beauty and wit. Ten months later, Pauline married Prince Camillo Borghese, an extremely rich Italian aristocrat. Pauline later said, "I would have rather remained a widow with 20,000 livres income a year than be married to a eunuch." She was beautiful and enterprising; under her direction, the house was transformed. Every Wednesday she gave sumptuous parties, gathering her guests from the emperor's court.

Today, we can admire the furniture collected by Princess Pauline: magnificent bronzes, fireplace embellishments, chandeliers, candelabras, and clocks. Thanks to her, we can still enjoy one of the most magnificent French Empire settings ever created.

The emperor abdicated in 1814 and Pauline decided to sell the palace. The Duke of Wellington was captivated by it and persuaded the British government to buy the house along with all its furniture. In 1824 the first Earl Granville took possession. It was during his long

Having passed through the Gallery, admired the Throne Room, (previous pages) and alighted the Louis XV staircase (right), we finally enter the apartments of Princess Pauline Borghèse (opposite), whose portrait by Lefèvre dominates the antechamber, filled with magnificent Empire furniture.

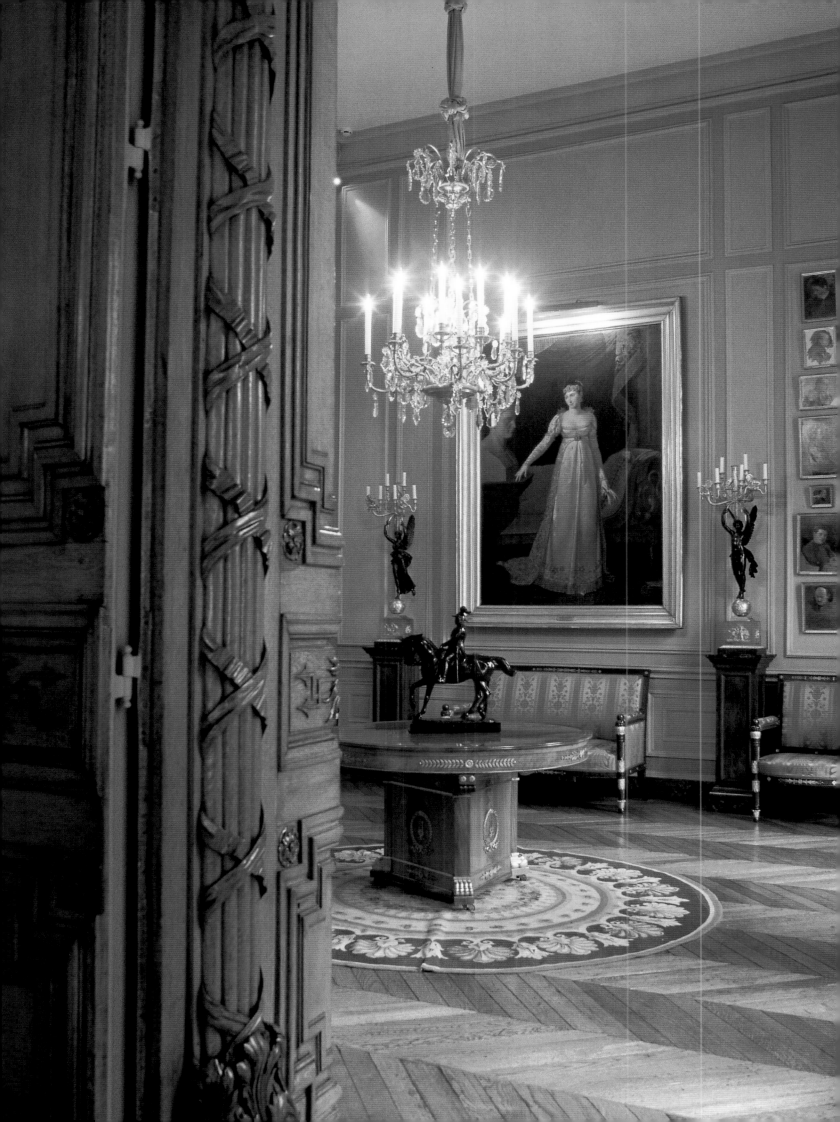

(Right) Sir Alfred and Lady Diana Duff Cooper are seen shortly after their marriage, which was one of the great social events of the year. "Duff" was, in his early years in politics, and Diana was one of the most popular women in society.

(Below) Diana Duff Cooper as ambassadress to Paris, her last official post.

(Opposite) The splendid Duff Cooper library, designed and conceived by three leading Paris tastemakers: Carlos de Bestegui, Georges Geffroy, and Christian Bérard. "Duff" is immortalized in the Latin inscription.

reign as ambassador that Queen Victoria visited Paris on three separate occasions. Her first visit came as the result of an invitation by the new Emperor Napoleon III, and his Empress Eugénie. The Queen used to refer to this visit as "one of the most charming and triumphant of my entire life."

During World War II, the residence was spared thanks to its concierges Spurgeon and Christie. At the end of the war, Sir Alfred Duff Cooper became the first ambassador in residence. Due to him and his spouse, Lady Diana, the house enjoyed three outstanding years, during which time the gilded salons shone again with their customary brilliance.

The Duff Coopers were one of the most interesting and glamorous couples of their time. Lady Diana was the daughter of the Duke

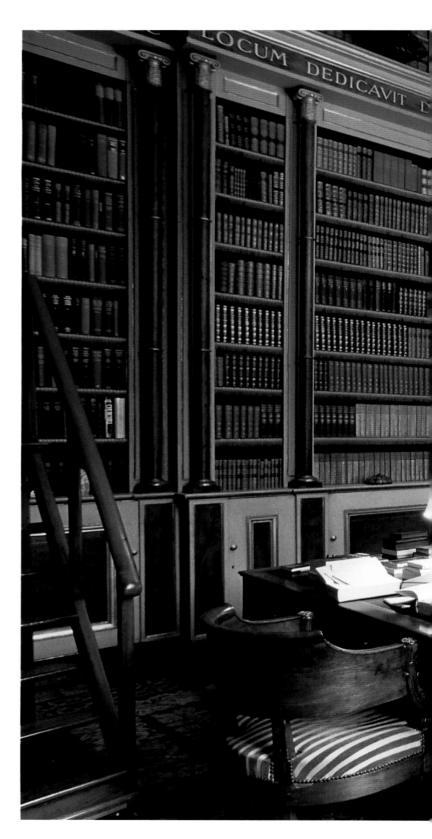

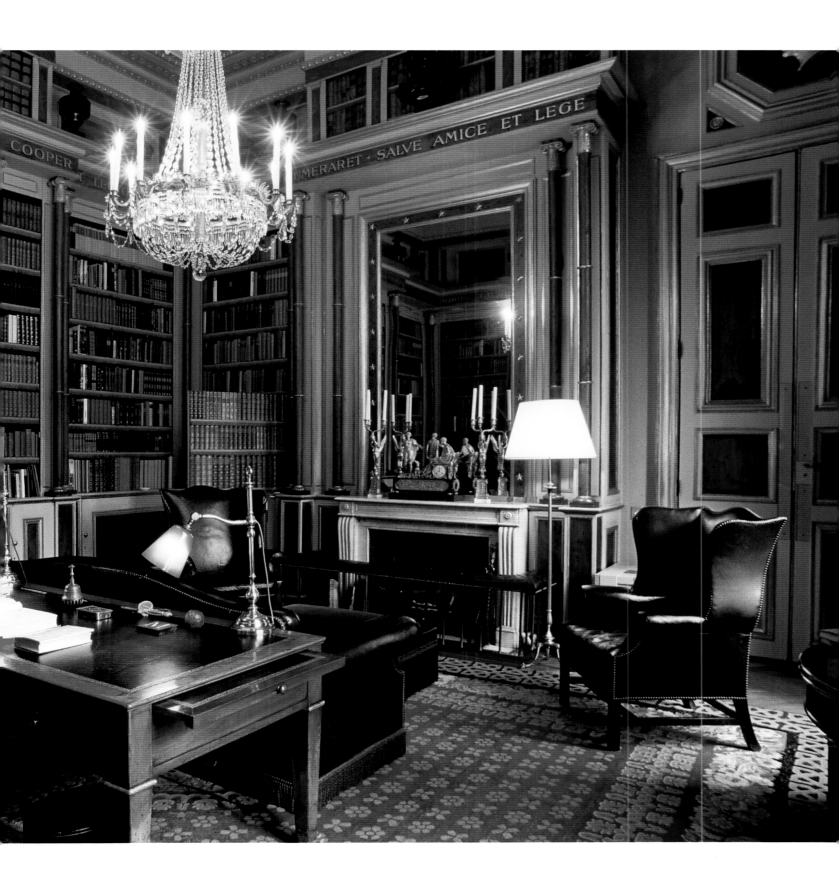

The present ambassadress, Lady Jay, is an impeccable and very popular Paris hostesses, and the British embassy epitomizes the glory and glamour of the Kingdom. (Right and opposite) Dinner will shortly be served in the Red Room. Lady Jay pays particular attention to placing her guests and to creating menus that make use of the best British foods. An army of footmen is in attendance (below) to polish silver and do whatever else is necessary to run the house.

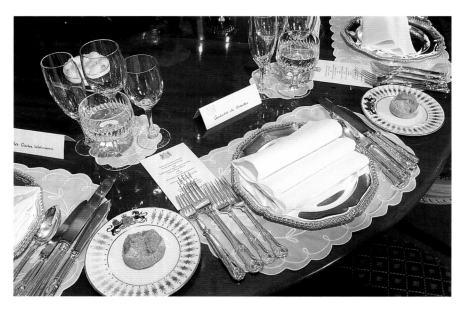

of Rutland, grew up in extreme luxury and grandeur at Belvoir Castle, and was so extraordinarily beautiful that the legendary German director Max Reinhardt chose her to be the lead in his passion play, "The Miracle," which toured throughout North America. Diana Cooper was compared to Eleanor Duse. Duff, on the other hand, was a career politician, served as First Lord of the Admiralty, then Churchill's personal representative to the Far East during World War II, and in 1943 became British Representative to the French Committee of Liberation in Algiers. This position led inevitably to his last official post as British Ambassador to France from 1944 until 1947.

Very much part of the British establishment, the Coopers were close to the royal family. Among their friends were everybody from the Churchills to Lord Beaverbrook, and from Daisy Fellowes to Noël Coward.

Diana Cooper was an original who, as ambassadress in the immediate postwar years, nonchalantly dismissed protocol while making the British embassy a center of

(Following pages) The British Embassy has a very imposing façade on the Faubourg Saint-Honoré, a short distance from the United States Embassy and the Elysée Palace, residence of the French president. All three institutions have large gardens running down to the avenue Matignon. These are fine places for entertaining large groups of people, particularly on national holidays. Tents can be set up for the annual garden party to celebrate the Queen's birthday. Tea is served on the British lawn; the neighboring Americans prefer hot dogs on their holidays, but the French always have champagne and elegant canapes. (Center) The ballroom is a perfect place for grand inside entertaining, on such occasions as visits from members of the royal family or of the British government.

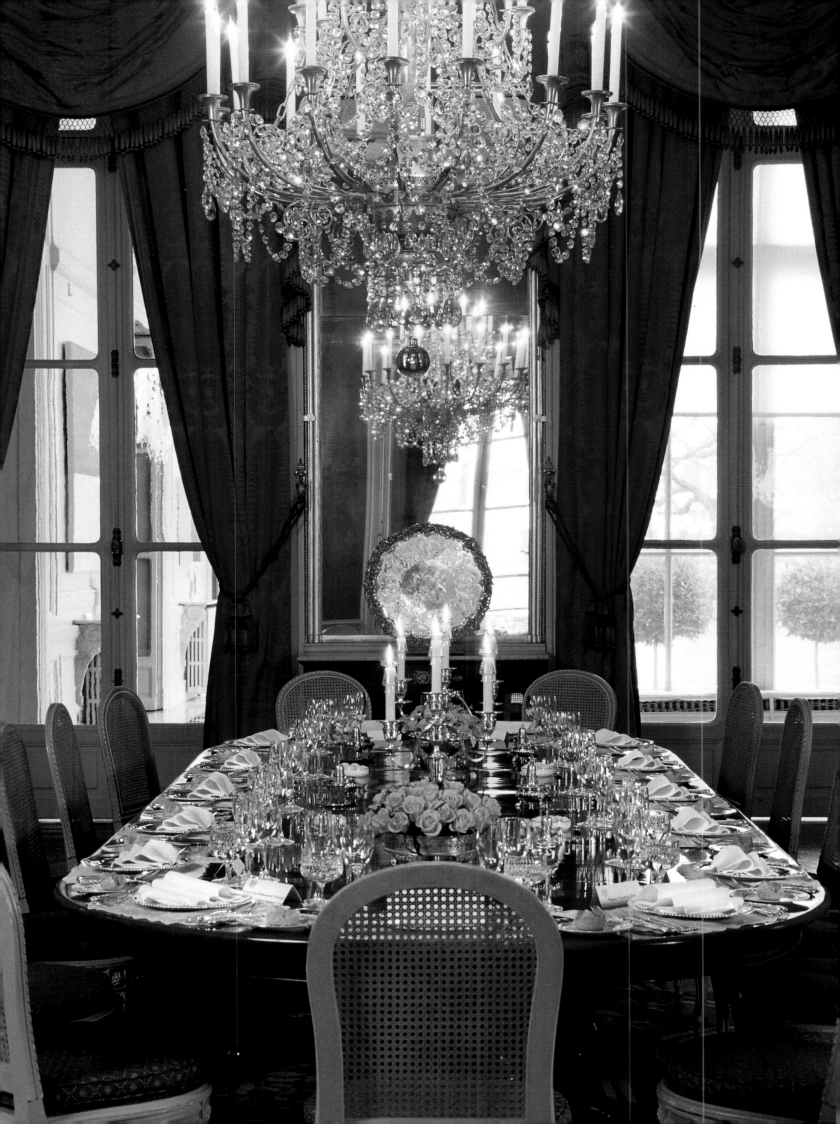

French cultural life. Here, the Prime Minister of the Labour Party, Clement Attlee, and the Foreign Minister, Earnest Bevin, were to meet the likes of Jean Cocteau, Louise de Vilmorin, and Carlos de Bestegui in confrontations that

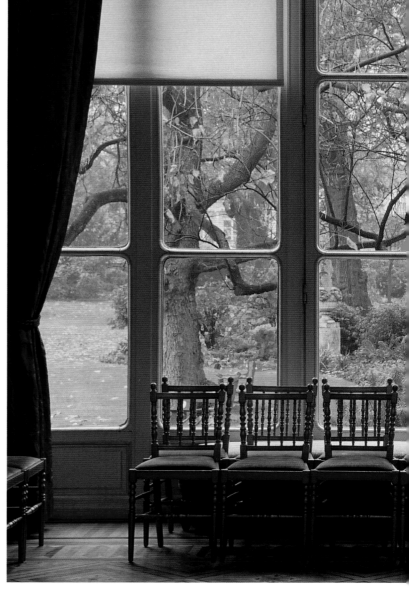

were highly successful thanks to Lady Diana's magic hand.

Also included in her "petite bande" were Edouard Bourdet, director of the Comédie Française, the painter Drian, the renowned pianist Jacques Février, and composer Georges Auric.

Linking the Duff Coopers to the French power structure were Gaston Palewski, de Gaulle's *chef de*

cabinet, and Paul Louis Weiller, the aviation magnate, whose generosity became particularly essential when the Coopers left the embassy in 1947 and set up an alternative embassy at the Château St. Firmin in Chantilly, much to the discomfort of their less glamorous successors, Sir Oliver and Lady Harvey. An admirer wrote, "When Lady Diana receives, the Green Salon shines in all its previous splendor. From six to eight, all of Paris comes through. All you have to do is turn up at the Green Salon to know everything that is going on."

Diana Cooper (left) with a friend in the 1930s. She was an extraordinary beauty, quite unconventional, a collector of tastemakers in all the arts, and somewhat of a bohemian herself, although the daughter of the land-rich Duke of Rutland. She enjoyed a short career as an actress, in Max Reinhardt's passion play The Miracle, but enjoyed a far longer career as a great hostess.

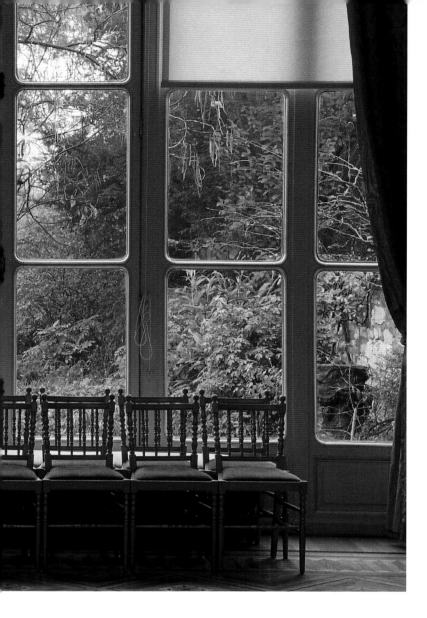

Today, the pace of diplomatic life has changed considerably. The present ambassador, the thirty-fifth representative of the United Kingdom to live in the Hôtel de Charost, is Sir Michael Jay. He and his wife Sylvia give many formal dinners and receptions, and also organize exhibitions and lectures in the house. Lady Jay pays particular attention to food. "I only serve traditional recipes," she says, "and only use British produce.

Every year, the embassy receives more that twelve thousand people and has close to a thousand house guests: ministers, state functionaries, bankers, business and travel specialists, painters and writers. Sir Michael and Lady Jay make every effort to turn this exceptional house into a very active center to best convey the traditions of their country.

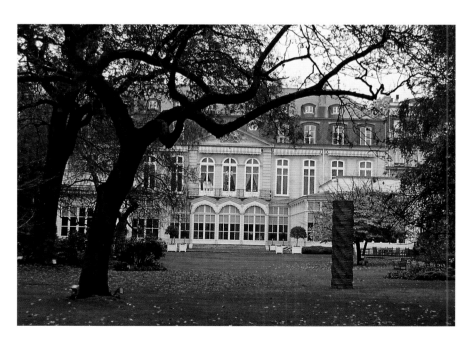

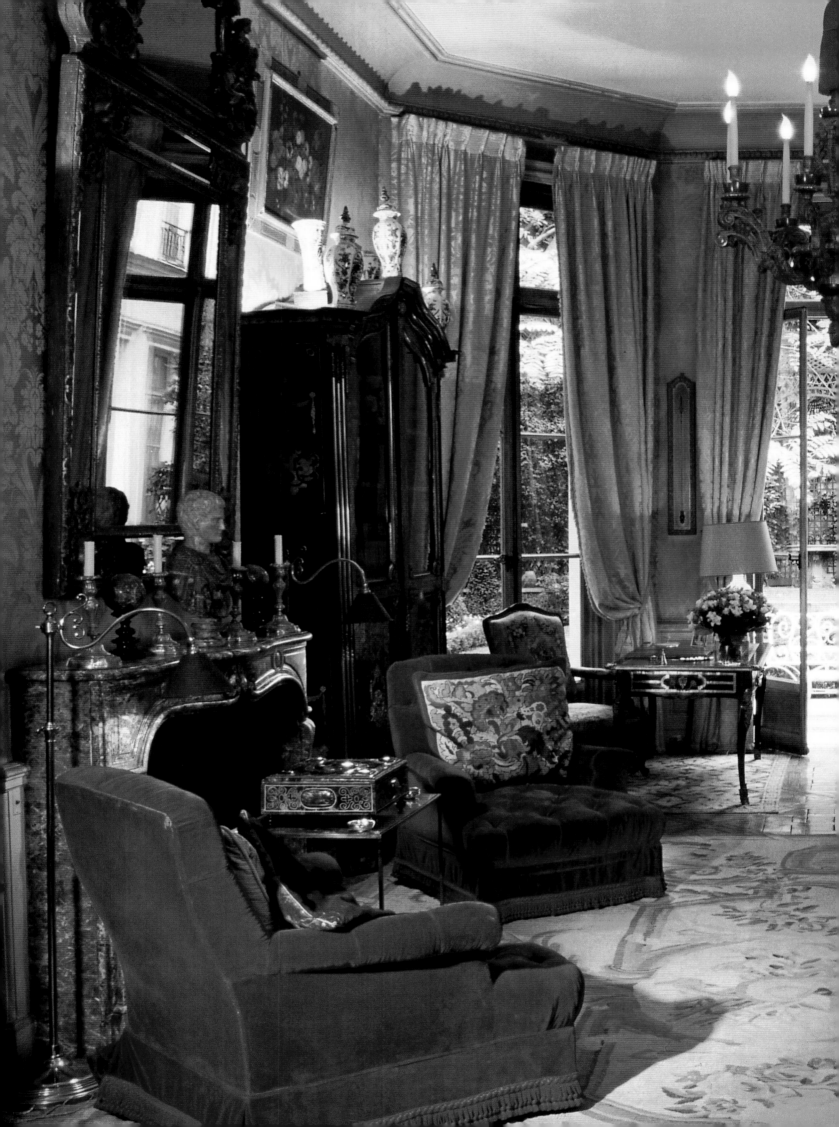

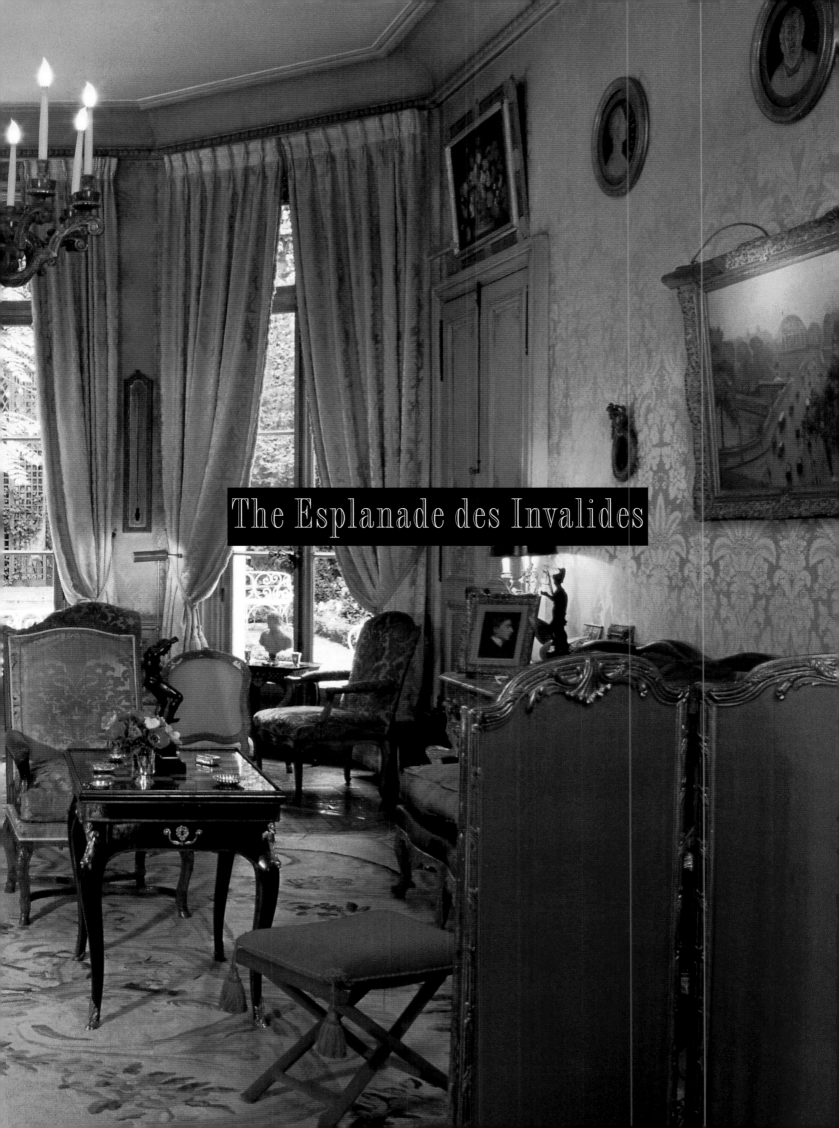

The Esplanade des Invalides

In a Family House

T his house is on the Esplanade des Invalides, with a view onto two of the most beautiful monuments in Paris, the Hôtel des Invalides (1671-76) and the Church and Dôme des Invalides (1679-1706). At one time the esplanade stretched from the Hotel des Invalides to the Seine, where one could find a ferry to cross the river to the right bank. On both sides of the esplanade were many private houses, quite often inhabited by generals of the Empire, and later by other well-known families.

From the outside, one cannot imagine what is to be discovered here; a large blue porch, a stone staircase, a charming hedge-filled garden that comes into view as we mount the stairs. This is a happy house. We all know that, in order to anchor and gather together a family, a home is the principal element. In the country, it is quite usual to come upon these family houses filled with history and memories, where several generations live together, homes which, as Saint-Exupéry wrote, "instilled in us reserves of sweetness." We go there to find our roots, to feel the march of time, not with fear but rather in serenity, following a path illuminated by the experience of those who preceded us.

It is far rarer to find such a treasure in Paris. Yet it is a family house in the very center of the city that we will now visit, a well thought out home, conceived as such and still maintained in this way today.

The ground floor was the domain of the couple's grand-parents. "My father-in-law," says our hostess, "was the person around whom everything was organized. He was a marvelous gentleman, so warm,

(Right and opposite)
Views of the elegant formal garden, with its trimmed hedges and stone fountain set against green trellis. It was in this garden that the elderly family patriarch recently passed away, with a glass of champagne in his hand. His grandchildren are seen below romping around on an autumn day.

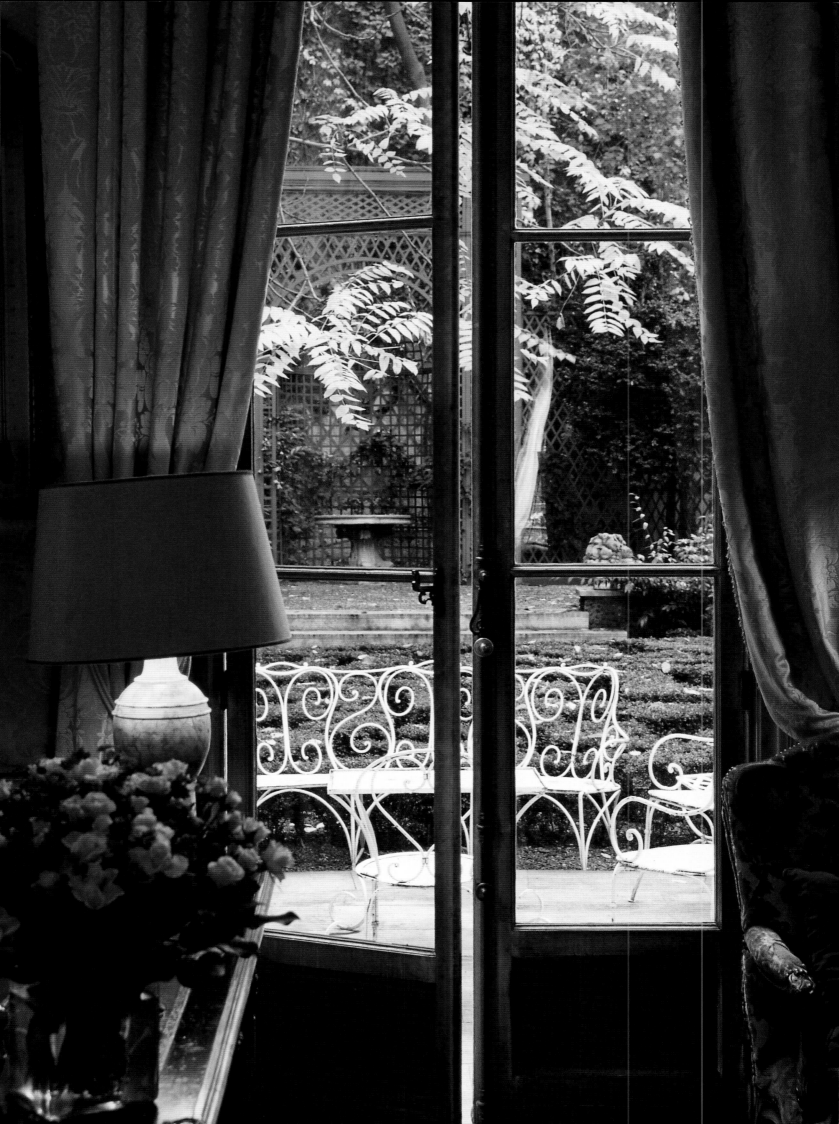

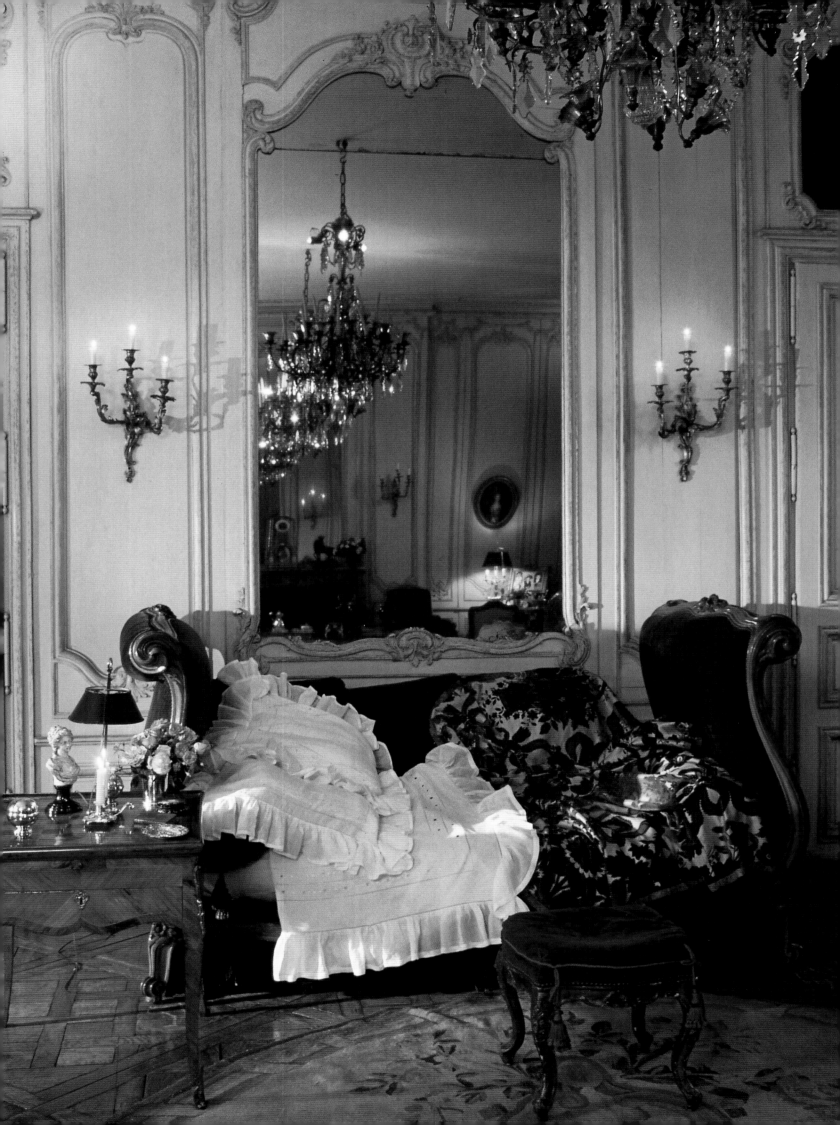

(Opposite and right)
Views of the main living room
which looks out onto the
Invalides. It is furnished in
the Louis XV style, and the
daybed is made up for the
night when there is an excess of
family visitors. The house is
filled with family mementos,
such as a photograph of the
sister and brother of the host
(left) and a portrait of a
relative in the 19th century,
placed on a Regency table
(below) next to a Renaissance
bronze. This room is on the
ground floor and the garden is
reflected in the mirror.

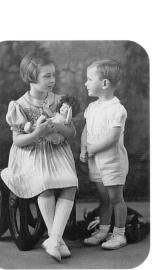

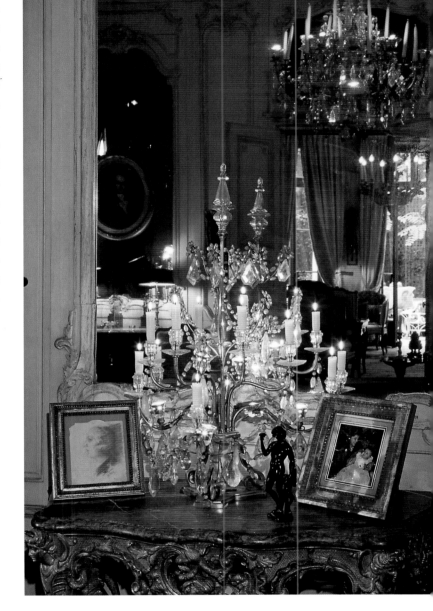

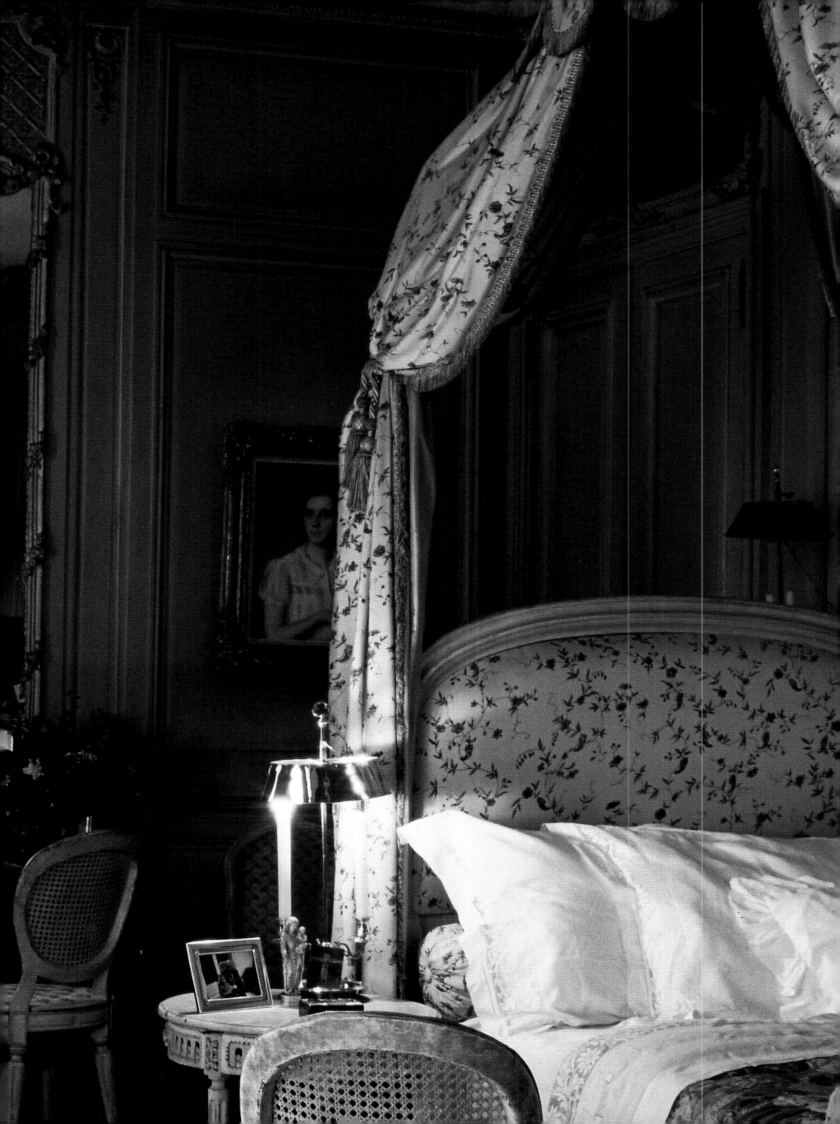

with such a deep sense of family. When I first arrived here as a young bride, I recognized in him something I had learned from my father: a passion for family life, and my husband and I continued on this path all our lives. He had a very strong personality, and his enjoyment of life was the very soul of the house. As soon as I arrived here, everything was fine. I had my own quarters on the first floor with my husband and children, and soon we took over the floor above. Each time we had a child was a happy moment for my father-in-law, and he made plans for each of them. He liked to be with

people, but he respected our independence, adapted to our way of life, trusted all of us, and gave freely of his affection. Doors were never locked. Every morning, we visited my in-laws and gave them the latest news. Until he breathed his last, my father-in-law loved making plans, foreseeing our future, and he was never bored. At the end of his life, he never complained of old age, and was delighted with the world we shared. 'I had a wonderful life,' he used to say. 'The more one takes care of others, the happier one is.'

"Today, my husband and I have open house every Wednesday for our married children and thirteen grandchildren. The invasion never stops. They are happy to get together, I think, and know that they always will be greeted here with joy and love. Everybody passes by,

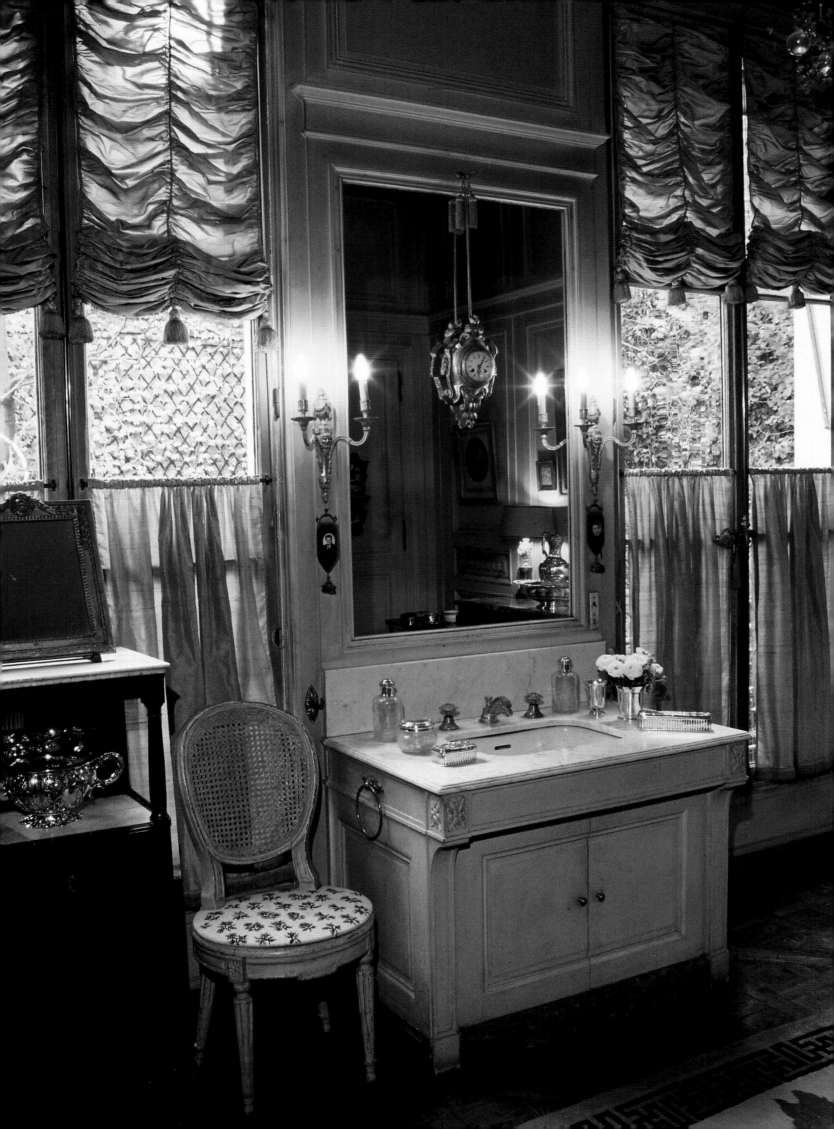

The grandmother's bathroom and drawing room, decorated in Louis XVI paneling and pale, almond-green drapes, overlooks the garden. It is quite large and filled with eighteenth century silver and bibelots. The closets are still filled with the wonderful couture clothes this lady of fashion bought at Balmain, Patou and Dior. Hat boxes from the designers are seen below, as well as an elegant lace dress put out on a Louis XV chair upholstered in the same print used for the bed. Note the fine, late eighteenth century silver pitcher and basin that embellishes the small side table.

stays, loves to come, and the house is full of life. They also visit gladly on weekends, for long talks or to tell us about their projects. As many of them have worked, or continue to work, abroad, they are glad to be able to return to a very strong family center. As long as possible, my husband and I will do everything we can to keep this house alive along these lines. Certainly you need to have a compelling desire to center your life on the family, believing it to be the most essential joy."

If, in our time, this is an exceptional situation, the torch has been passed with a sweet and calm strength, by a firm and generous hand. Whoever has had the good fortune to live here for a few days is struck by the harmony that reigns. In a big city, which encourages individuality, one would like to think that there are many such houses, where familial love is tantamount.

One of the rooms the family prefers is the downstairs library, which leads out to the garden. The walls are covered in a golden-yellow damask, and the room is lit through three large French doors. The atmosphere of this room is most agreeable—elegant, warm, and comfortable. On both sides of the marble fireplace, large Louis

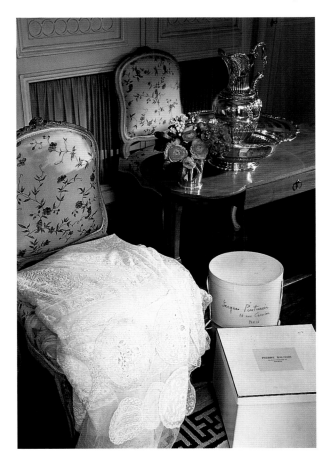

Lit by three large French windows looking over the garden, the grandparents' first floor living room was a meeting place for the entire family. This somewhat sober room is highlighted by a set of fine Regency caned furniture and a colorful 18th century Aubusson carpet.

(Below) The grandmother, with two of her children, is seen in the main living room. Behind the Louis XV canape is a fine Chinese Coromandel screen.

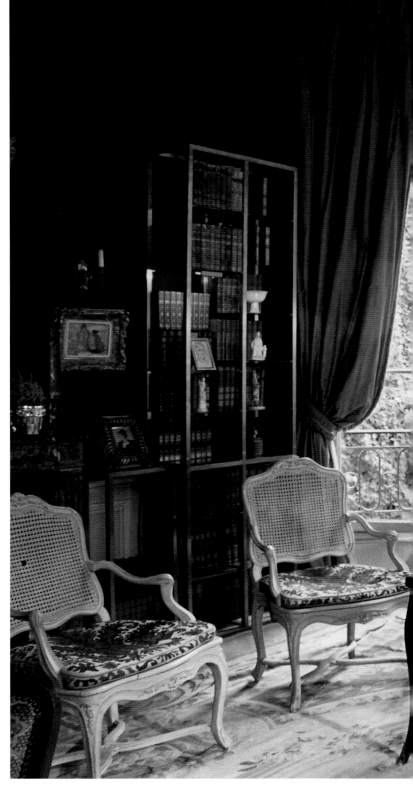

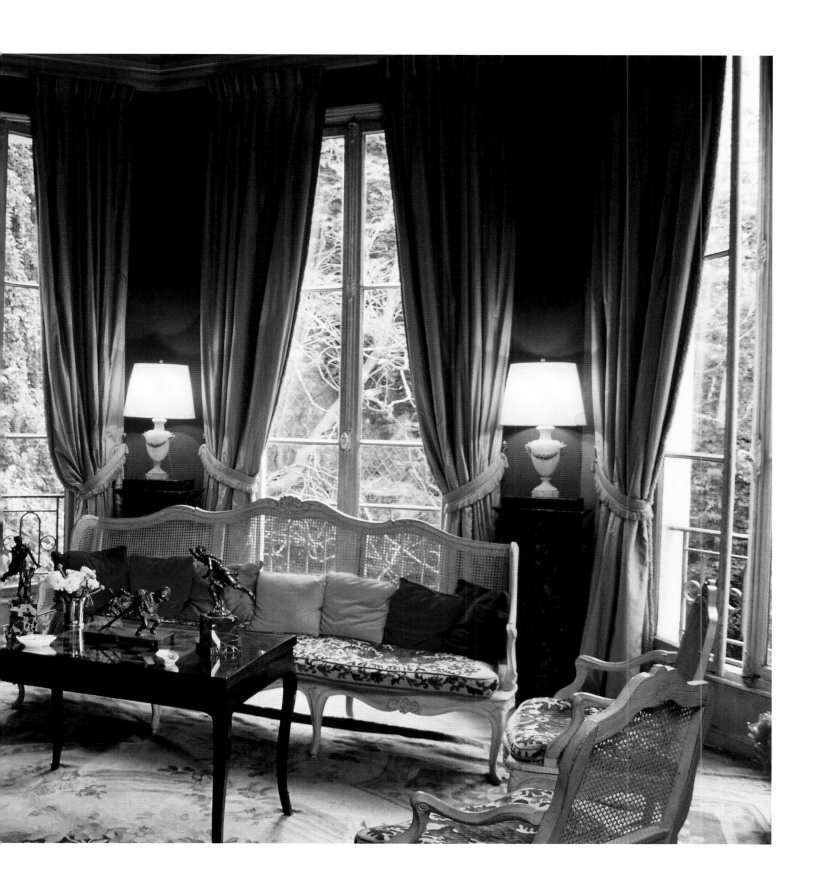

*Adjacent to the living room
seen (opposite) through a
communicating door is the
grandfather's study. This
delightful small room is
completely tented in the same
striped beige fabric as the
curtains framing the door.
The Louis XV armchairs
are upholstered in a very
masculine dark-brown
leather. On the living room
fireplace, set against a lovely
Regency mirror, is a 19th
century bust of a distinguished
family member.*

XIV Boulle cabinets hold books with magnificent old bindings, and on the facing wall there is a lovely view of Paris by Marquet, which brings in a modern and lively note. Throughout the house we will find this same contrast between a classical eighteenth century setting and art of our times, in such paintings as very pretty interiors by Lebasque.

A leather-covered Regency sofa, underneath a large painting, bears the traces of time and seems to have not only inspired long conversations but to have absorbed

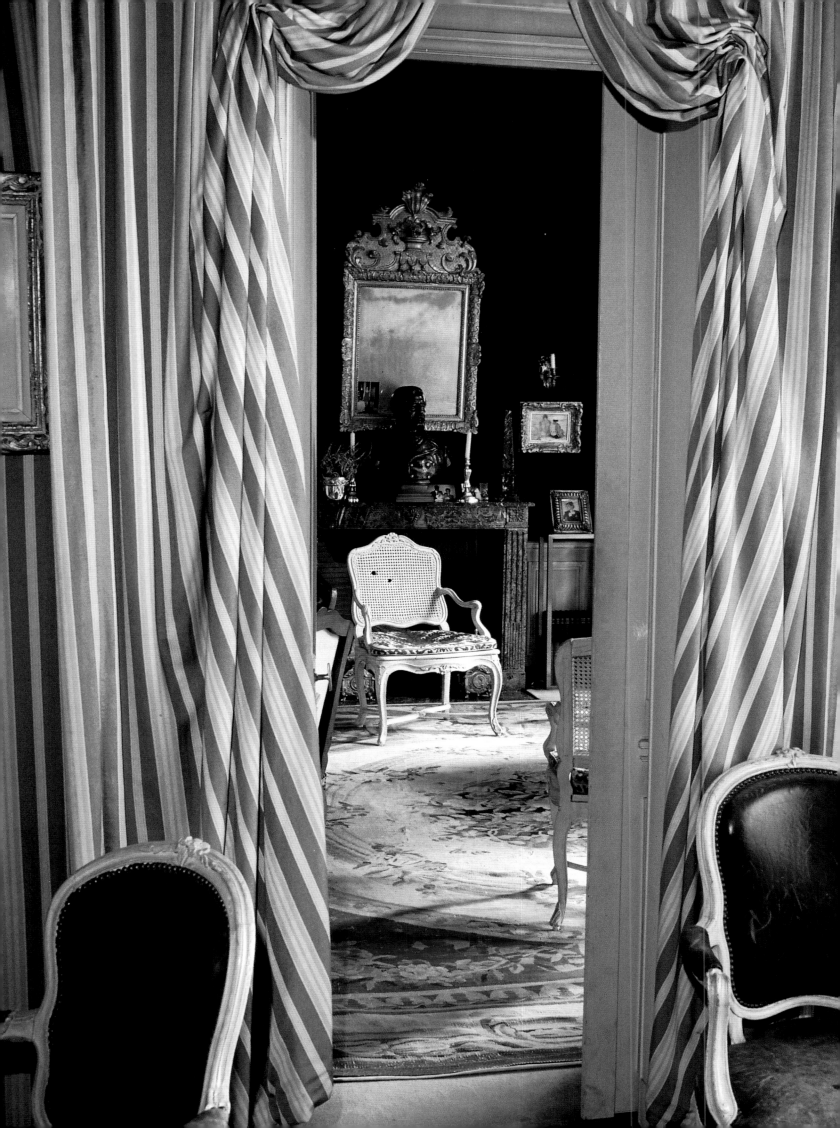

them. In the living room, with its dove-gray Louis XIV paneling, the atmosphere is clear and transparent. This side of the house looks onto the Esplanade des Invalides and its neat rows of chestnut trees. Under a mirror is a wonderful Louis XV daybed—which is sometimes made up for the night when the house is full—with embroidered linen sheets and a satin bedspread embellished with blue-green silk.

This wonderful house and its family atmosphere, is very similar to a nearby *hôtel particulier* where my father grew up. He often spoke to me about his life there in the 1920s, remembering how warmly his grandmother greeted her guests. His grandparents generally waited for him in a small salon permeated by the sweet fragrance emanating from the garden. His grandfather could usually be found reading the newspaper, his grandmother

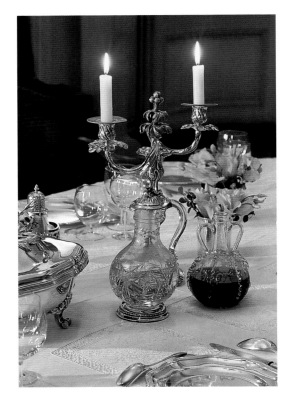

playing solitaire. On Sundays, at least twenty family members came by with their friends for a delicious lunch cooked by the housekeeper, known as Bonne Maman. The chef used fresh ingredients from the family estate, and generally prepared a luscious roasted chicken.

The dining room, shared by all three generations of the family, is on the ground floor and overlooks the Esplanade des Invalides. It is the scene of many happy family gatherings. Here, the table is set with lovely silver gilt plates, Venetian goblets, and pink roses for a family birthday dinner. Concealed in the elegant Louis XV paneling (left) is some of the crockery used for entertaining. In the soft candlelight this could be a scene from an 18th century painting.

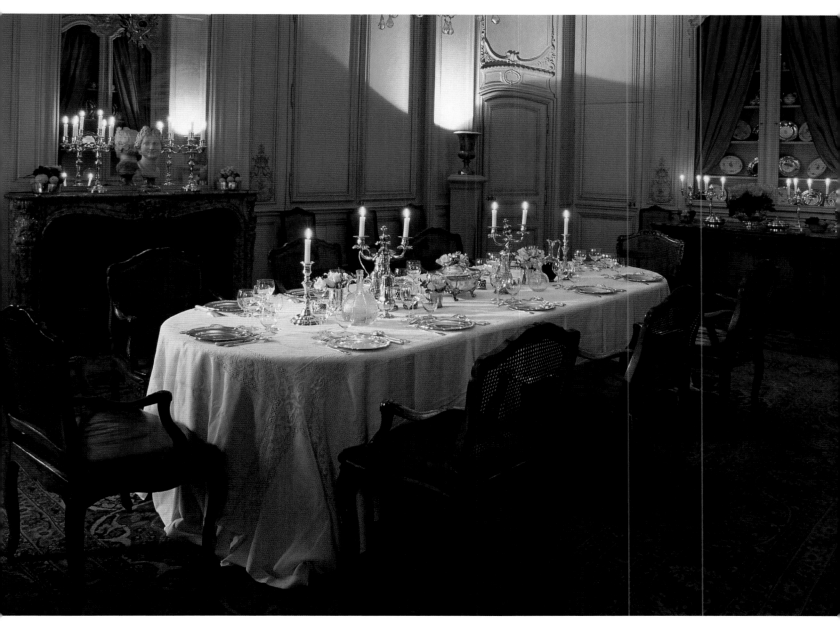

He recalled how every morning, exactly at eight, a suite of carriages from the Louvre stables would pass under the window.

Then there was the house's concierge, Etienne, who regularly gave his employer very definite opinions on the important political figures who came to visit. He would ring a bell once, twice, or three times, according to a pre-arranged code, to warn the valets who was arriving in order to prepare them to receive the guests. So clear are these descriptions that even today I can summon up the clear and limpid air of an early summer's day on Paris, a city that could and did create a life in the country for a happy few.

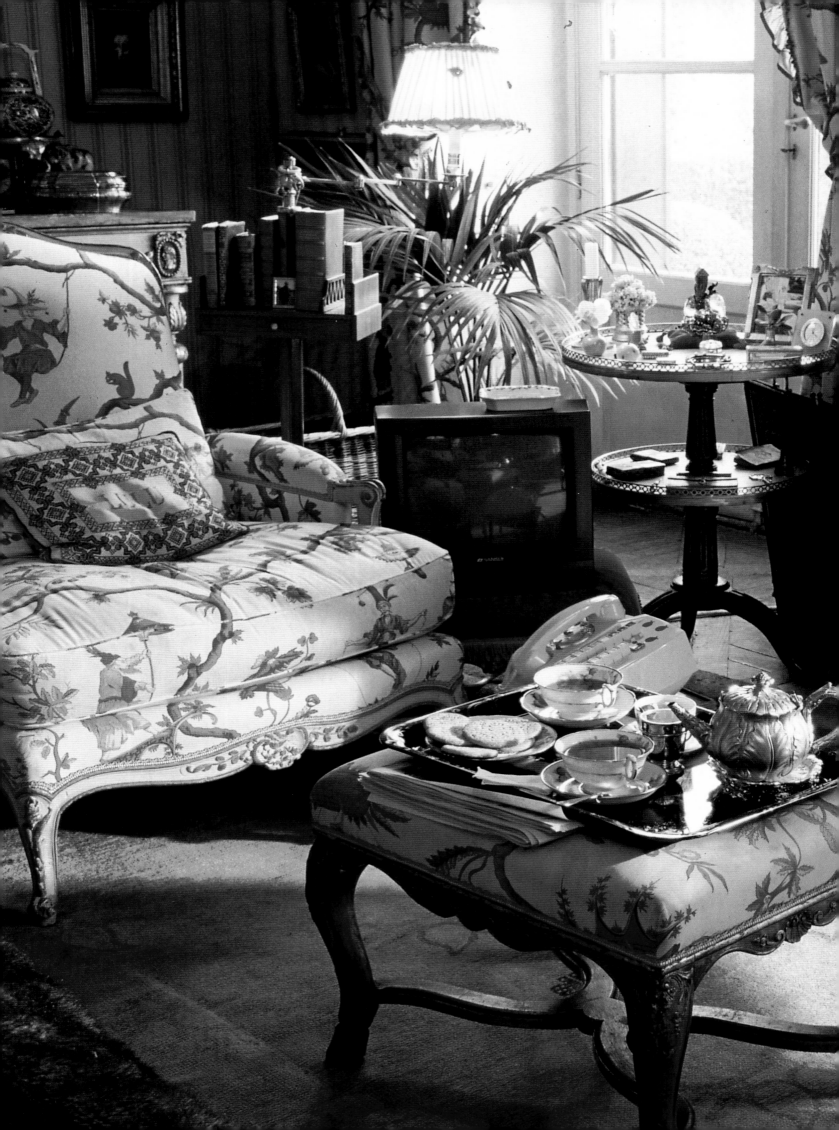

Between Courtyard and Garden

An Anglo-Indian
Enchantment

This small, lovely *hôtel particulier* has the calm of a provincial house. The long, low house is fully set within a garden: on one side is a paved courtyard with a single tree, and on the other boxwood balls, climbing roses, and camellias punctuate a long lawn terminating with an imposing topiary elephant.

The main living room is lit naturally via two French doors. Set around the Louis XV marble fireplace is a group of armchairs covered in a light-toned chinoiserie chintz and a comfortable sofa that lends itself easily to conversation. Everywhere there are bouquets of flowers, plants, and wicker baskets that bear witness to the love of the mistress of the house for the art of gardening. Further down is her bedroom, upholstered in another green-and-rose Chinoisere pattern, with a Louis XV canopied bed, and a dressing table laden with a pale tortoiseshell toilette set. On her desk is a plethora of small travel diaries of places she has visited, all beautifully bound in rose-colored leather.

The spirit, personality, and character of our hostess, the Baroness..., is felt everywhere. At tea time, she enjoys seeing her friends visiting from all over the world—travelers, diplomats, musicians. And yet the conversation often centers around Germaine de Staël, one of the most extraordinary figures of the nineteenth century, who reigned in this house, in this very salon.

Let us go back a bit in time. The first *hôtel particulier* on this site was constructed in 1660 by the architect Antoine Lepautre for the First Chamberlain of the Duc d'Orléans. Lepautre was also the architect of two wings of the Château de Saint-Cloud and the Hôtel de Beauvais in the Marais. In 1750 the house was rented by the Duc de Saint-Simon, who moved in with his daughter Charlotte, the Princesse de Chimay. Here, Saint-Simon completed his celebrated *Mémoires*, and here he died on March 10, 1755.

In 1771 the house was enlarged by Jacques Denis Antoine, a young architect who became famous when he won a competition for the building of the Hôtel des Monnaies on the quai de Conti, which became, in effect, the French Mint. After his award, this fashionable neo-classical architect built several

(Previous pages)
Afternoon tea is set out in front of the fireplace of the house's main living room, whose French doors look out onto the garden. The baroness uses this room for small lunch parties, and creates a very English atmosphere here.

(Opposite)
As soon as a visitor enters the house, it is quite clear that the baroness is a passionate gardener. Baskets and snippets of plants from the garden are everywhere. English-born, the baroness travels around the world looking for new flowers and plants, and advises many of her friends on their gardens.

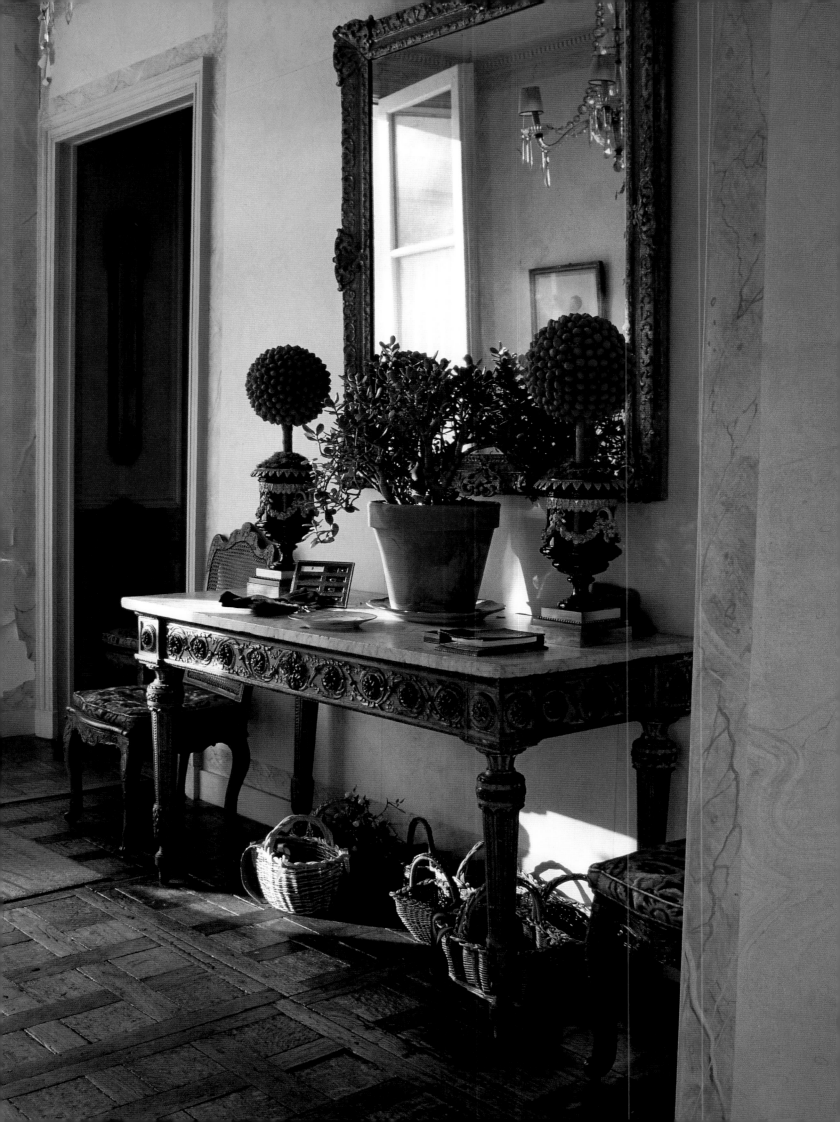

town houses on the rue de Varenne and the rue des Saints-Pères.

During the Consulate, Madame de Staël moved in and held here a renowned salon where one could find "a great many of the people the capital considers intelligent, literary, and powerful." Lucien and Joseph Bonaparte, Mathieu de Montmorency, Benjamin Constant, and Juliette Récamier (see pp. 172-85) mixed here with ambassadors and distinguished foreigners.

Germaine de Staël was the daughter of Louis XVI's finance minister. In her youth, she attended the salons of her Vaudois mother, where she met some of the great personalities of her time: d'Alembert, Diderot, Grimm, Buffon and

others. She had an independence of spirit and a thirst for freedom which never left her. Already at the age of eleven, she was writing poetry, and at twenty married Baron de Staël-Holstein, attaché of the Swiss embassy in Paris, and became an instant personality at court and in society. After the French Revolution, she showed extraordinary courage saving several friends. Benjamin Constant, the Swiss writer and political theorist, became her lover and in 1795 she was sent into political exile in Coppet. Her residence there became a political and literary Mecca, and she became known as "the political conscience of Europe."

In 1797, she returned to Paris, and during the Consulate and First Empire she suffered both persecution and exile. Napoleon tried in vain to get rid of this rebellious and dangerous spirit. "Let her go wherever she wants", he said "but far from Paris so that I no longer hear about her". She traveled

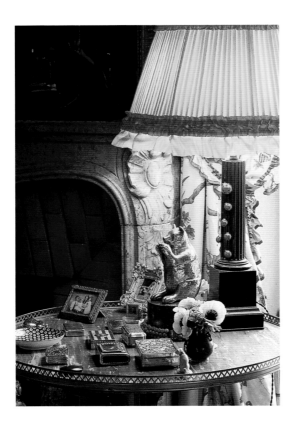

Views of the main living room once again show the owner's love of flowers; miniature bouquets abound as do lovely old paintings of flowers. Miniature models of period furniture add an amusing touch. The table behind the pillow-filled chintz sofa would be more in place in a cozy London flat than in a far more formal Paris "hôtel particulier." The owner's dog, Ben, has gone around the world several times with her and is very much a fixture of the house. The baroness greatly enjoys receiving friends from all over the world.

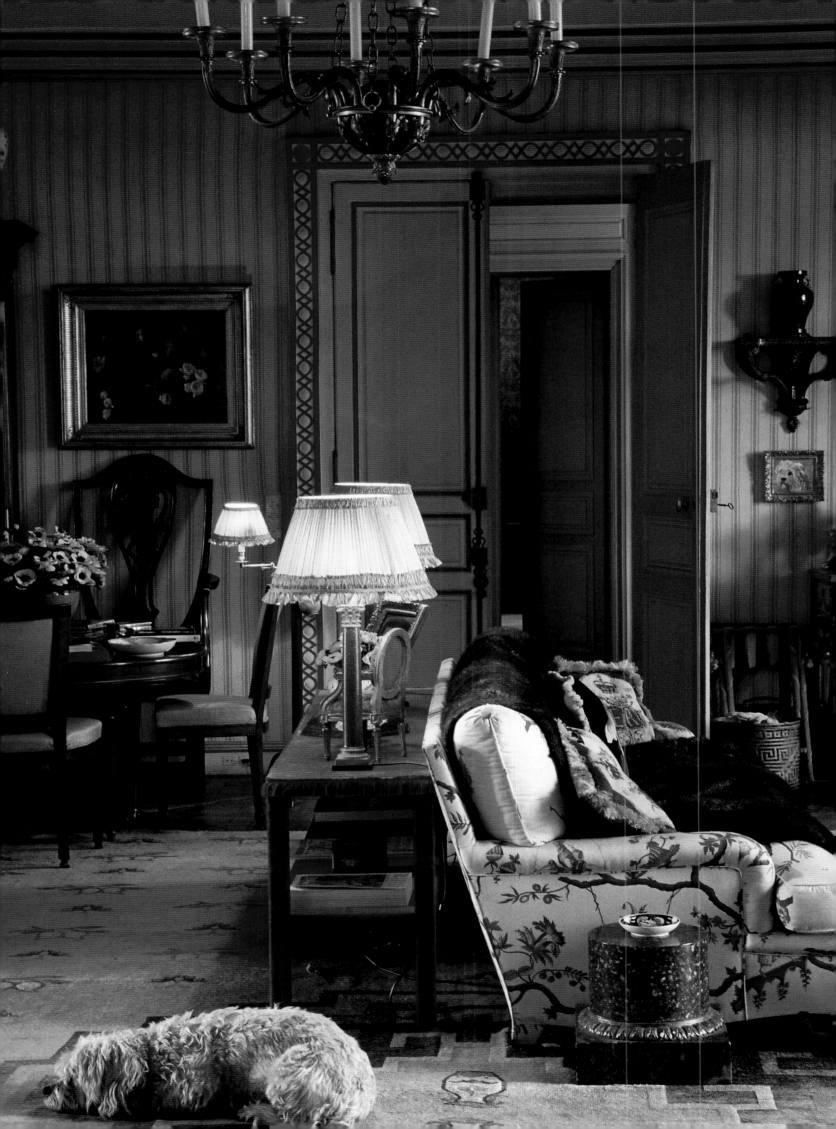

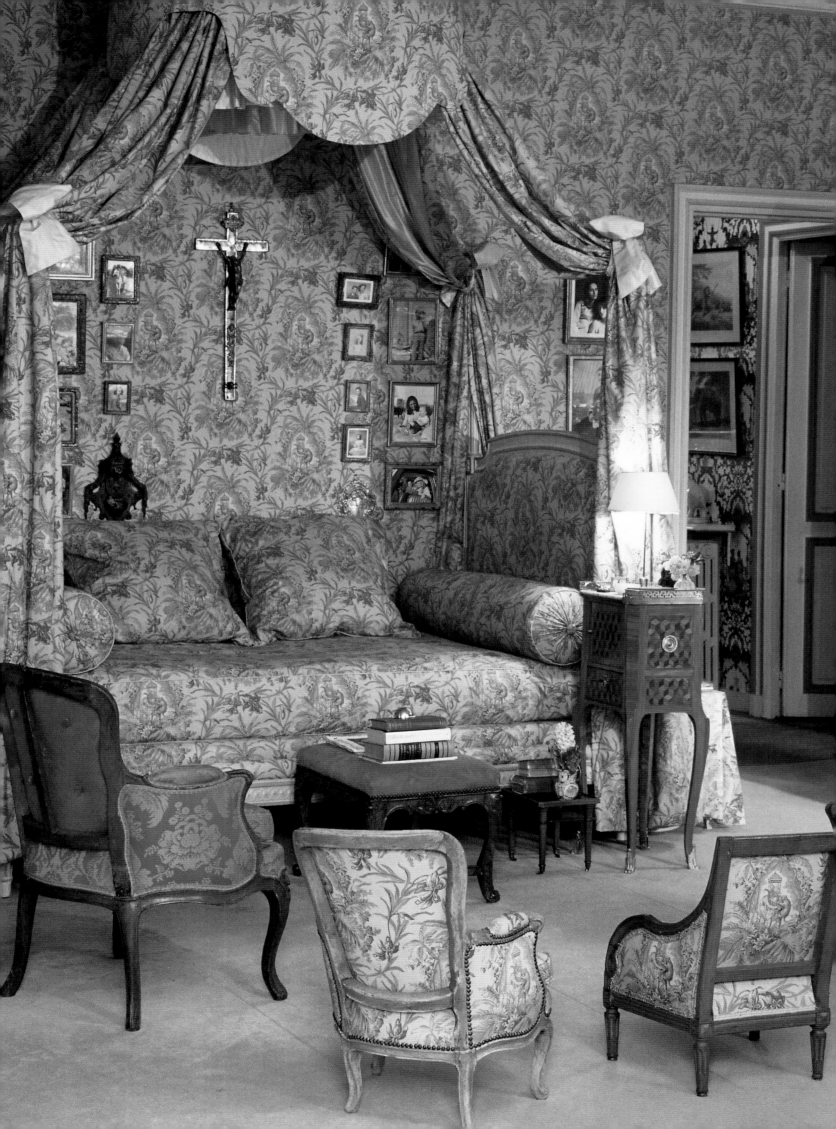

through Germany and Italy, returned to France and was chased out once again by the Imperial police. There were ten years of exile in Poland, Russia, Sweden, and England which she wrote about in detail. She hated her exile, but in 1810, at the age of forty-four, she met John Rocca, a young twenty-three-year-old officer who was dazzled by her genius and her misfortune. She had a son by him in 1812, and married secretly in 1816. After Napoleon fell, Madame de Staël returned to Paris; by now, she was famous all over Europe. She and Chateaubriand opened the way to modern times, and made a strong imprint on Romanticism. She died in 1817, aged fifty-one.

Today, the house is inhabited by someone her equal in charm and spirit. The lady who succeeded Madame de Staël in this house is also passionate about what she

does, but her work and passions incite neither fury nor jealousy. The Baroness has always been interested in botany and created in the south of France a splendid garden populated by rare plants. In this field, many seek her advice and ask if they may share in her discoveries. Each year, she generously receives specialists and gardening enthusiasts from England, the United States, and Italy—not to mention France—who want to hear how she created her garden.

In Paris, she likes to receive her friends in a very English atmosphere. The large chintz sofa, and the sofa table behind it, are straight out of an Eaton Square drawing room. Her house is filled with little curiosities. She adores India, which explains the elephant in the garden. She loves squirrels, which seem to be climbing everywhere— on the foot of a bronze lamp, on

(Right) Travel notes, bound in rose leather, are placed on the desk in the bedroom. The baroness is a great traveler to exotic places and has a particular passion for India which she visited with her parents and where she spent her honeymoon. She is of Anglo-Indian origin, and her family were among the most distinguished bankers of the Subcontinent before settling in Europe. Her trips are always long, studious and well prepared; in addition to visiting monuments and museums, she studies the local flora and brings back specimens for her garden.

(Previous pages) The bedroom walls and bed are upholstered in a lovely Chinoiserie chintz, and miniature chairs lend an entertaining note. Family pictures are hung on the walls, particularly on both sides of the cross over the bed. Our hostess is a close friend of the English royal family, and is often their guest at Windsor Castle. The embroidered pillow, with the Queen's initials, was a gift to mark a quarter century of Her Majesty's reign.

(Opposite) On the fireplace is a photograph of the baroness' husband, an elegant and much beloved figure in French society. He is seen at the races in a bowler hat. Shortly after their marriage, his mothe made copious notes (left) on French etiquette: how to politely accept or refuse an invitation, how to correctly phrase a letter of condolence, seat a dinner according to protocol, how to politely regret an invitation from somebody you don't know, and so forth. The handwriting seems as forceful as the instructions.

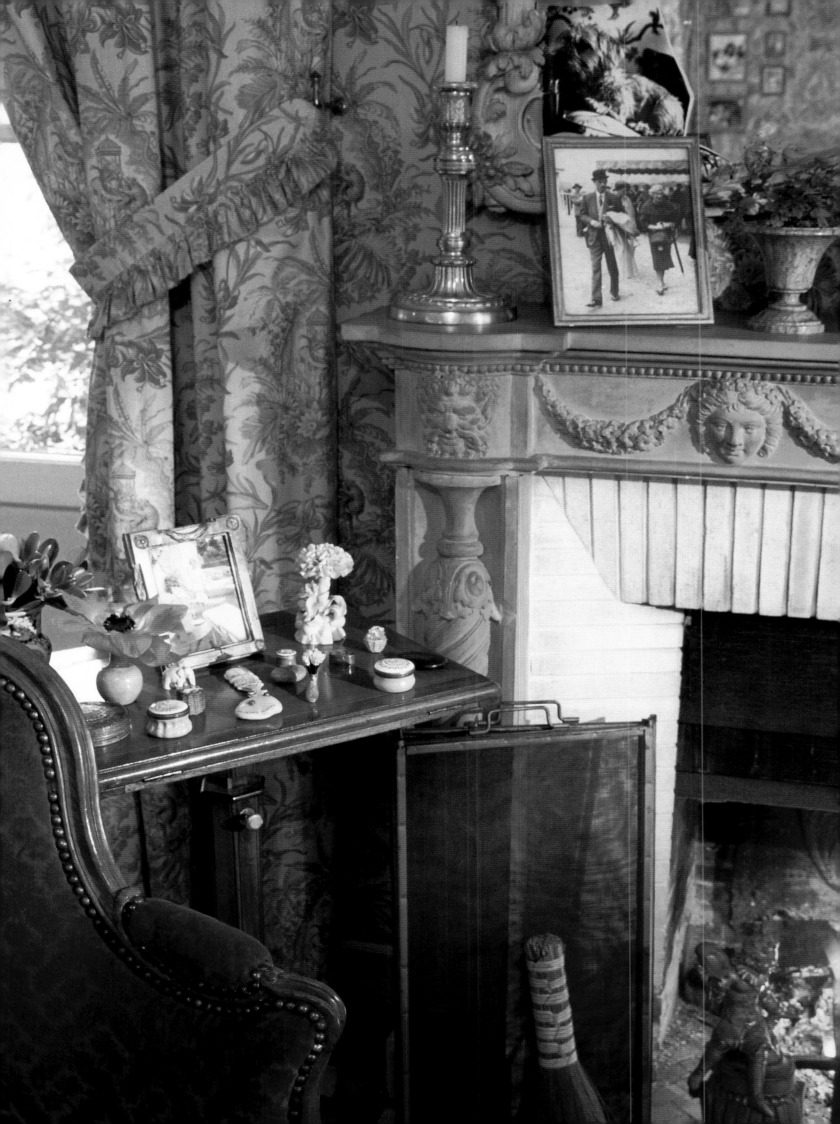

her ring, attached to magnificent necklaces, and even painted onto the face of her watch. Yet more are tooled onto the leather bindings of her charming, small diaries, in which she keeps her impressions of exotic travels.

Other animals are seen, along with Chinamen, printed onto the chintz used in the main living room. Tiny bouquets of flowers are disseminated around the house. In short, this is a world of fantasy, in

total contrast to the cold discipline one can sense upon a small piece of paper left for her, many years ago, by her mother-in-law, and still piously preserved in a drawer. Dating to the turn of the century, it concerns etiquette and sets out in a firm hand models for social correspondence. For instance, how to refuse an invitation from a person of the same age, older, or of official rank, how to regret an invitation to visit between 5 and 7 o'clock , expressions of sadness at a death, expressions of joy for a wedding or engagement. It was impossible to misbehave with instructions from such an organized mother-in-law.

But the baroness, like her predecessor in this house, is a free spirit. She isn't afraid to affirm her independence of spirit, courage, tenacity, humor, and creativity—which were also the dominating character traits of Madame de Staël.

The baroness has made several gardens, all of which were much admired. The first was in a country house outside Paris, and when that was sold she tackled a very arid terrain at her house in the south of France, totally redid everything, and created a setting of great beauty thanks to determination and knowledge. There is now a collection of roses, irises and rare plants from all over the world, surrounded by olive trees, and her creation is a mecca for garden enthusiasts. Each year she visits private and public gardens in England and Scotland, goes to the Chelsea Flower Show to find new species, and is very generous in dispensing advice to her friends. In Paris, the garden is very simple, really a lovely, green carpet leading down to a topiary elephant, with bamboo on all sides and highlighted by camellias, roses and boxwood. The elephant, of course, is another reminder of her Anglo-Indian origins.

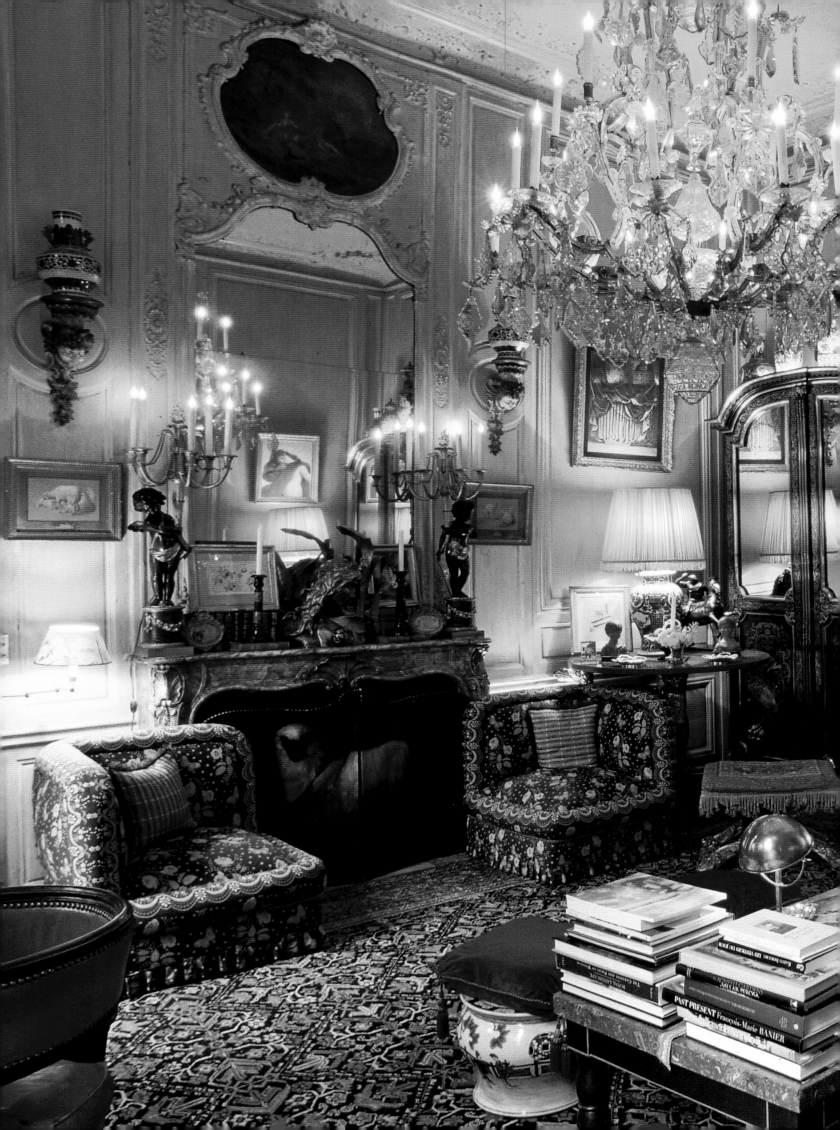

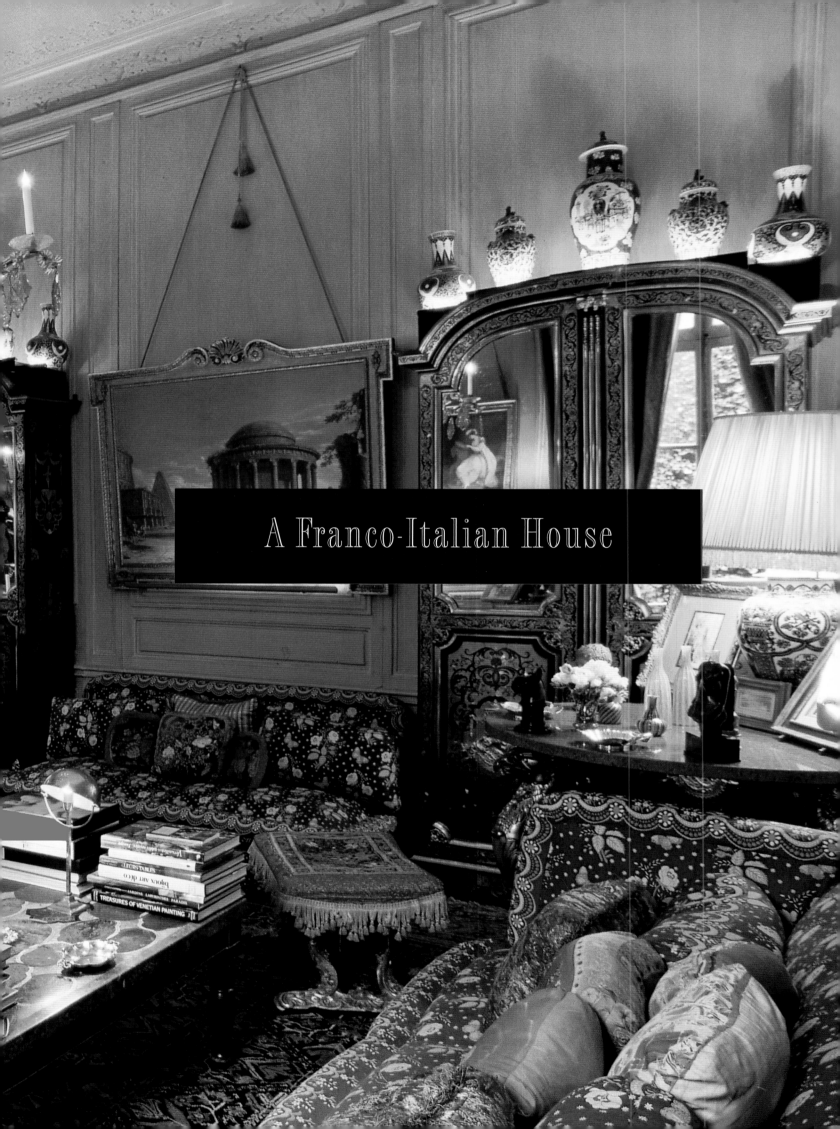

A Franco-Italian House

With Venetians in Paris

If a single word is used to describe this two-story flat on the Rue du Cherche Midi, it would be "daring": a daring mix of styles and objects such as eighteenth-century Spanish mirrors, a black bed that once belonged to Christian Dior, a portrait of the Duchesse de Berry, Louis XIV Boulle armoires, light velvets and silks—essentially, an intriguing mix of French and Italian styles. Undoubtedly, the owner, an Italian aristocrat, knew how to make the house a reflection of her strong personality. She had it decorated in the same way she dresses—in bright colors, and with charm and audacity.

The marriage of styles here is more specific than that of Italy and France; it is the refinement of Venice and Paris, the luminescent fantasy of the former and the rigorous elegance of the latter.

The two houses of our hosts, one on Venice's Grand Canal and the other off a grand French boulevard, have a great deal in common. Our host, the prince, is a Venetian aristocrat; tall, graying, distinguished, a brilliant conversationalist, he operates a large farm in the Veneto, which produces a highly reputed wine. When not in or near Venice, he is inevitably to be found in an opera house or at a music festival. The princess, meanwhile, plays a major role in restoring works of art in Venice, watches over several bright, attractive, and successful offspring—two of whom live in Paris—and has sparkling eyes and a wit that puts at ease anybody fortunate enough to be near her. Her houses reflect her personality, her hospitality is easy and relaxed, and Parisians feel that much happier the moment they cross her threshold.

Considering the Franco-Venetian link, it is not surprising that our hosts sought out an apartment in Paris for those times of year when the fog and cold envelope Venice like a giant spider web, putting it to sleep until the Spring sun awakens the dreamy city. Their friend André Oliver, the late fashion designer, had an apartment in the left bank building where

(Previous pages) The upstairs bedroom perfectly reflects the Franco-Italian decoration of this left bank apartment.

(Opposite) One of the two large reception rooms on the first floor, that the owners refer to as the "piano nobile," is lit by a bronze Venetian chandelier, possibly made for the "bucentoro", or ship of state, of a Venetian doge.

(Below) The garden courtyard is a total surprise, lushly planted with bamboo, ferns, trimmed boxwood, and a large camellia, all watched over by a stone sphinx; it all prepares a visitor for the Italianate atmosphere of the house.

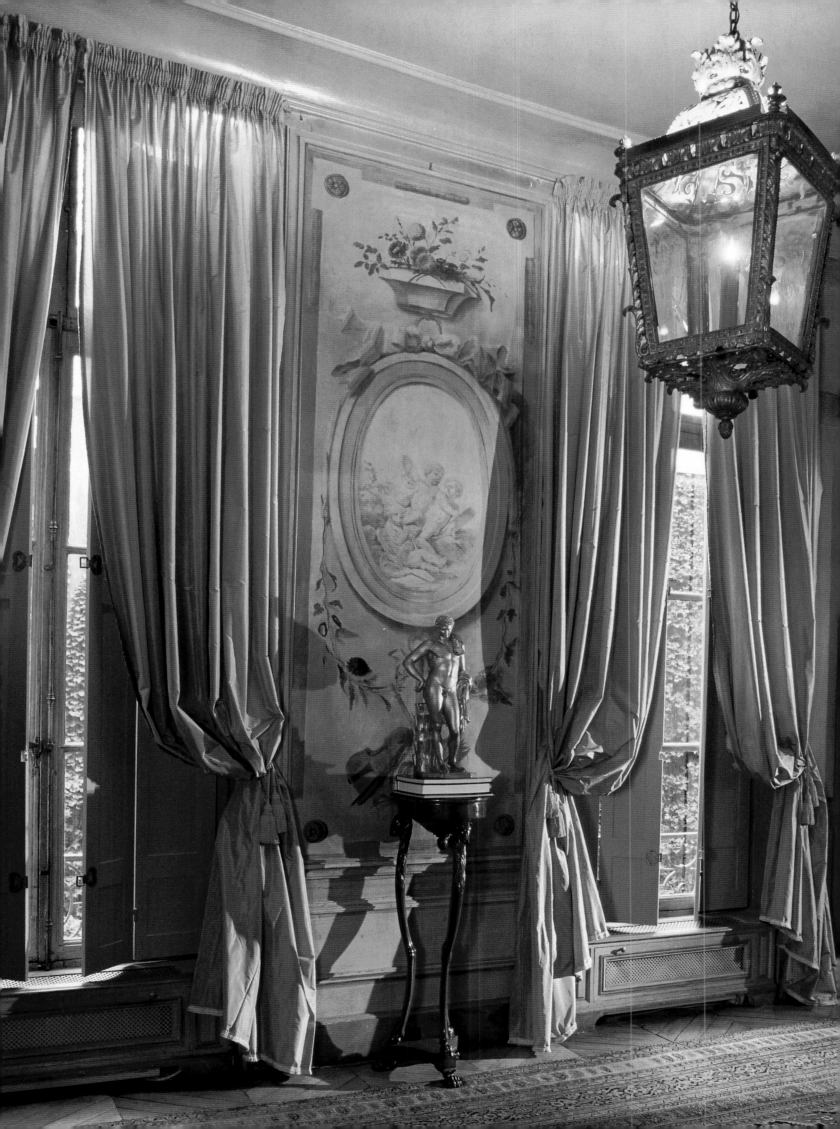

they now live. Andy Warhol had an apartment-studio overlooking the courtyard garden; Violet Trefusis also lived there. The best fashion boutiques and antiques stores are a skip away, and one day an apartment came up for sale whose two floors could easily be divided into "his" on the ground floor and "hers" on the *étage noble*, both connected by a staircase that was soon to resemble one in their Venetian palace, albeit on a far smaller scale. And this was to be watched over by two eighteenth century, life-size portraits of Venetian gondoliers. The apartment, like many in the Faubourg Saint-Germain, had been in the possession of one family for many years, and it needed a great deal of work before they could move in.

The princess immediately called on her good friend Renzo Mongiardino, and they went to work. Mongiardino, referred to by other members of the family as "il Mago," or the magician, was the most

sought after decorator in the world until his death. He started his career as a set designer at La Scala in Milan, working closely with the renowned film director Luchino Visconti. His scholarly grasp of period styles and sense of theater allowed him to bring a feeling of history as well as excitement to any room he touched. It is no wonder that he soon became the decorator of the most demanding people in the world, including clients such as Stavros Niarchos, Marella Agnelli, Heinrich Thyssen Bornemisza, and Drue Heinz. And it was Mongiardino who was chosen by Marie-Hélène de Rothschild to redecorate the Hôtel Lambert (see pps. 8-41), probably his greatest creation.

Our hosts' apartment was a close collaboration between client

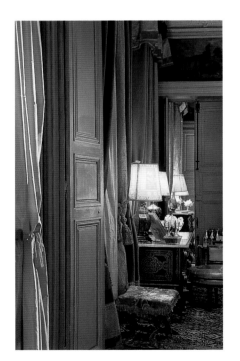

The first-floor rooms are grand and quite formal, in keeping with their original eighteenth-century wood paneling. Here, Renzo Mongiardino kept to the original style by using elaborately elegant French silks and damasks and the especially made passementerie, which France exports around the world. In Lyons, Mongiardino was able to order copies of eighteenth-century fabrics to use in the heavy drapes (opposite); but he also incorporated precious antique textiles, such as the velvet embroidered in silver and gold (left) that covers a footstool.

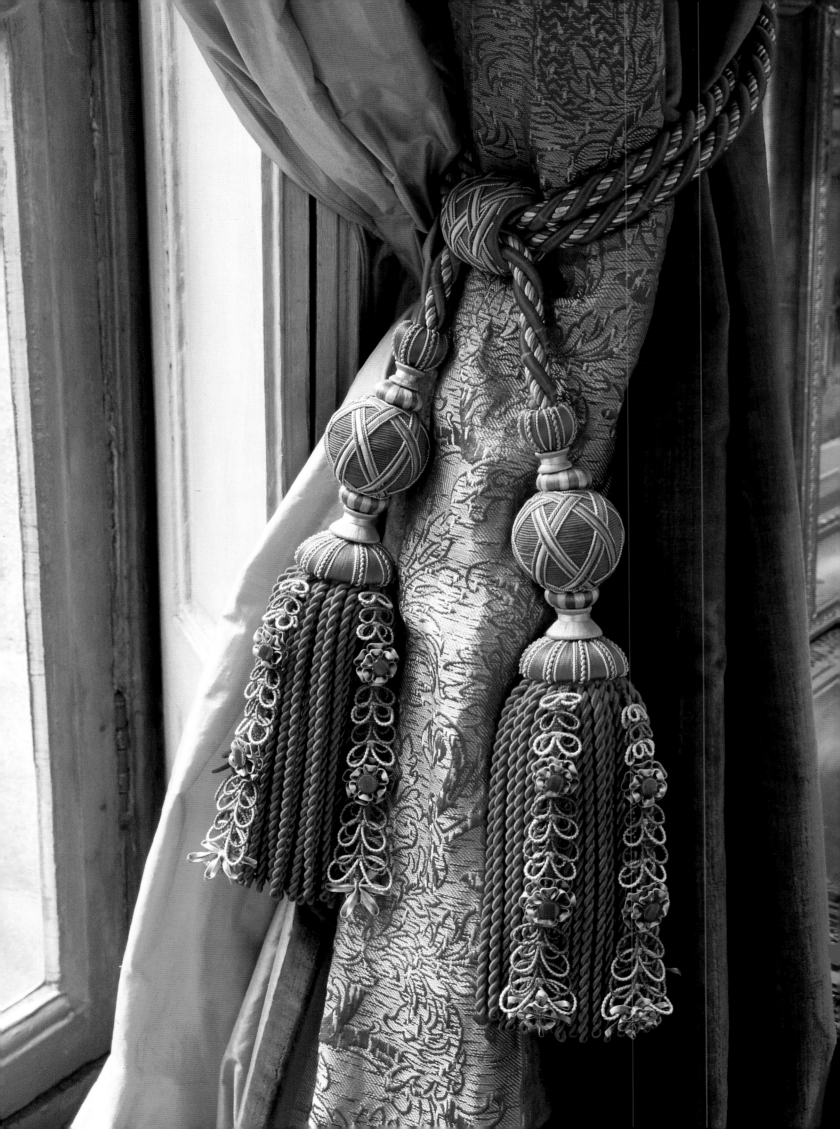

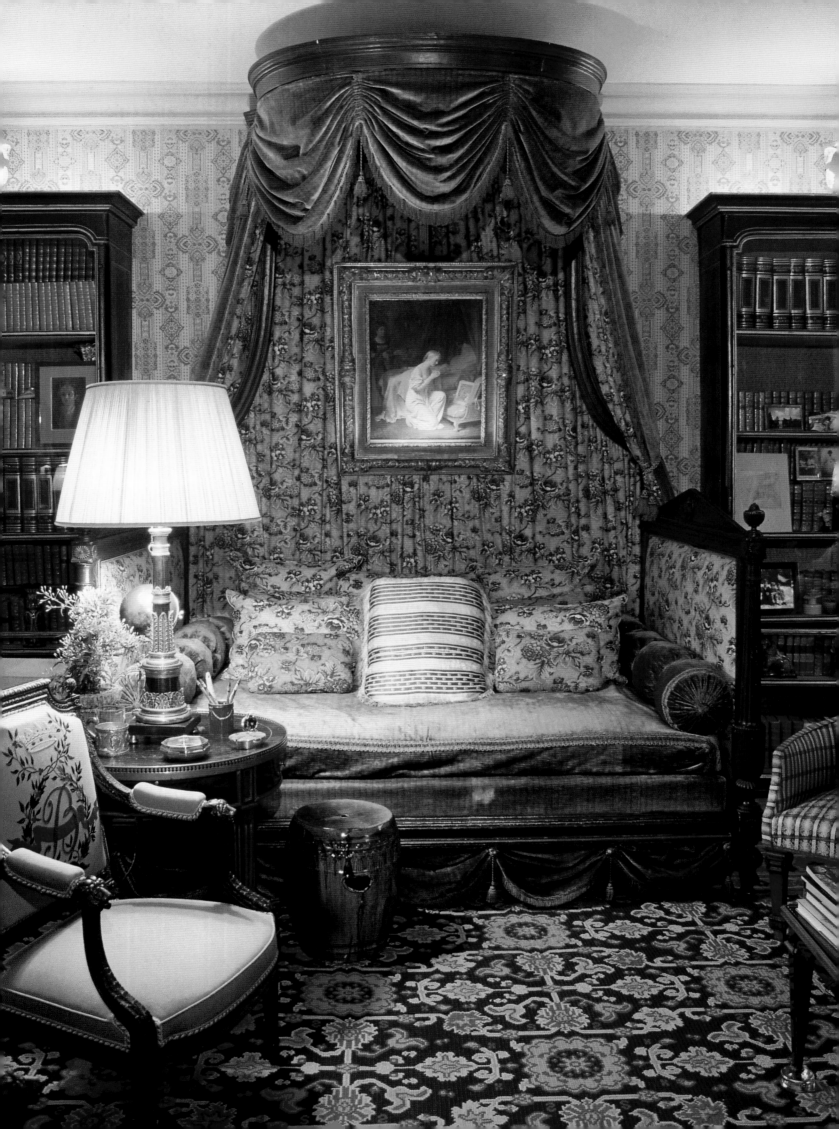

and decorator, and is very much in the taste and image of the princess. Like the best of Renzo's work, it doesn't cry out Mongiardino, yet still it reflects his personality and flair.

The apartment's character is established by the garden, encountered immediately after entering through the large wooden door on the street. Limited in size, filled with sun-loving bamboo and a large camellia tree, enclosed by an ivy-covered wall, and carpeted in grass and gray gravel, this secret place is guarded by an eighteenth-century stone sphinx with the

enchanting features of a courtesan. This is definitely not a French *entre cour et jardin*, but rather what one would except to find hidden behind the façade of an Italian Renaissance house. When developing the Paris garden, one suspects that the hostess was summoning up her own garden in the palace on the Grand Canal. And, when entering the house, you realize that she and Renzo were bringing to Paris the elegant coziness of the northern Italian country houses she knew so well in her childhood.

The narrow hallway leads to a small, rustic dining room with wrought-iron chairs and pale-green felt walls, onto which are sewn cut-out patterns of paisley shawls (paisley is a Mongiardino signature). From the dining room one enters the prince's large bedroom, which is also very much a place for entertaining (one suspects that hidden away somewhere is a small room in which he sleeps!). Two large Regency black lacquer book cabinets frame a Directoire daybed surmounted by a canopy from which hangs a yellow and blue chintz that is a perfect contrast to the printed cotton fabric upholstering the walls. Directly above the bed is a lovely painting by Marguerite Gérard of a young girl saying her prayers before going to bed. A top-quality sound system, lots of opera CDs, opera set drawings by George Wakhevitch and Eugene Berman, and a view of

(Opposite) The primary room downstairs is the prince's bedchamber, which also serves as a cozy living room. Above the canopied bed is a lovely and appropriate representation, by Marguerite Gérard, of a lady saying her evening prayers. On an adjacent wall, (below) is a wonderful portrait of Marie-Caroline, the Duchesse de Berry, by Madame Vigée-Lebrun. This was painted before her marriage to Count Lucchesi-Palli, an ancestor of the owner of this delightful apartment. Our host's crown and initial are embroidered onto the armchair, a gift of the English decorator John Stefanides, a close friend and habitual house guest in Venice.

Venice by Ziem all clearly mark this out as the host's territory, but his wife makes use of it for gathering smaller groups before or after cozy lunch parties. On another wall is the portrait by Madame Vigée-Lebrun of the Duchesse de Berry, from whom the prince is directly descended. In this portrait, executed in 1816, Marie-Caroline, the only daughter of King Francis I of Naples, is shown at age seventeen, when she had just arrived in France to wed the Duc de Berry, second son of King Charles X of France.

The rooms are far more imposing on the first floor. The antechamber is covered by almond-green wood paneling, into which eighteenth century painted panels of putti are placed in oval frames crowned by rose-colored ribbons. Green silk curtains frame the windows opening onto the garden below. In the adjacent large salon, an imposing Piedmont rock-crystal chandelier sets all the room's colors into relief, including those of two views of Italy by Ghisolfi, the blue of the Chinese porcelain garniture ornamenting the magnificent Boulle cabinets, and the butterfly-motif material that covers the two benches. In addition, there is the silver and gold of the antique textiles covering the gilded footstools, and the crushed velvet of the curtains with large gold and red silk borders.

In the adjacent Louis XV salon, yet more colors greet us: straw yellow in the paneling, gold damask highlighted in iris on the Ottoman bed, blue and rose passementerie, while above the bed glitters the rock crystal of a superb Spanish Renaissance mirror. These are rooms within which to entertain in the grand, traditional style, and Mongiardino was, as always, up to the task.

The gold damask curtains of the princess' bedroom rise toward an elaborately stuccoed ceiling. (Opposite) The room is dominated by an elaborate rock-crystal chandelier from Turin and a Renaissance mirror from Salamanca. Screens covered with drawings soften the two corners of the room and nestle against the daybed.

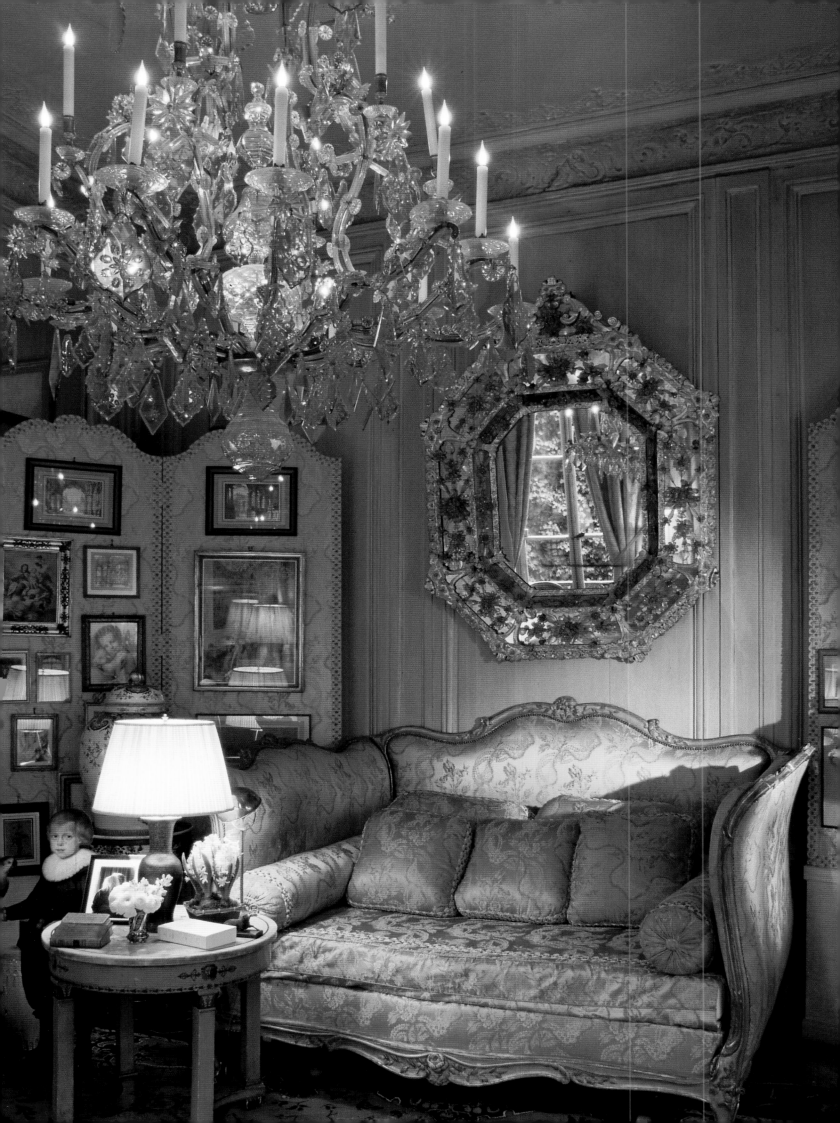

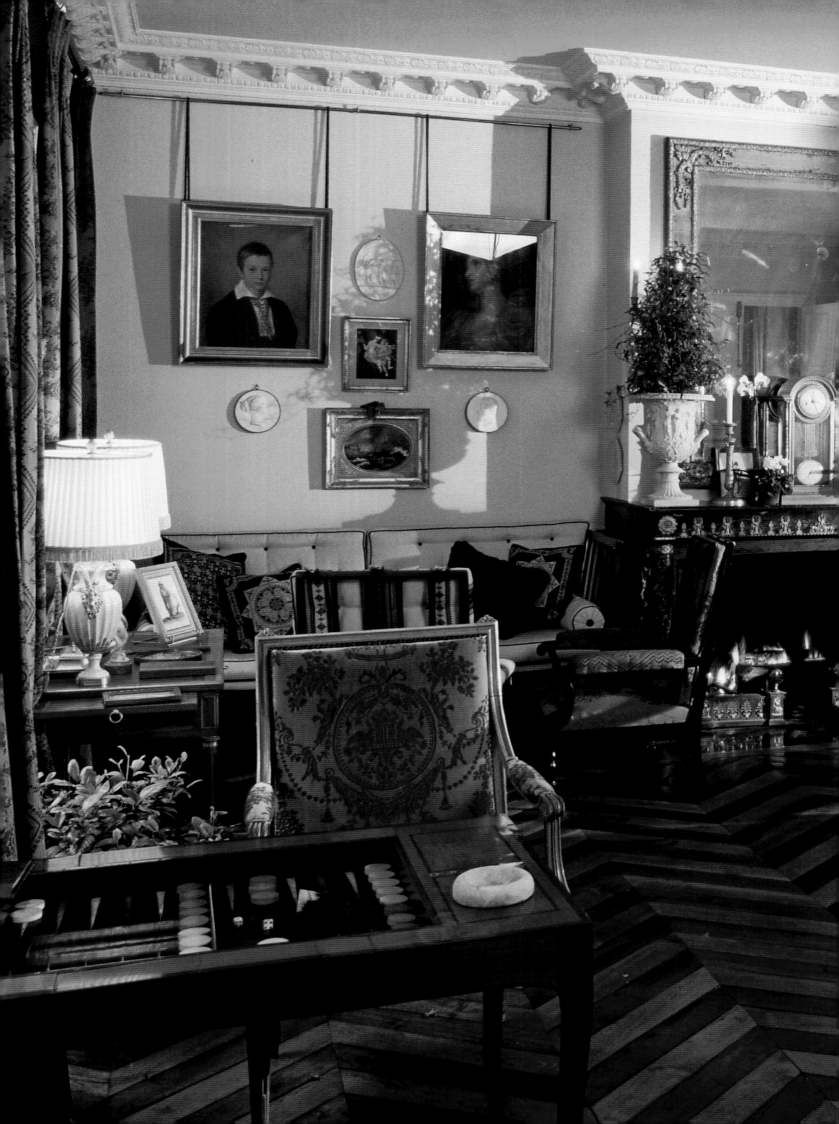

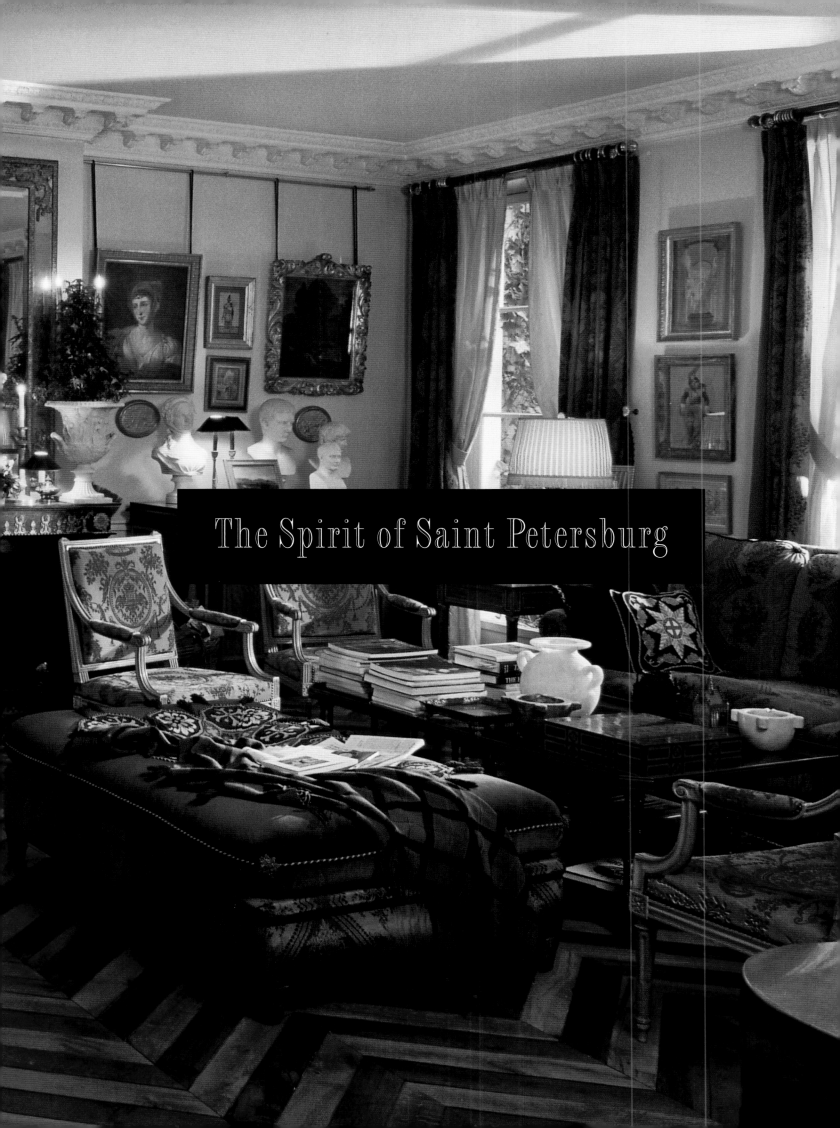

The Spirit of Saint Petersburg

A Luminous
House

For several years, the owner of this house looked through old editions of Russian drawings and watercolors, dreaming of Pavlovsk, the palace of the Emperor Paul near Saint Petersburg. When, quite unexpectedly, she discovered an *hôtel particulier* dating back to the late eighteenth century at the end of a cobblestone courtyard, she decided to transform this rather abandoned dwelling into the family house, and create here her own version of northern Europe.

Leaving behind a rather over-decorated place, she decided to create a peaceful, light, and airy environment, and went straight to work. Absolutely fascinated by architecture, she made a great many sketches, then, with the help of a contractor, started working furiously on plans. "The place spoke to me," she said, "and I felt a great freedom with which to act." She opened the windows, put up walls,

created terraces, floors, staircases, and, as the final touch, an enclosed garden.

"When we were children in the country," she explains, "we felt protected by the house's walls, and I wanted to rediscover this sense of security in Paris, to establish real roots for my children by building something beautiful, seeking inspiration from the white light and poetry of Russian fairy tales. That's why I chose light and powdery colors for the walls, such as gray, celadon, or ivory."

The decor for her office was inspired by a dressing room at Osterley, near London, a neo-Etruscan decoration in burnt Sienna and ivory; there are doors with Wedgwood motifs, ice-blue taffeta curtains, and two-toned oak parquet floors. A joyous confusion reigns here: mail, photographs, children's drawings, little reminders pinned onto the walls, invitations hung on the curtain embrasures. Opposite the office is the even more private domain of the owner—the studio where she paints.

A Swedish castle was the inspiration for the dining room, and it is

(Previous pages) The large living room of the ground floor looks onto the entrance court. It has a very neo-classical Russian atmosphere thanks to the pale yellow walls and white moldings, blue ottomans and sofas, an Empire fireplace, a two-tone zig-zag parquet floor, Russian paintings, and neo-classic plaster of Paris busts and urns.

(Opposite) The house is accessed from a narrow street by a paving stone pathway punctuated by boxwood in large terracotta planters. In summer, glycinia climbs the outside walls. The gray walls inside are highlighted in white, the black and white meander motif of the gray drapery borders and antique black and white marble floor all recreate the atmosphere of a house on the Neva. The statue is crowned with a wreath that was awaiting a more characteristic use.

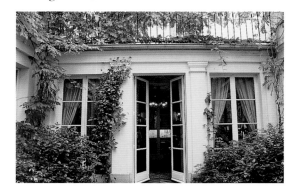

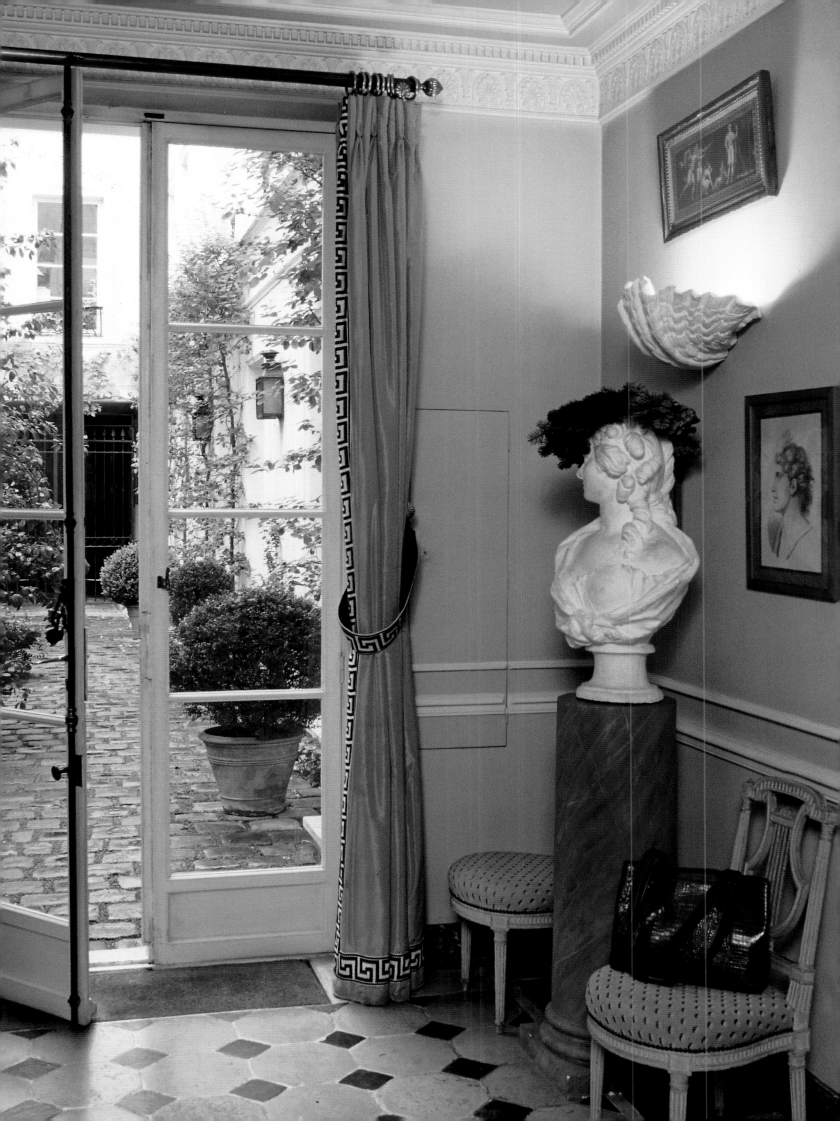

(Opposite)
*On the Empire fireplace of
the main living room is an
Empire gilt bronze candlestick,
a lovely orchid and cyclamen
in a silver vase.*

(Above)
*Between the French windows
of the living room is a
backgammon table, and
(below) are books and
magazines scattered on the
ottoman that reflect the interests
of our hostess, a talented artist.*

(Right)
*The photograph is of her
father and aunt, dressed for a
costume party.*

an astonishing decoration. Against a celadon background is set an amusing ochre-colored bamboo and a frieze with abstract renditions, in a somewhat geometric form, of clouds; the artist feels they alternate between smiling and frowning cumulus structures. It has a coffered ceiling with distinct areas marked off by white moldings. On these are motifs inspired by unfurled umbrellas: all this is the work of the mistress of the house, as is the rest of the painted decoration. Between the six French doors, narrow mirrors reflect the light of day or the glow of candles. This room opens onto a small courtyard that has been turned into a garden, planted with jasmine, clematis, and roses.

In the main salon, a visitor is transported deep into Russia. The yellow upholstery of the armchairs is a perfect fit with the Nattier blue chosen for the curtains, sofas, and Ottoman. The atmosphere of calm and serenity that reigns in this room is quite different to that of the library, situated on the first floor. There, the warm tones of the embroideries or prints that cover the English furniture are reinforced by red curtains.

Our hostess is a descendant of Lucien Bonaparte, the younger brother of the Emperor Napoleon I and the President of the Council of Five Hundred. He was a leader who played a decisive role in the coup d'état of 18 Brumaire by boldly haranguing the troops while the Council was about to outlaw Napoleon. This succeeded in dispersing the Five Hundred, the Directory was overthrown, and Napoleon became First Consul.

Today, our hostess evokes the passionate feelings Napoleon had for Juliette Récamier,

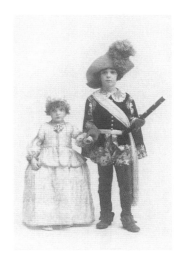

(Below) Princess
Bonaparte, an ancestor of
our hostess, is surrounded
by family members. Our
hostess's grandfather is seen
in the medallion (left) while
his father poses uneasily
(right), with a boater
on his knee.

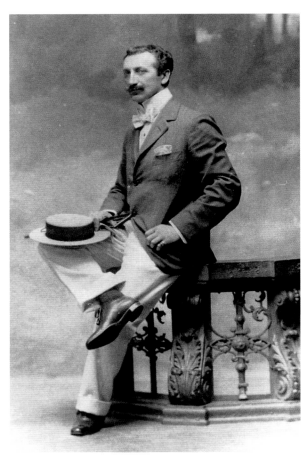

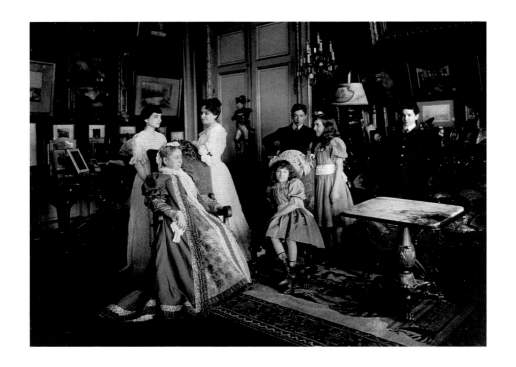

(Opposite) A gallery on the
first floor leads to the library.
On the left is the entrance to
the office, on the right to the
studio. The bi-color parquet,
hexagonal multi-tier Russian
table and the same gray and
white tonality as in the
entrance hall carry out the St.
Petersburg atmosphere. The
shelves are filled with art books
and sales catalogs.

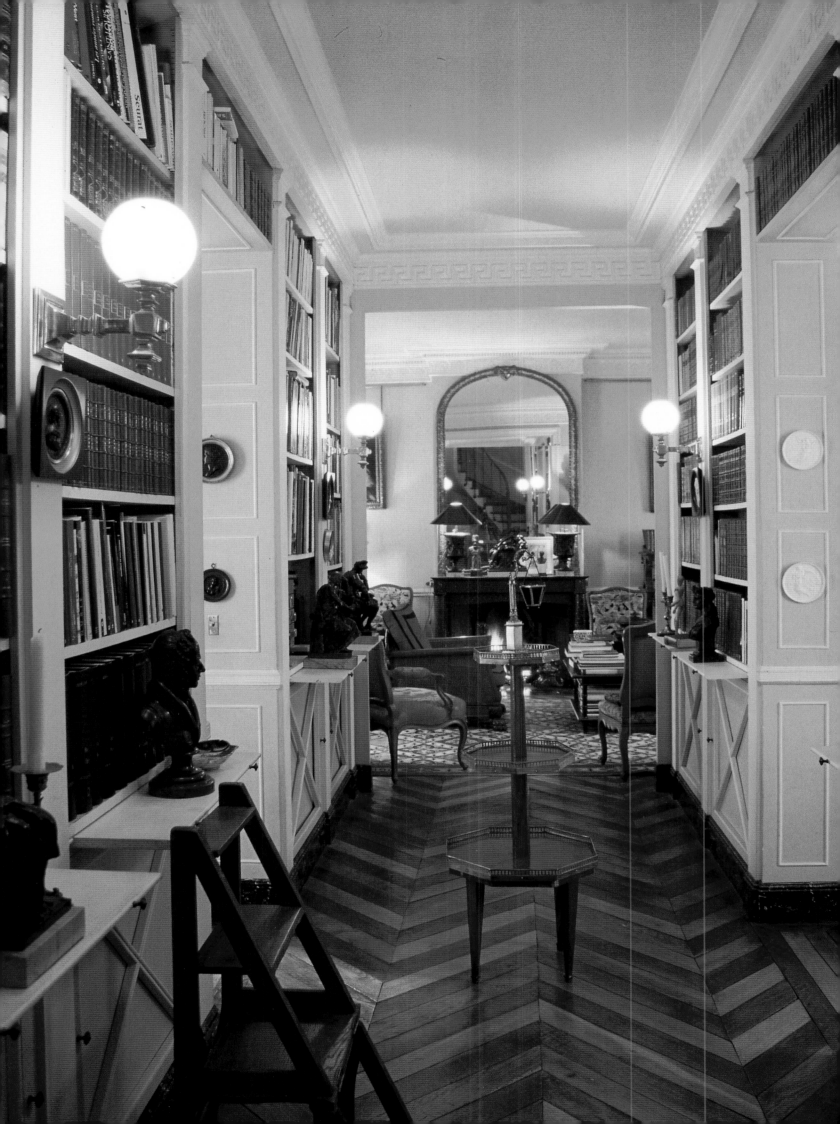

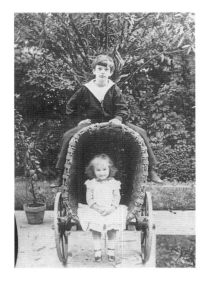

The owner's grandfather is seated in a pram, dressed in girl's clothes, in accordance with the style at the time. His older brother, fortunately, has graduated into a sailor suit.

(Left) The house has a small interior garden used in the summer for dining. It is then filled with roses, and is a delicious place to spend the evening hours.

The studio (opposite) and the office (right) were both painted by the owner in tones of Wedgwood porcelain and Wedgwood motifs inspired from antiquity. All the stenciling on the walls was executed by the owner. It is, of course, her studies from life that are placed on the easel.

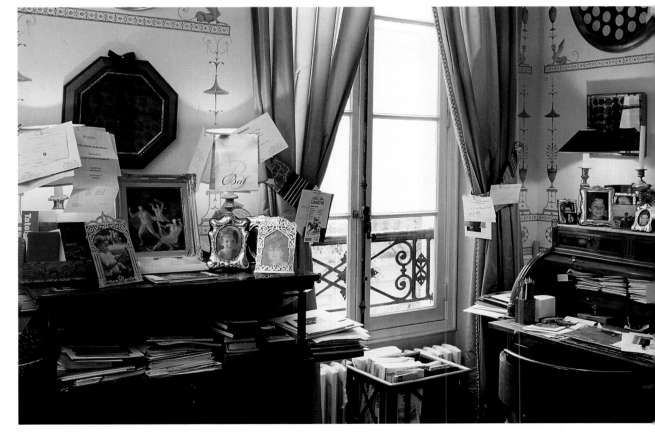

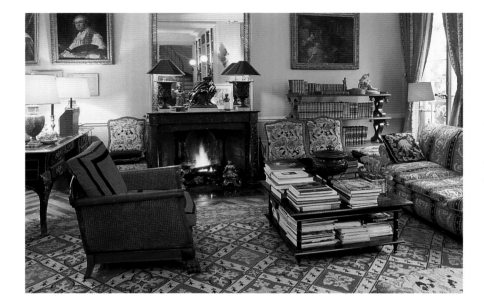

The first floor library is a warm and cozy place, where red predominates in the 19th century English embroidered carpet and upholstered furniture. Art books are piled up on the tables. This is a favorite gathering place of the family.

who lived here and of whom her friend the Duchess of Devonshire said, "First she is good, then she is spiritual, and finally she is beautiful." Lucien Bonaparte was twenty-four when he met her in 1799. He fell madly in love and inundated her with passionate letters. But Juliette didn't share the same feelings, and instead proposed mere friendship, which drove Lucien to despair. "Your calm is killing me," he told her.

For the first time, Juliette was able to exert an immense seductive power over members of the opposite sex. Indeed, she was to become the very idol of her period, and her salon was the most sought after in all of Paris. Yet she preserved with one and all a distant attitude, analyzed fifty years later by the author and statesman, Sainte-Beuve, who wrote, "She was really a magician who could, unwittingly, transform love into a friendship that pre-

served all the fragrance of the first passionate moment. She would have liked to stop everything in April."

Until, that is, she met the Vicomte François René de Chateaubriand, considered by many to be the founder of Romanticism in France. He was to be the true love of her life. For the first time, she let her feelings show, and this great author became the epicenter of her life. The socialite and coy seductress moved into his house, the Abbaye aux Bois on the rue de Sèvres, and turned her salon into a political and literary institution centered around the man she loved.

Everything reflected the interior harmony she radiated, the subtle relationships she could create with others, and her unique talent for bringing out the best in everybody she knew. As for Chateaubriand, he wrote in his *Mémoires d'outre-tombe*: "As I reach the end of my life,

(Overleaf) There is a beautiful dining room on the ground floor which can easily sit sixteen around two mahogany tables. It has two sets of three French doors, one leading to the inside garden, the other to the kitchen, which also has a large table for family dining and some antique furniture to harmonize with the more formal dining room. The dining room is prepared for Christmas dinner; yellow roses have been placed in a moss support, and the best Apt porcelain has been brought out for the occasion. Again, all the wall decorations were executed by the owner, and the pale ivory curtains with red and white borders (through which the kitchen can be seen) bring back the neo-classical look.

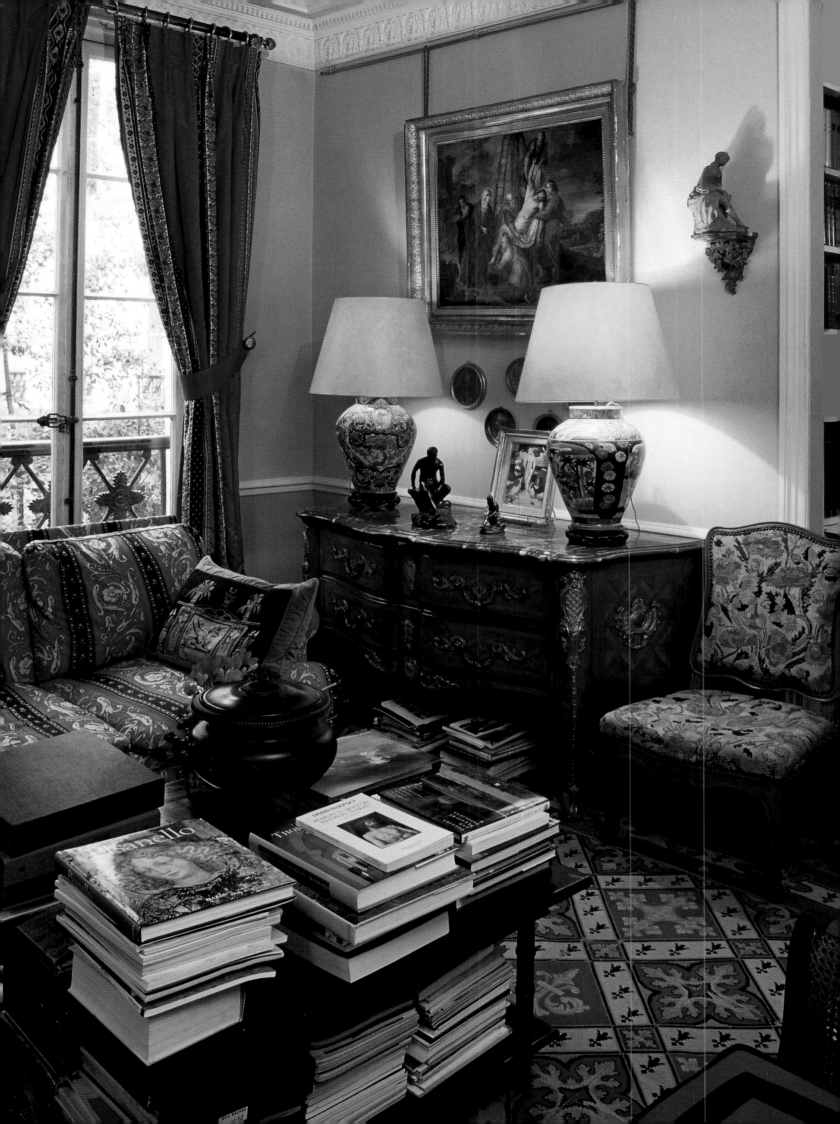

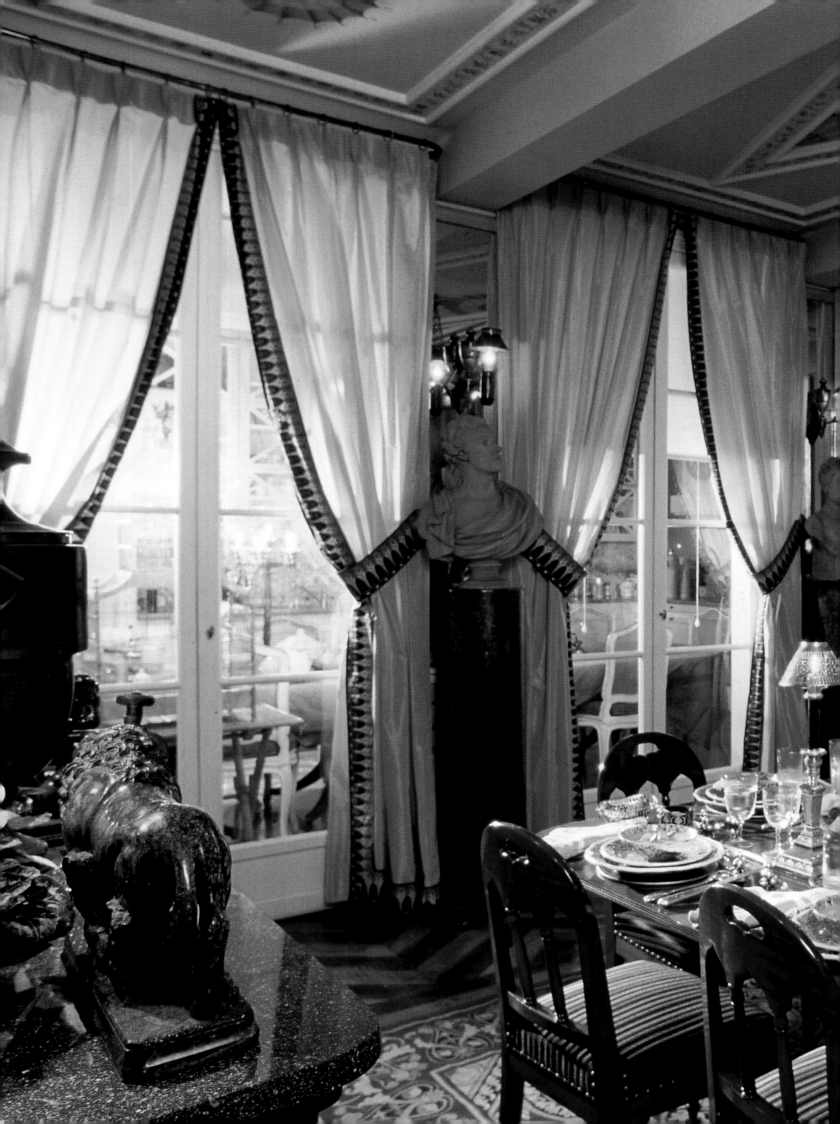

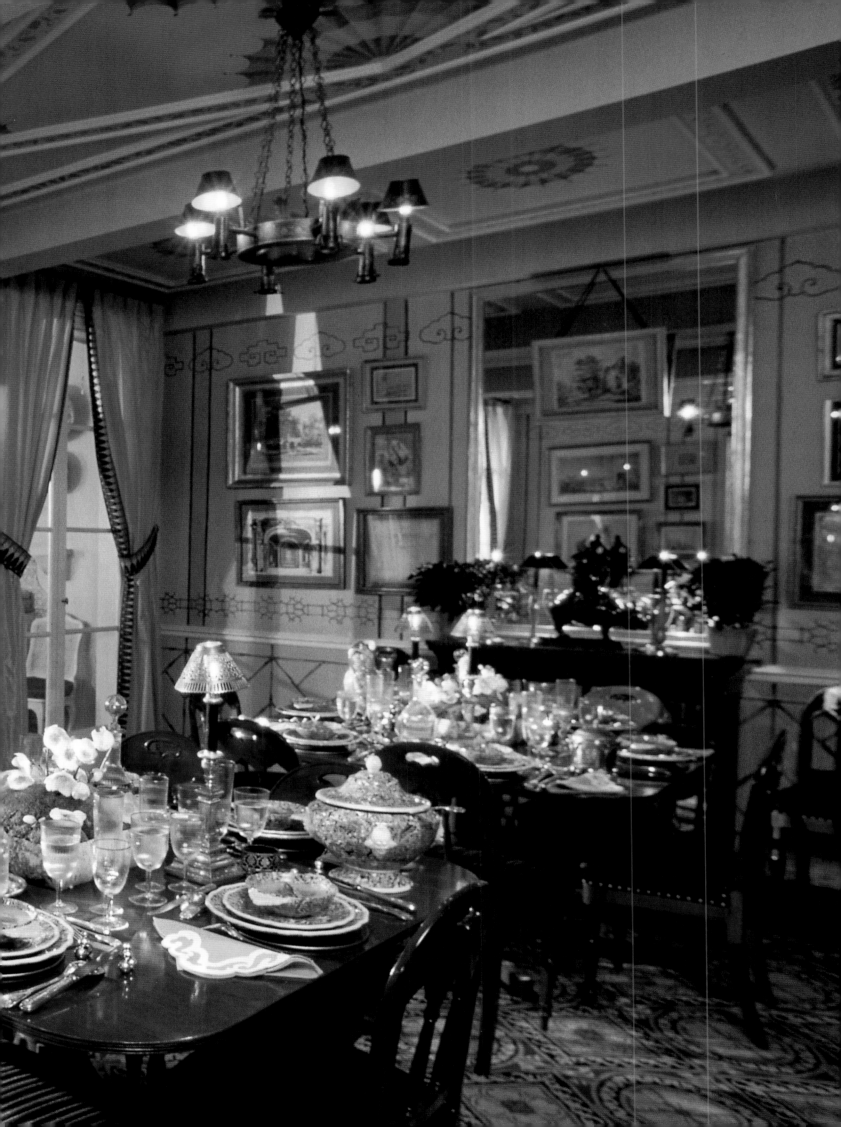

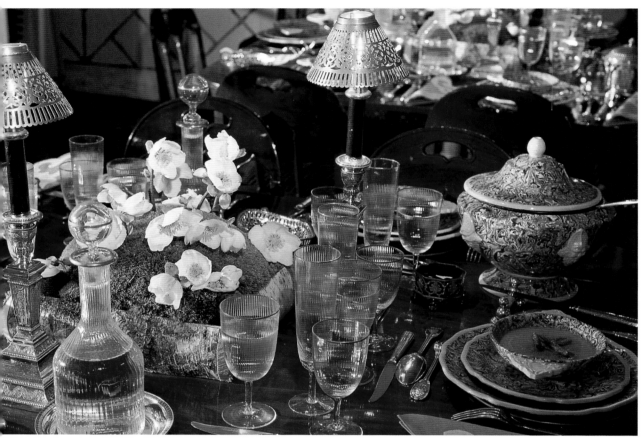

it seems to me that everything I have ever liked was epitomized in Madame Récamier, and that she was the hidden source of all my affection. All the memories of different times in my life, of my dreams as of my realities, are shaped, mixed, confused to make up a bouquet of both charm and sweet suffering, of which she has become the visible form."

Our hostess speaks with admiration of the very special atmosphere Madame Récamier was able to create in her salon, and perhaps Récamier was an inspiration for her. On the evening of our visit, she was giving a dinner party. She had set out, on two mahogany tables,

plates from an eighteenth century set of Apt porcelain, a bouquet of Christmas roses, and candles shining through gilded shades, whose flames were reflected in the room's mirrors. One could see the great kitchen table and oriental faience plates on the kitchen walls through the glass doors with their elegant ivory taffeta curtains. We could imagine how much the adorable Juliette Récamier would have appreciated this open space, its subtle lighting, and how much she would have enjoyed herself in this mysterious and romantic atmosphere.

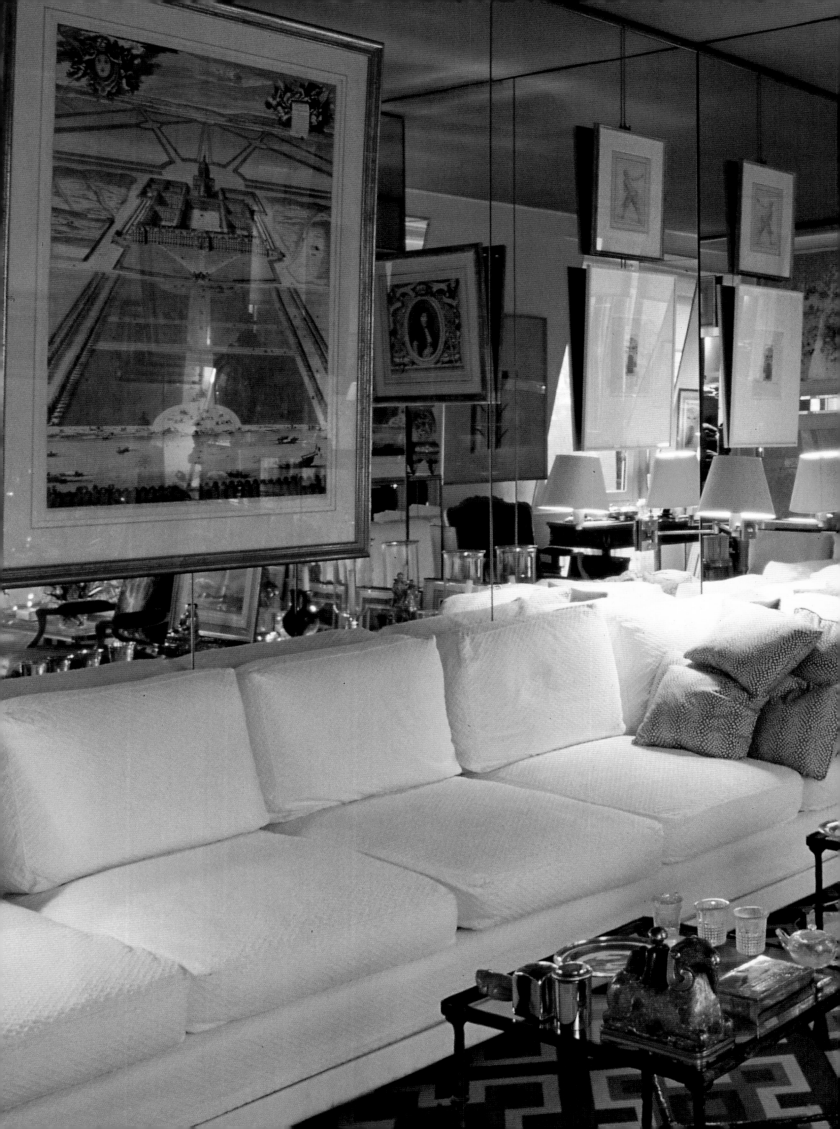

A Scot In Paris

With Walter Lees

Walter Lees is a Scottish gentleman whose highly original wanderings have taken him through El-Alamein, Calcutta (where he met Mother Teresa), every capital of the world, and, above all, Paris. He had a severe and spartan upbringing in Scotland, joined the army at sixteen, and went to war at the tender age of nineteen! He was a member of the 51st Highlanders Division, which distinguished itself in 1942 at Tall al'Aqaqir. Lees was taken prisoner by the Germans directly after the Battle of El-Alamein, succeeded in escaping from his jailers on the way to Germany, but was quickly recaptured .

At the end of the war, he became part of the light brigade of General Bellamy, and was at the Hotel King David in Jerusalem during the terrorist bombing led by Menachem Begin, later Israel's prime minister, in which ninety-one British soldiers were killed. Promoted to the rank of major, he was later transferred to Cairo, and became an information officer for General Offrey. In 1947, he joined the staff of the last British Viceroy to India, Lord Mountbatten, and was in New Delhi for the dramatic partition of India and Pakistan, after which Mountbatten returned to Britain, as did his entire staff.

In 1948 Lees was named honorary attaché to the British Embassy in Paris, then led by Sir Alfred Duff Cooper (see pp. 124-26). He remained there for eight years, during which time he became deeply attached to France. Following a stint in the business world, he traveled widely and, a few years ago, decided to tour India, a dream he had been unable to fulfill in 1947 for political reasons. He traveled the subcontinent in a taxi, with a camera thrown around his shoulder, and was overwhelmed by the many-faceted nation.

He became a passionate photographer, toured the world, and etched on film the great multitude of faces that crossed his path. On the walls of his Paris apartment are a few examples of the way this unparalleled gentlemen sees his

Walter Lees's small living room (previous pages) seems much larger than it really is thanks to floor-to-ceiling mirrors, the perfect scale of his furniture, and a plethora of objects on the walls and tables, all of which are in exquisite taste. Among the elegant objects seen here are a silver box (below) and a teapot (opposite) that could have been used for the Mad Hatter's tea party in "Alice in Wonderland." Lees is one of Christie's major assets in Paris, and he loves to entertain his friends and their clients in an area that is, on occasion, the size of their antechambers. Everybody fits in among the plates and glasses and enjoys the fun and informality of a host in a city where hostesses entertain with trepidation and endless forethought. Sometimes, his guests end up chatting in the bathroom (overleaf), which is decorated with more flair and imagination than many a living room. Walter Lees's photographer's eye is in evidence in the impeccable way his prints and drawings are hung around the mirror. Note how cleverly the calligraphy hangs on a mirror that also reflects the street below.

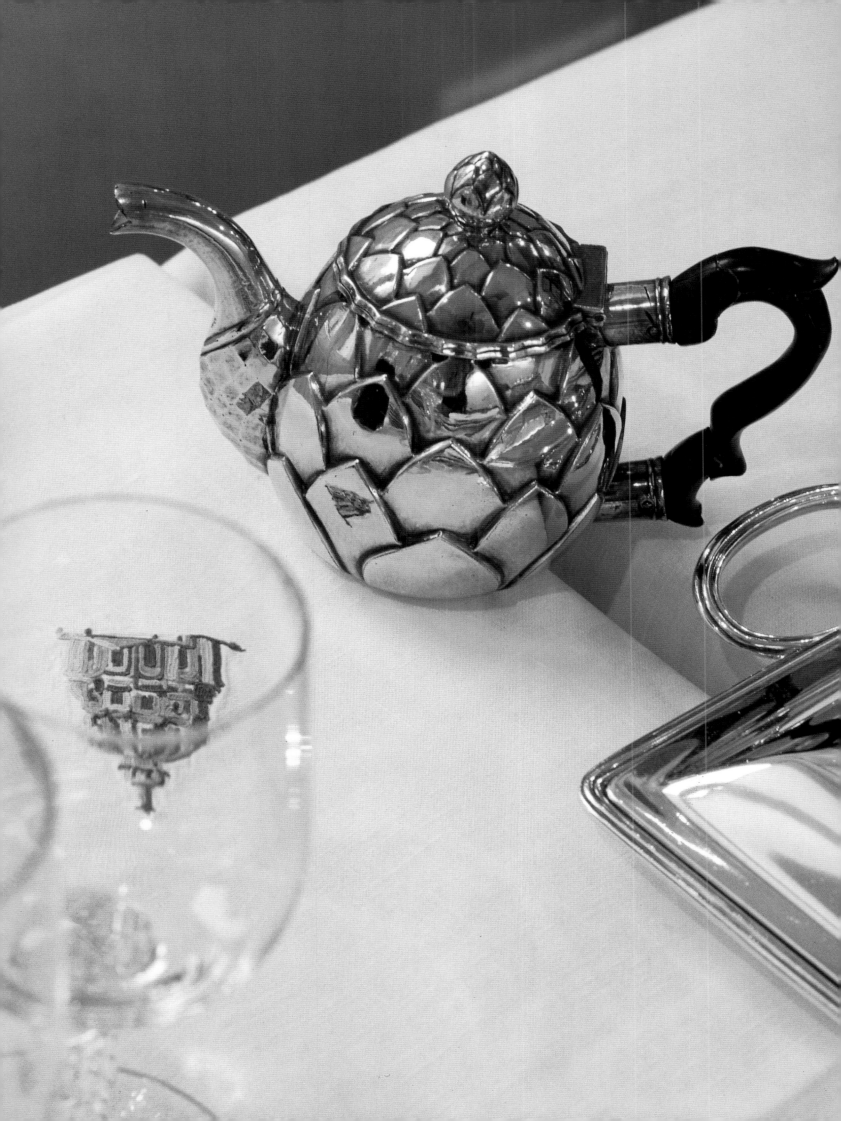

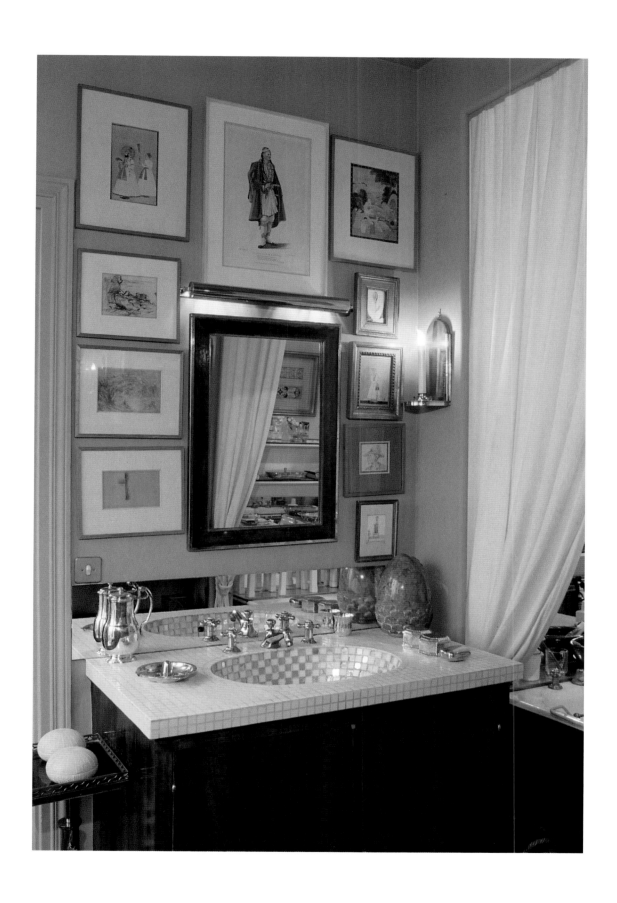

fellow human beings. Very differ-
ent from these photographs were
those he exhibited at Christie's in
the spring of 1999 for a benefit hon-
oring Mme. Giscard d'Estaing's
foundation for children. This col-
lection of poetic and charming

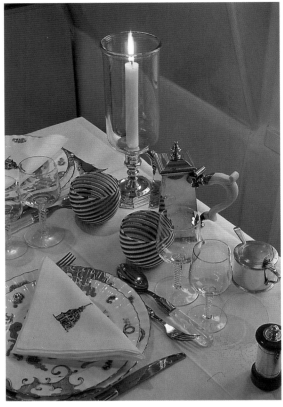

(Center)
Walter Lees greets his
guests on the outside
staircase leading to his
apartment. The stairs
overlook the courtyard
(below), and on good
days—clearly not the
case here—guests find
themselves dining here
with plates balanced in
their laps.

photographs was entitled "The
Flowers of Bagatelle," and included
daffodils, irises, peonies, clematis,
and roses. The once-young repor-
ter had been transformed into a
photographer of flowers. "I adore
France, and wanted to make a ges-
ture for the wife of her former
president."

Lees is as full of enthusiasm as a
young man. At an age when he
could easily retire, seated in a
leather armchair near a fire in his
native Scotland, he never stops run-
ning around the world. Between
trips he summons up memories of
his dearest friends—Dame Margot
Fonteyn, Alberto Giacometti, and

Mother Teresa, who, humorously,
used to call him Walter Scott. And
in his small house he entertains
all of Paris and never fails to aston-
ish his guests with the feats he can
accomplish in such a restricted
space.

(Above) Lees also likes
to have a few friends in to
dine. On such occasions
his table is every bit as chic
as that of his good friend
Hubert de Givenchy (see
pp. 64-79).

(Opposite) Glasses,
dishes and wine bottles
form a splendid geometric
composition. The wall of
the storage area is an
opaque window; everything
has its place and not an in-
ch is wasted.

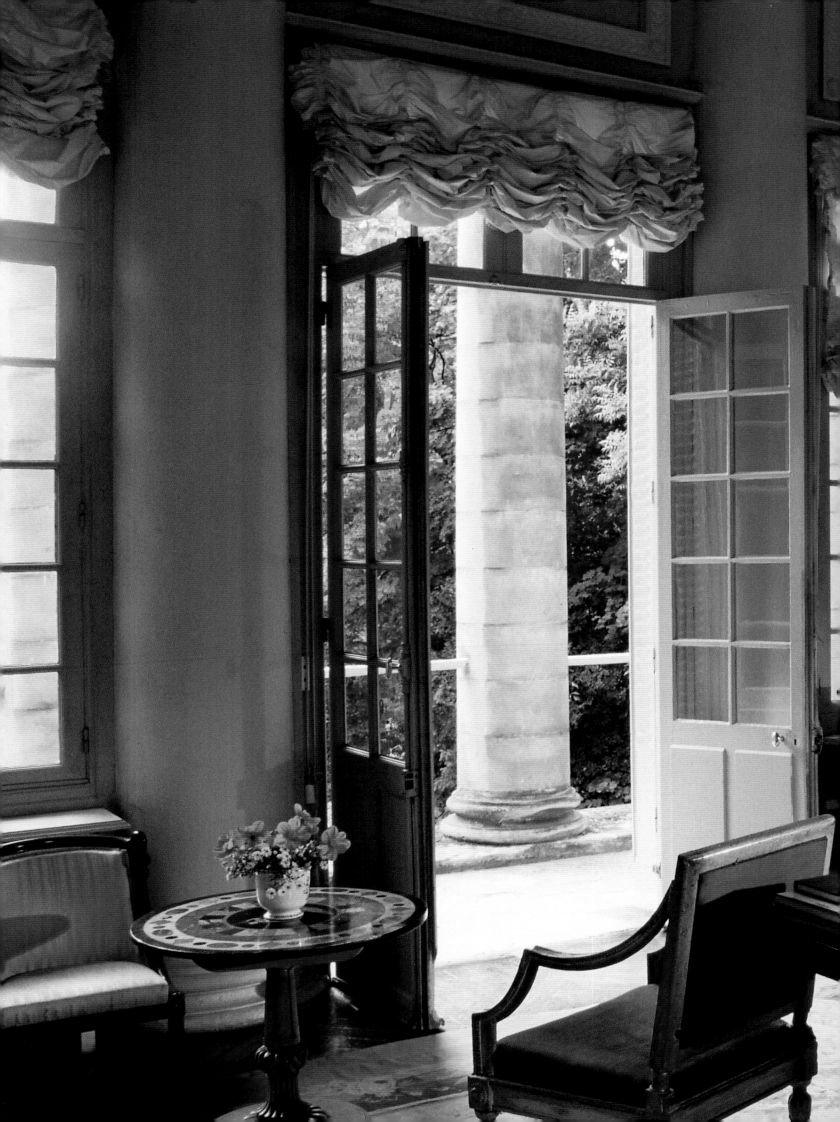

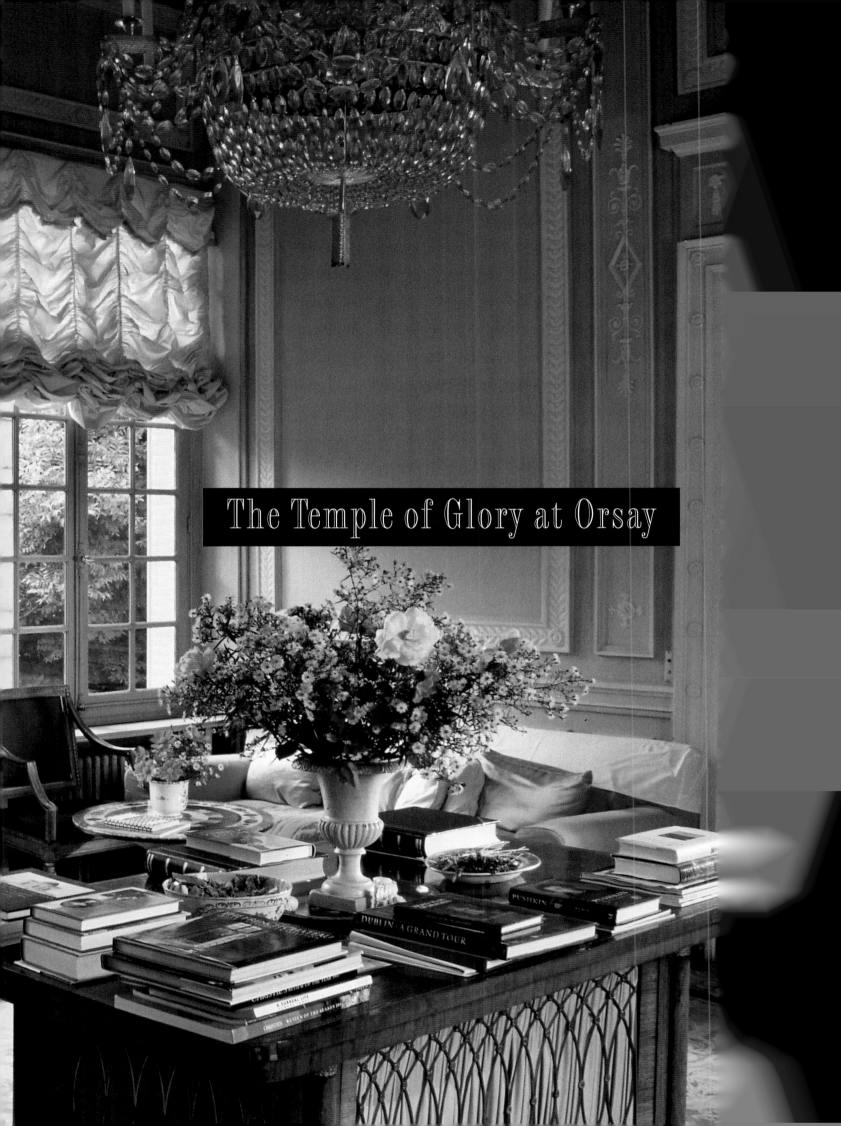

The Temple of Glory at Orsay

With Lady Mosley

When the French General Moreau, victor in the Battle of Hohenlinden, fought on December 3, 1800, against the Austrians, came back to Paris, his young wife and mother-in-law had a special surprise in store. A beautiful Palladian villa, known as the Temple of Glory, had been built in his honor in the park of the former Château d'Orsay.

On May 23, 1801, as the entire country expressed its acclaim and blew fanfares, the general went aboard a ship flying bunting and sailed along the lake at Orsay to a terrace, where his entire family awaited his arrival. And there stood the superb "temple." Pierre Vignon, who was to build the magnificent Church of the Madeleine based on Paros's plans a few years later, was the architect.

Who, then, was his admiring mother-in-law? None other than Jeanne de Gury-Hulot, wife of the general treasurer of Martinique and a friend of Josephine de Beauharnais. Her daughter Eugénie, also known as "the general," was an adored fixture of the salons of the time. Soon a terrible jealousy developed between mother-in-law and daughter-in-law over the young General Bonaparte, whose increasing glory quickly eclipsed that of General Moreau. A Creole, like Josephine, Jeanne de Gury-Hulot became terribly jealous over the ascent of the future empress.

Napoleon Bonaparte allowed no obstacle to get in the way of his unlimited ambition. In 1804 he arrested Moreau as a "conspirator" and sent him into exile in the United States. Farewell to France and farewell to the Temple of Glory. In 1807, it was sold to Arrighi de Casanova, the future Duke of Padua,

*(Previous pages)
The Temple of Glory was built in the grounds of the Château d'Orsay at the beginning of the nineteenth century. The Ionic columns of its formal, Empire façade (see page 203) are seen through the French doors of the living room, which open onto a narrow terrace. The Empire style is carried out in the gray and white wall moldings, the bronze and crystal chandelier, and the style of the drapery. There is enough Empire furniture here to enhance the setting, and the flowers are fresh from the garden.*

Lady Mosley is seen reading by the fireplace. Her passion for books is not surprising in view of her literary family, the Mitfords, and their background. The atmosphere of this part of the house is appropriately British, and one can readily imagine oneself anywhere in the English countryside.

Unity, Nancy, Pamela, Diana, Jessica, and Deborah, the youngest, who is the present Duchess of Devonshire, chatelaine of Britain's legendary Chatsworth, with its extraordinary collections of paintings and drawings.

The eldest, Nancy, wrote very humorously about their childhood

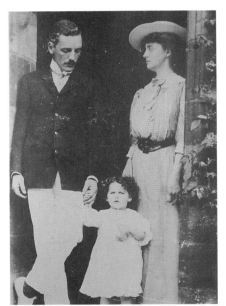

who kept it until 1815. The park and the "temple" were abandoned until 1950, when the property was bought by Sir Oswald and Lady Diana Mosley, née Diana Mitford, of the renowned literary family.

Lady Diana was one of six daughters of Lord Redesdale, all of whom were well known for their beauty and strong personalities:

Diana Mitford (above), later Lady Mosley, was part of a renowned and eccentric English family about whom a great deal has been written, particularly concerning the turbulent days leading up to World War II. The six Mitford sisters and their parents, Lord and Lady Redesdale (center), variously reflected the different political points of view that prevailed in Britain. Traditionalists, particularly in the upper classes, felt that dictators should not be opposed as only they could keep order in Europe, while many liberals felt that revolution leading to a Soviet-style Utopia was the answer to glaring social inequality. It was Nancy Mitford (below) who achieved literary fame thanks to such books as "Love in a Cold Climate," "Voltaire in Love," and biographies of Frederic the Great, Madame de Pompadour, and Louis XIV.

(Opposite) In the downstairs living room is a splendid Empire "chaise longue" that once belonged to the great actress Talma.

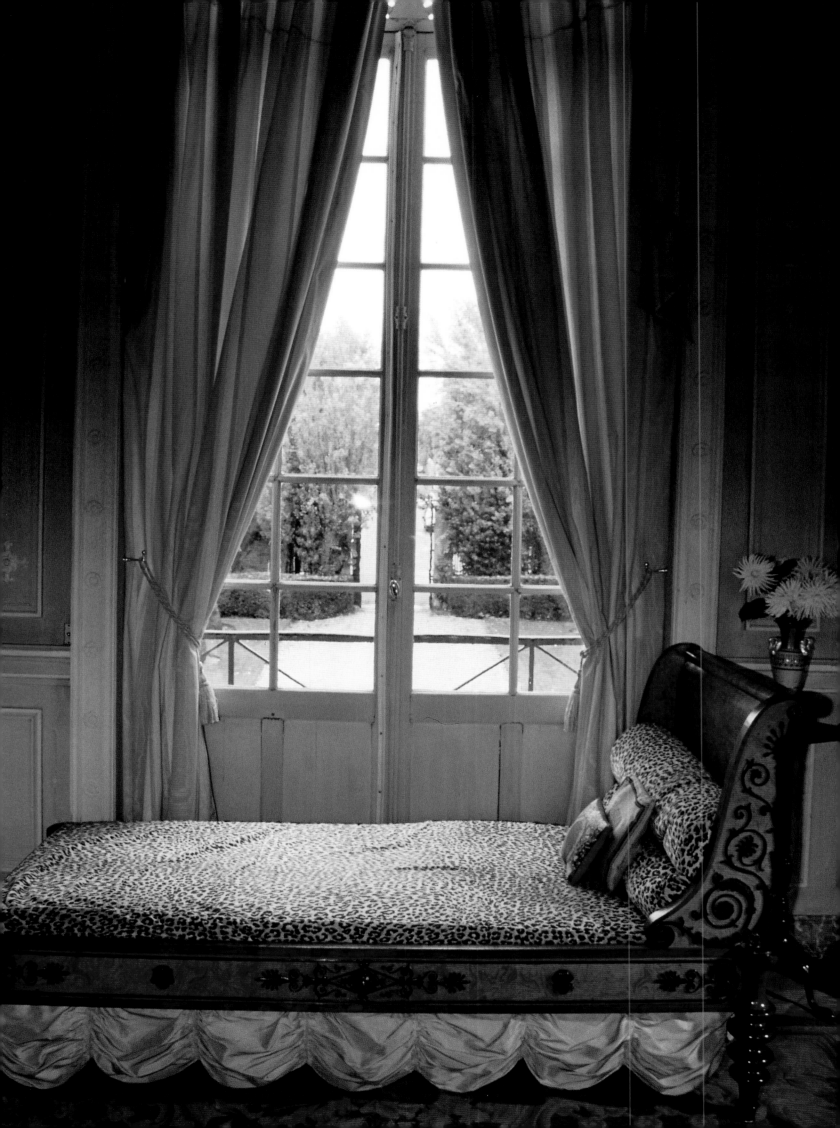

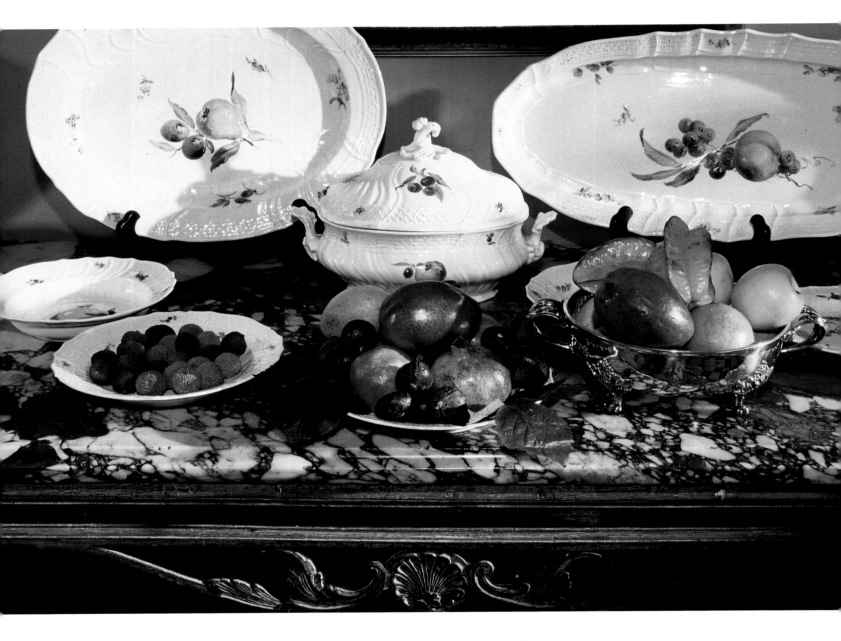

in England in her first novel, *Pursuit of Love*, published in 1945. She described the family, using the pseudonym Radlett for them, and named her eccentric parents Uncle Matthew and Aunt Sadie. Uncle Matthew was a resplendent English aristocrat with an absolutely dreadful character. "He ground his teeth so ferociously that he used up two sets of dentures per year. He loved only the English countryside and fox hunting. His ideas on young girls' education were terribly stilted . . . in other words practically nonexistent." His only son was sent to Eton. The six sisters were brought up at home by a series of nannies. Even so, "the tyrant" was adored by his children.

His passion for hunting took, on occasion, curious turns, which Nancy Mitford evoked in her book.

"Uncle Matthew had four magnificent bloodhounds with which he hunted for his children. Two of us set out in front to sow the field, then Uncle Matthew and the others followed the hounds on horseback. We had a wildly delightful time. One day he came to our house and chased Linda and me across the plain of Shenley. This caused immense agitation in the neighborhood. Weekend visitors from Kent were blown over, as they were on the way to church, by the spectacle of four enormous bloodhounds barking as they chased two little girls. To them, my uncle seemed to be a corrupt aristocrat from a novel, and I was endowed, even more than before, with an aura of folly and perversity, and was considered both dangerous and 'impossible company' for their children."

When the Radletts were not madly happy, they fell into the deepest gloom. Their emotions were never ordinary; they either loved or hated, laughed or wept, and lived in a universe of superlatives. Had they been children of a poor family, undoubtedly they would have been taken away from

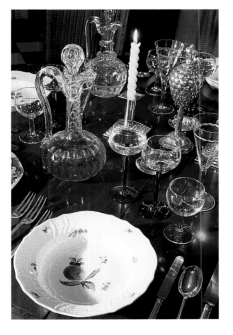

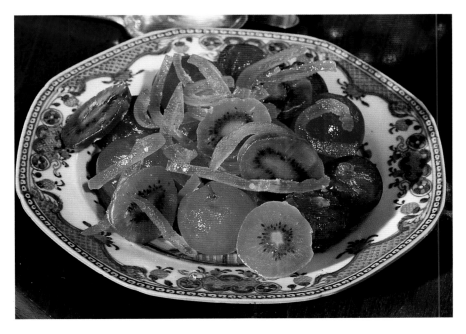

The "Temple" was recently sold, and Lady Mosley has moved to Paris. She enjoyed entertaining small groups, particularly at lunch, and friends enjoyed coming to the Temple of Glory, particularly on Sundays. The cooking was taken care of by her Irish butler, who had been in her household for years, and guests could come early, swim in the pool, lunch, take walks in the countryside or simply chat. On these occasions, she used her beautiful and rare set of Saxon porcelain, placing it directly on the mahogany dining room table, and only used her fine linen tablecloths for dinner parties. Exotic tropical fruit is displayed on the dining room console table (opposite), and candied fruit was served after dinner (left). Wine was served in lovely carafes, and an Augsburg silver-gilt pineapple cup (above) lent a particularly elegant note to her table setting.

(Above) Geraniums were planted around the garden in large pots, and Lady Mosley paid particular attention to the kitchen garden (below), where she also grew roses and dahlias. True to her English origins, she is a devoted gardener and spent a great deal of time working outside. The house's swimming pool is located in this area, and was bordered by these flower groups. Despite her age, Lady Mosley kept in shape by actively exercising in the pool. The house has now been sold and the owner has moved to an apartment in Paris.

their bawling and enraged father, who was constantly slapping them, and would have been placed in a home with respectable children. Or he would have been removed by force and put into prison, as he refused to allow them to be educated. Nature sometimes provides its own remedies, and the children no doubt had in them enough of the character of Uncle Matthew to overcome these storms. "In the end it was an excellent education," Nancy would say later. "If we never learned to walk a straight line, we did learn to run quickly."

At eighteen, Diana, considered one of the beauties of her generation, married Bryan Guinness, with whom she had two children. Guinness was heir to an immense beer and banking fortune, and the couple was emblematic of the gilded youth between the wars. She divorced, and married Sir Oswald Mosley, founder of the British Fascist Party. Together, they had two children, Max and Alexander, the latter a publisher who lives in Paris.

After the war, the Mosleys went to live in France, and once they moved into the the Temple of Glory, they restored the stucco and wainscoting to its original state, and redecorated the place in its original Empire colors; once more there were pastel walls, melting harmoniously into the heavier tones of the woodwork. In the main living room, a pale rose ceiling reflects the light: "I chose a

(Opposite) The facade of the lovely Palladian 'Temple de la Gloire,' put up in 1801 and designed by Pierre Vignon, architect of Paris' renowned church of the Madeleine. Two staircases, made of stone blocks so large that they blend into the ensemble, lead up to the central living room, whose porch is created by the Ionic columns and entablature. Lady Mosley's small office was on the right, her late husband's on the left.

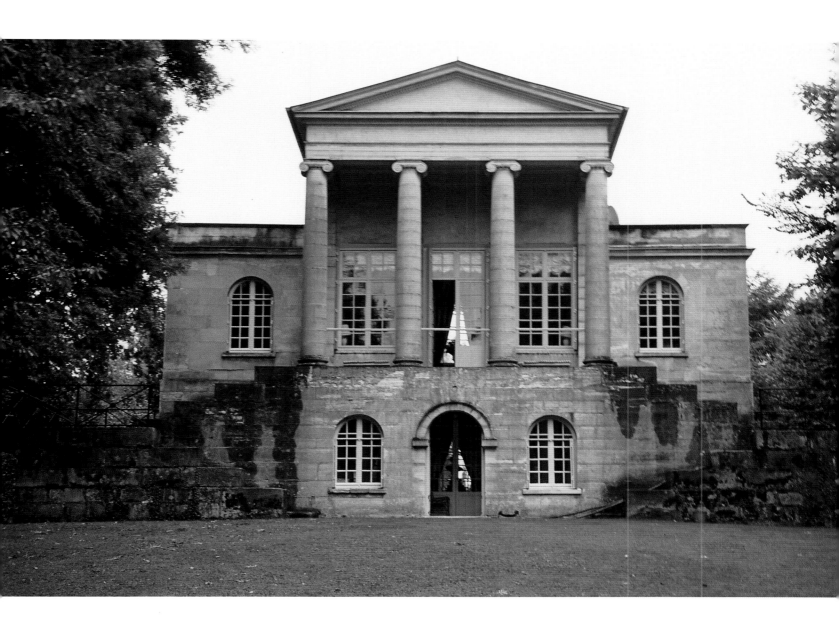

rose petal that I particularly liked, and used that for the color of the ceiling," says Lady Mosley. The walls are pale gray, the large Aubusson carpet has a floral motif, and there are parquetry tables of a marble color, all of which make up a very clear and serene Palladian setting.

The furniture, mostly French, came from their houses in Britain and Ireland, from the sales rooms of the Drouot auction house, and from Venice, where they spent several weeks every year: blue and gold armchairs, narrow banquettes to receive special guests, and a large globe, which adds a dramatic note to this peaceful universe. In fact, the globe once belonged to Talma, the great dramatic actor of the Empire period.

Emilio Terry, a very fashionable French interior designer before and after World War II, was a good friend of the Mosleys, to whom he presented this book with his sketches.

(Opposite) At the end of a long lawn in front of the Temple is a small lake and stone bench where Lady Mosley liked to sit when not busy gardening.

Two rooms flank the salon. Left is the small Salon of Diana, where Lady Mosley likes to read, seated close to the fireplace, surrounded by photographs, family portraits, and books. Everywhere there are accents of pale blue, her favorite color (that of her eyes, in fact) and this shade is found throughout the house. On the right is the study of her late husband, who died in 1980. Nothing has been touched here, and a blue note is lent via an old porcelain stove.

"It's a charming place, but where do you actually live?" asked the late Duchess of Windsor, one of Diana's close friends, when she first visited the Mosleys. In fact, large though it may be, the house has just three rooms.

Two symmetrical stone staircases lead from the living room terrace to the lawn, which runs down to the water and the park, planted with very old plane, chestnut and cherry trees. From here, one proceeds to a far wilder area of the garden, which Diana calls "my piece of England." This is a field of daisies and marigolds, and beyond is the orchard. Nearer the house is a flower garden where Lady Mosley works every day in season.

Diana Mosley has lived in the Temple for forty-eight years. "So many things have transpired here. Nobody can ever take that happiness away from me."

Acknowledgements

I should like to thank France Anthonioz and Raymond de Nicolay, as well as my publisher, Colette Véron, for all their help. I would also like to thank all those who opened their houses to me. I am grateful for their hospitality and their trust.

Further Reading

Adams, William Howard. *A Proust souvenir*. New York 1984

Balla, Ignatius. *The romance of the Rothschilds*. New York 1913

Burchell, S. *Imperial masquerade. The Paris of Napoleon III*. New York

Clermont-Tonnere, Elizabeth de. *Pomp and Circumstance*. New York 1929

Cooper, Duff. *A durable fire. The letters of Duff and Diana Cooper*. New York 1984

———*Old men forget*. London 1953

———*The Second World War*. New York 1939

Corti, Egon Cesar. *The rise of the house of Rothschild*. New York 1972

Cowles, Virginia Spencer. *The Rothschilds, a family of fortune*. New York 1973.

Druon Maurice. *Alexander the God*. New York 1960

———*The Curtain falls*. New York 1959

———*Les Rois Maudits*. Paris 1955

Fowlie, Wallace. *Characters from Proust*. Louisiana State University Press. 1983

Fregnac, Claude with Wayne Andrews. *The Great Houses of Paris*. New York 1979

Hamel, Frank. *Famous French Salons*. New York 1908

Hastings, Selina. *Nancy Mitford, a biography*

Loliée, Frederic Auguste. *The gilded beauties of the Second Empire*

Martin, Benjamin Ellis. *The stars of Paris in history and letters*. New York 1899

Mitford, Nancy. *Frederick the Great*. New York 1970

———*Love in a cold climate*. London 1956

Mohl, Mary Elizabeth. *Madame Récamier with a sketch of society in France*. London 1862

Mohrt, Francoise. *The Givenchy style*. New York 1979

Morton, Frederic. *The Rothschilds; a family portrait*. New York 1962

Mosley, Sir Oswald. *My life*. New York 1972

Olsen, Donald J. *Paris; the city as a work of art*. New Haven 1986

Proust, Marcel. *Remembrance of things past*. (C.K. Moncrieff, translator). New York 1981

Radziwill, Ekaterina. *La société à Paris*. Paris 1887

Sedgwick, Henry Dwight. *Madame Récamier, the biography of a flirt*

Skidelsky, Robert Jacob Alexander. *Oswald Mosley*. New York 1975

Stael-Holstein. *Anne Marie Germaine (Necker). Considerations on the principal events of the French Revolution*. New York 1830.

———*Germany*. New York 1814

Turquan, Joseph. *A great coquette, Madame Récamier*

First published in the United States in 2000 by
The Vendome Press
1370 Avenue of the Americas
New York, NY 10019

Distributed in the United States and Canada by
Rizzoli International Publications
through St. Martin's Press
175 Fifth Avenue
New York, NY 10010

Library of Congress Cataloging-in-Publication Data

Nicolai-Mazery, Christiane de.
 [Visite privé. English]
 The finest houses of Paris / by Christiane de Nicolai-Mazery ; photographs
by Jean-Berbard Naudin.
 p. cm.
 ISBN 0-86565-217-1
 1. Mansions--France--Paris. 2. Interior decoration--France--History--
20th century. 3 Upper class--Dwellings--France--Paris. 4. Lifestyles--
France--Paris. I. Naudin, Jean Bernard. II Title.

NA7513.4.P3 N5313 2000
747.24'361--dc21
 00-038145

Original edited by Colette Véron, assisted by Brigitte Leblanc
English translation and editing by Alexis Gregory
Design and French layout by Corinne Pauvert Thiounn
English layout by Charles Davey *design* LLC, New York

Separations by Offset publicité, Maisons-Alfort, France
Printed and bound in Great Britain by Butler & Tanner Ltd
Frome and London